CLASSICS IN PSYCHOLOGY

CLASSICS IN PSYCHOLOGY

A NOTE ABOUT THE AUTHOR

CHRISTINE LADD-FRANKLIN was born in Windsor, Connecticut, in December, 1847. She received her A. B. from Vassar College in 1869 and studied thereafter at Johns Hopkins, Berlin, and Göttingen Universities. Ladd-Franklin taught at Johns Hopkins and Columbia and undertook investigations in the area of logic, reasoning, and intuition. Drawing on her training in physiology, she became increasingly pre-occupied with the nature of color vision, developing one of the major theories in this area. She conducted numerous empirical investigations and also wrote reviews and theoretical interpretations in the field. She died in 1930, shortly after the major collection of her articles was published.

Colour
and
Colour Theories

By
CHRISTINE LADD-FRANKLIN

ARNO PRESS
A New York Times Company
New York ★ 1973

Reprint Edition 1973 by Arno Press Inc.

Reprinted from a copy in
The Princeton University Library

Classics in Psychology
ISBN for complete set: 0-405-05130-1
See last pages of this volume for titles.

Publisher's Note: The color plates could not
be reproduced in black and white and have been
omitted from this edition. Appendix C, which
explained those plates, has also been omitted.

Library of Congress Cataloging in Publication Data

Franklin, Christine (Ladd) 1847-1930.
 Colour and colour theories.

 (Classics in psychology)
 Reprint of the 1929 ed. published by Harcourt, Brace,
New York, in series: International library of psycho-
logy, philosophy and sceintific method.
 Bibliography: p.
 1. Color-sense. 2. Color. 3. Light. I. Title.
II. Series: International library of psychology,
philosophy and scientific method. [DNLM: WW150
F831c 1929F]
QP483.F7 1973 152.1'45 73-2971
ISBN 0-405-05143-3

International Library of Psychology
Philosophy and Scientific Method

Colour and Colour Theories

Colour
and
Colour Theories

By
CHRISTINE LADD-FRANKLIN

LONDON
KEGAN PAUL, TRENCH, TRUBNER & CO., LTD.
NEW YORK: HARCOURT, BRACE AND COMPANY
1929

PRINTED IN GREAT BRITAIN BY
STEPHEN AUSTIN AND SONS, LTD., HERTFORD.

CONTENTS

 PAGE
Preface vii
Introductory (from Professor Woodworth) . xi

PART I

I. Vision 3
II. A New Theory of Light-Sensation . . . 66
III. On Theories of Light-Sensation . . . 72
IV. Normal Night-Blindness of the Fovea: Dis-
proof of the König Theory of Colour . . 92
V. The Rods and Cones of the Retina: Their
Dissimilarity in Function 105
VI. The Theory of Colour Theories . . . 114
VII. The Evolution Theory of the Colour-Sensations
(The Ladd-Franklin Theory of Colour):
A Question of Priority 126
VIII. On Colour Theories and Chromatic Sensations:
A Criticism of Parsons' *Colour Vision* . 132
IX. The Nature of the Colour-Sensations . . 148
X. Practical Logic and Colour Theories: On a
Discussion of the Ladd-Franklin Theory 165

PART II

SHORTER CONTRIBUTIONS AND REVIEWS

1. Light-Sensation (A New Theory) . . . 189
2. Colour-Blindness and William Pole . . . 191
3. The Extended Purkinje Phenomenon (for White
Lights) 193
4. Cones are Highly Developed Rods . . . 198
5. An Ill-considered Colour Theory . . . 202

CONTENTS

PAGE

6. Change in Relative Brightness of Whites of Different Physical Constitution as seen in Photopic and in Scotopic Vision : Disproof of the Hering Theory of Colour 209
7. The Uniqueness of the Blackness-Sensation . . 211
8. Putting Physiology, Physics, and Psychology Together 213
9. The Reddish Blue Arcs and the Reddish Blue Glow of the Retina : Seeing your own Nerve Currents 215

APPENDIX A

Eine neue Theorie der Lichtempfindungen
(A New Theory of the Light-Sensations) . 219

APPENDIX B

ARTICLES BY OTHER WRITERS

1. Dr. Troland's Discussion of Colour Theory (Neifeld) 231
2. The Ladd-Franklin Theory of the Black Sensation (Neifeld) 241
3. The Colour-Sensation Theory of Dr. Schanz (Neifeld) 247
4. Black : A Non-Light Sensation (Michaels) . . 255
5. Later Discussion of the Ladd-Franklin Theory of Colour (Israeli) 260

APPENDIX C

Explanation of Charts 275
Development of the Colour-Sense (Frontispiece) . 279

APPENDIX D

LIST OF DATES AND ORIGINAL SOURCES

Glossary 283
Index 285

PREFACE

D R. LADD-FRANKLIN has written, in the course of
a long and belligerent career, many vigorous articles
on the subject of colour vision ; she maintains that she
could not do half as well again if she were to write afresh
all the matter that they contain. It has been decided,
therefore, to bring them out as they stand, with indications
in square brackets (chiefly footnotes) where emendations
were required. It is remarkable, however, how little
alteration has been necessary—presumably because many
of the scientists who interest themselves in colour are just
as much in need now of the arguments that are here
brought forward as they were at the time these several
articles were written. As v. Kries has lately said, of his
own articles of like date (*Klin. Monatsblatt für Augenheil-
kunde*, 1923, p. 578, Bd. 70), it is proper still to refer the
reader to these discussions, for only in a few minor points
do they need to be changed.

The topic of this book, then, is the Ladd-Franklin
theory of colour. Dr. Ladd-Franklin has been the first
(and is still too nearly the only) physiologist to consider
colour always in the light of the development of the
colour-sense. This aspect of the subject is frequently
reproduced in the present volume. There seemed to be
no good reason for endeavouring to avoid repetition when
it has constituted an essential part of an article. The
reader can skip these repetitions if he likes—though it is
quite possible that (since it is hammering that drives a
thing in, and this theory has had undeserved difficulty in
getting itself accepted) they may serve a useful purpose.

With this mass of argument in definite form, Dr. Ladd-
Franklin can now pass on to other aspects of the subject
of colour-sensation.

It is one of the minor misfortunes of science that the
Ladd-Franklin theory of the colour-sensations should
have been so long in securing recognition. The theory
came out for the first time in 1892—in the *Zeitschrift f.
Psychologie*, and in the *Proceedings of the International
Congress of Psychology* (as well as in the printed
programme which introduced that Congress) ; and a
longer article appeared immediately afterwards in *Mind*.
The very next year Professor Burdon Sanderson, as
President of the British Association for the Advancement
of Science, had occasion to discuss at much length in his
presidential address the then new facts of colour—facts
which were chiefly discovered in the laboratory of
König, and in the discovery of which Dr. Ladd-Franklin
had taken part. He said at the end of this discussion,
" All of this can be most easily understood in terms of
the Ladd-Franklin theory." [1]

But the fate of theories is largely a matter of accident—
that of Mendel was for a long time obscure. That a change
has already taken place may be gathered from the report
of Professor Troland (*Science*, 11th July, 1926) on the
Appendix written by Dr. Ladd-Franklin to the English
translation of Helmholtz' *Physiological Optics*. He says :—

A new chapter of " The Nature of the Colour Sensations ",
by Christine Ladd-Franklin, forms an important addition to the
volume. After discussing the inadequacies of the Helmholtz
theory of colour vision, Mrs. Franklin stresses the importance
of what she calls the Helmholtz-König *facts* of colour vision.
These are embodied in the curves of the three fundamental
sensations, as computed to fit the view that the two species of
dichromatic vision are " reduction systems ",[2] in which the green
and red sensations have not yet been developed. Mrs. Franklin
does the important service of presenting the exact graphs of the

[1] *Nature*, vol. 48, pp. 469, 1892.
[2] According to Dr. Ladd-Franklin, v. Kries' so-called " reduction "
systems should be replaced by primitive, undeveloped, dichromatic
systems. Neither the red nor the green constituent has disappeared, but
they have not yet been differentiated from one another. If this were
not the case, the sensation at the low-frequency end of the spectrum
would not be *yellow* for these defectives, as it is.

three sensations as found by König, compensating to some extent
for the absence of certain significant portions of the second edition.
Finally she expounds anew her well-known developmental theory
of colour vision as a resolution of the combined difficulties of the
Helmholtz and Hering views. The exposition is clear, concise,
and convincing. A chemical substance, a rosaniline carboxylate,
has been noted which has decomposition reactions accurately
paralleling those of the completely differentiated molecules
postulated by the developmental theory.

The fame of Helmholtz is so great and so secure that
he can well dispense with the claim to have devised
the satisfactory colour-theory, in spite of the great
importance of his work on the subject. In reality he
contributed little to the theory which bears the Young-
Helmholtz name; while the rival theory of Hering
suffers from the complexity which it has acquired in the
hands of Professor Müller, in the effort to make it explain
things which it is not adapted to explaining, for instance,
all the König-Helmholtz facts of colour-mixing.

As regards the arrangement of the articles, a full list
with the original dates of publication will be found at the
end of the volume immediately before the Index. The
discussion of the subject given by Professor Woodworth
in his *Psychology* is reproduced entire (by kind permission
of Messrs. Holt, New York, and Messrs. Methuen, London)
in the form of an introductory section, and presents
in brief form the kernel of this whole book. For the
reader's convenience, the Dictionary survey has been
placed first, since it provides a better general approach
than the special formulations. The other contributions
are in the order of their original appearance, 1892–1927.

It remains only to record the Editor's indebtedness to
Messrs. Macmillan for permission to reprint Mrs. Ladd-
Franklin's contribution on Vision to Baldwin's *Dictionary
of Psychology*, to Dr. Casey Wood for allowing portions
of the article on The Evolution Theory to be reprinted from
the *American Encyclopædia of Ophthalmology*, and to the
editors of the *Psychological Review*, of the *American*

Journal of Physiological Optics, and of the American
edition of Helmholtz' *Physiological Optics* (Dr. J. P. C.
Southall) for similar courtesies. Finally, we wish to
thank a distinguished graduate of Vassar College,
Mrs. William Reed Thompson, Vassar '77, for generously
enabling the volume to be issued at a price within the
reach of research workers in this field and thus greatly
facilitating its publication.

 C. K. O.
MAGDALENE COLLEGE, CAMBRIDGE.
 January, 1929.

INTRODUCTORY

THEORIES OF COLOUR VISION

[*The subject of this book is one continuous argument against the colour theories of Helmholtz and of Hering. As has been said already, every other theory, with the exception of the Ladd-Franklin theory, falls into one or the other of these two classes—it is either a* three-colour *theory, with no yellow and no white (Helmholtz), or it is a* tetrachromatic *theory, with white added (Hering). Both theories recognize black as a sensation, and as a non-light sensation ; hence we shall not have frequent occasion to discuss black, though the reader will note the contributions in the Appendix by Neifeld and Michaels. It happens that the inadequacies of the two theories are not of the same kind in both cases—the facts which Helmholtz explains are the very ones which are contradictory to the Hering theory, and those which the Hering theory explains are the very ones which are contradictory to the Helmholtz theory. One can put it in this way :* Helmholtz confutes Hering and Hering confutes Helmholtz. *The extraordinary vitality which these two theories have shown, considering how insufficient they are, can be accounted for only on the ground that they were devised and ardently defended by scientists of great distinction. The fame of Helmholtz especially is so great, and so well-deserved, that it seems like nothing less than* lèse majesté *to assume that there is anything inadequate in his theory of colour. The physicists, moreover, who alone follow his theory at the present day, cannot be got to consider the facts of colour-sensation, which it fails to account for—which it is contradictory to.*

In the light of the known development of the colour sense (wholly ignored by all the other writers on the subject,

*and even explicitly by Fröbes) it has not been difficult to
hit upon a conception (nothing more recondite than that
of a few chemical reactions) which suffices to hold together,
and to make consistent with all our other knowledge of
physics and of physiology, a large mass of complicated
(" enigmatic ") fact. This is the function of a theory,
as shown by Bridgman in* The Logic of Physics,
1927 *(p. 37).*

*In order that this argument may be put before the reader
at once in brief form we cannot do better than reproduce
the discussion of colour theories as given by Woodworth, in
his* Psychology.]

Of the most celebrated theories of colour vision, the
oldest, proposed by the physicists Young and Helmholtz,
recognized only three elements, red, green, and blue.
Yellow they regarded as a blend of red and green, and
white as a blend of all three elements. The unsatis-
factory nature of this theory is obvious. White as
a sensation is certainly not a blend of these three colour
sensations—it is, precisely, colourless ; and no more
is the yellow sensation a blend of red and green. More-
over, the theory cannot do justice to total colour-
blindness, with its white and black but no colours,
or to red-green blindness, with its yellow but no red or
green.

The next prominent theory was that of the physio-
logist Hering. He did justice to white and black by
accepting them as elements ; and to yellow and blue
likewise. The fact that yellow and blue would not blend
he accounted for by supposing them to be antagonistic
responses of the retina ; when, therefore, the stimuli
for both acted together on the retina, neither of the two
antagonistic responses could occur, and what did occur
was simply the more generic response of white. [This
required him to think that all the brightness of any
chromatic sensation is due to some constituent whiteness.]
Proceeding along this line, he concluded that red and

green were also antagonistic responses; but just here he committed a wholly unnecessary error, in assuming that if red and green were antagonistic responses, the combination of their stimuli must give white, just as with yellow and blue. Accordingly he was forced to select, as his red and green elementary colour-tones, two that would be complementary; and this meant a bluish red and a bluish green, with the result that his " elementary " red and green appear to nearly every one as compounds and not elements. It would really have been just as easy for Hering to suppose that the red and green responses, antagonizing each other, left the sensation yellow; and then he could have selected that red and green which we have concluded above to have the best claim [to being unitary].

A third theory, propounded by the psychologist Dr. Christine Ladd-Franklin, is based on keen criticism of the previous two, and seems to be harmonious with all the facts. She supposes that the colour sense is now in the third stage of its evolution. In the first stage the only elements were white and black; the second stage added yellow and blue; and the third stage red and green. The outer zone of the retina is still in the first stage, and the intermediate zone in the second, only the central area having reached the third. In red-green blind individuals, the central area remains in the second stage, and in the totally colour-blind the whole retina is still in the first stage.

In the first stage, one response, white, was made to light of whatever wave-length. In the second stage, this single response divided into two, one aroused by the long waves [waves of low frequency] and the other by the short [waves of high frequency]. The response to the long waves was the sensation of yellow, and that to the short waves the sensation of blue. In the third stage, the yellow response divided into one for the longest waves, corresponding to the red, and one for somewhat shorter waves, corresponding to the green.

Now, when we try to get a blend of red and green by combining red and green lights, we fail because the two responses simply unite and revert to the more primitive yellow response ; and similarly when we try to get the yellow and blue responses together, they revert to the more primitive white response out of which they developed.

But since no one can pretend to *see* yellow as a reddish green, nor white as a bluish yellow, it is clear that the just-spoken-of union of the red and green responses, and of the yellow and blue responses, must take place *below the level of conscious volition*. These unions probably take place within the retina itself. Probably they are purely chemical unions.

The very first response of a rod or cone to light is probably a purely chemical reaction. Dr. Ladd-Franklin, carrying out her theory, supposes that a light-sensitive " mother-substance " in the rods and cones is decomposed by the action of light, and gives off cleavage products which arouse the vital activity of the rods and cones, and thus start nerve currents coursing towards the brain.

In the " first stage ", she supposes, a *single* big cleavage product, which we may call W, is split off by the action of light upon the mother substance, and the vital response to W is the sensation of white.

In the second stage, the mother substance is capable of giving off *two* smaller cleavage products, Y and B. Y is split off by the long waves of light, and B by the short waves, and the vital response to Y is the sensation of yellow, that to B the sensation of blue. But suppose that, chemically, $Y + B = W$, that is, $R + G + B = W$, then, if Y and B are both split off at the same time in the same cone, they immediately unite into W, and the resulting sensation is white, and neither yellow nor blue.

Similarly, in the third stage, the mother substance is capable of giving off *three* cleavage products, R, G, and B ; and there are three corresponding vital responses,

the sensations of red, green, and blue. But, chemically, R + G = Y ; and therefore, if R and G are split off at the same time, they unite chemically as follows : R + G = Y, and Y + B = W ; and therefore the resulting sensation is that of white.

This theory of cleavage products is in good general agreement with chemical principles, and it does justice to all the facts of colour vision, as detailed in the preceding pages. It should be added that " for black, the theory supposes that, in the interest of a continuous field of view, objects which reflect no light at all upon the retina have correlated with them a definite non-light-sensation —that of black."

PART I

I

VISION

VISION [1] [Lat. *videre*, to see] : Ger. *Gesicht, Sehen* ; Fr. *vision, vue* ; Ital. *visione*. The sense whose organ is the eye, whose adequate stimulus is light, and whose nerve is the *opticus*.

GENERAL

In the ordinary production of visual sensation, several distinct processes in the human organism are involved. In the retina the ether vibrations (which we know to be still ether vibrations when they reach this surface) are transformed into some other form of energy which can be conveyed along the nerves—we know not what form, but at least it must be something very different from light, because vibrations of that degree of rapidity would cause the destruction of delicate nervous tissues. In the occipital lobes of the cortex there takes place, under the influence of this conveyed excitation, some process which is the immediate condition of the visual sensation. Before reaching the cortex, the optic fibres pass through intermediate ganglionic stations (quadrigeminal bodies, optic thalamus), but it is not known that these have any essential part to play in the sensation that enters consciousness—they may have no other function than to effect reflexly the motions of pupil, ciliary muscle (accommodation), convergence, etc., which are essential to effective vision (Fig. 1). When the cortical centres have been destroyed, no visual sensation is possible,

[1] In this article, points that are of special interest to the psychologist will be discussed at some length. For the ordinary details in regard to the working of the eye as an optical instrument, see the textbooks of physiology ; a particularly good one is Howell's *Textbook of Physiology*.

but the same thing is not true concerning the retina : the basal ganglia and the retina may both be thrown out of action by disease, and sensation may nevertheless persist ; as a preceding symptom of migraine, which seems to be due to a spasm in the cerebral, or more rarely the retinal, circulation, and of epilepsy, there are very commonly experienced subjective visual sensations, which are sometimes in the form of rings and balls, like the pressure-phosphenes, or zigzags in incompleted curves

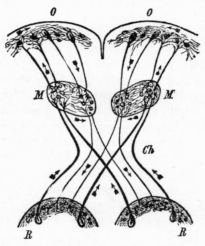

Fig. 1.—Hypothetical scheme for the optical conducting paths. *OO*, cortical centre ; *MM*, mid-brain ; *Ch*, chiasm ; *RR*, retinal terminations ; ↑, centripetal paths ; ↓, centrifugal paths ; →, lateral connecting paths.

(fortification-figures, scintillating scotomata), but which sometimes have the appearance of natural objects or of human figures. These frequently enter the field of vision at one side, and the patient instinctively turns the head and the eyes to follow them : this shows that the cortical process carries with it what is essential to spatial localization without the participation of the retina. But it also shows, as was plainly affirmed by Gowers before the recent work of Flechsig on the subject, that there are secondary cortical centres (association centres,

or, as they may perhaps be designated, perception centres) where the immediate data of visual sensation are worked up into complicated forms. This proves that chemical changes in the cortex, although not brought about by excitation coming in from below, suffice to affect consciousness (and with spatial attribute as well as simple sensation quality). On the other hand, there are cases on record of most disturbing visual sensations (rings and balls of colour) due to irritation of the cortex caused by a diseased retina which was entirely blind to light—as was proved by the fact that these disturbances ceased when the eye in question was enucleated.

There are, then, aside from the conducting fibres, four separate stations, in general, in the affection of consciousness by external light—the retina, which is, indeed, not only a neuro-epithelial surface, but also a true nervous centre shifted to the periphery (cephalopods, which have, taken together, all the different nervous layers of the human eye, have some of them in the brain and not in the retina) [1] ; the basal ganglia ; the primary visual centres in the occipital lobe ; and the final association-centres. Each of these may apparently be excited to its characteristic activity by internal sources of activity, in the absence of incoming stimulation from below.

In the lower animals the visual process is certainly of much less complexity than in the human visual organ ; all that is essential to such a process is that there should be some form of reaction to the transverse vibrations of the ether [or to the visible electro-magnetic radiations]. Any animal in which a portion of the ectoderm is so differentiated as to be a receptive organ for this form of excitation may be said to possess an eye, whether the reaction to the excitation is conscious or unconscious ; in certain of the lower forms of animal life the whole

[1] The optic nerve is not a nerve, properly speaking, but a portion of cerebral white matter pushed forward (Greef, *Arch. f. Ophthal.*, xxix, 85, 1900).

surface of the body is obscurely sensitive to light. Sensations of colour (as well as of form), as they exist in the perfected eye, are modalities of the fundamental luminous sensations, which are without question of rather recent phylogenetic development. Wherever there is an eye with two distinct forms of visual elements, rods and cones, it is probable that there is a sense of colour. Below that, there is no evidence of this aspect of the luminous sensation : many observers have declared that the lower animals have a colour sense, and that they have strong colour-preferences (Graber) ; but this conclusion is not warranted, for a preference for one region of the spectrum over another may perfectly well be a preference for a particular degree of brightness. Since we have found out that the relative brightness of the different spectral regions is, for ourselves, totally different according as the illumination is faint or bright (the Purkinje phenomenon), there is no reason to infer that animals have any sense for actual colour from the fact that they go from one coloured apartment into another, even though these have been made equally bright for the normal human eye.

The eye is considered to be the most highly developed of the sense organs, not only because of its comparative perfection as an optical apparatus (the lens is a piece of living matter which approaches the regularity of a solid with mechanically perfected curved surfaces), but also because of the number of different forms in which it effects sensible discrimination. The pressure sense, the heat sense, the cold sense, on the other hand, are senses with good local discrimination, but with variation within a single terminal organ for intensity only, without discrimination of quality—we cannot tell whether a given amount of heat comes to us from the infra-red or the red or the yellow rays of the spectrum. In the ear we have discrimination for different objective vibration-rates (the sound-waves) in the form of the different subjective quality attached to notes of different pitch, and to this discrimination is given up the physiological

VISION

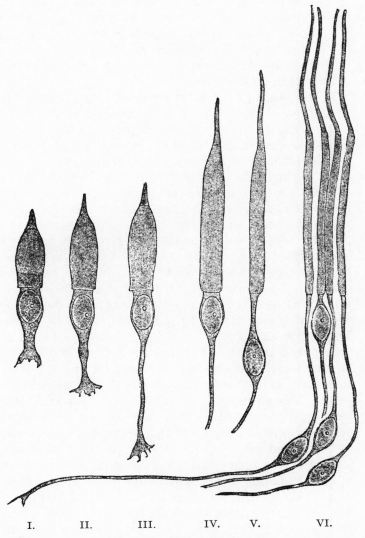

I. II. III. IV. V. VI.

Fig. 2.—Cones from the different retinal zones (Greef). I, close to the ora serrata ; II, 3 mm from the ora serrata ; III half-way between the ora serrata and the papilla IV periphery of the macula lutea V macula lutea , VI, fovea centralis. V. Graefe u. Saemisch, *Hdb. d. Augenheilkunde,*

space-discrimination in the auditory organ—namely, the succession of fibres of the basilar membrane ; there is left no means of acute local discrimination, and, in fact, in the auditory sense we have no space-discrimination other than by the greater loudness of a sound heard by one ear than by the other.

In the eye we have a far more keen and dominating sense for space than in any other sense organ—so much so that the quality which stands pre-eminently in consciousness for space itself is the retinal spatial quality. In this organ, the distribution of rods and cones within the sense organ is the primary physiological intermediary between physical and subjective space ; consequently there is left no very exact means for quality-discrimination within the sense, and, in fact, our subjective reactions to differences of vibration-period in light-waves are very inadequate. The whole gamut of light-waves is responded to by us subjectively with only four different sensation qualities—these are, in the order of their development, yellow and blue, red and green. They are the sensations which are produced in their purity by, about, the wave-lengths 576 $\mu\mu$, 505 $\mu\mu$, 470 $\mu\mu$, and a colour a little less yellow than the red end of the spectrum. For all intermediate wavelengths we have nothing in sensation except combinations of these hues, or *colour-blends*, as reddish-yellow, blue-green, greenish-yellow, etc., but with this very singular peculiarity, that non-adjacent colour-pairs do *not* give colour-blends (red and green reproduce yellow, and blue and yellow give white, or grey) ; were it not for this latter circumstance, the confusion in the response to ether-radiation distinctions would be far greater than it is now. Hence we have no means of determining whether the sensation which we get from wave-length 486 $\mu\mu$, say, is due to light of that wave-length as an objective cause or to a physical mixture of light of wave-lengths 492 $\mu\mu$ and 470 $\mu\mu$; in other words, our visual organ, as a means of giving us knowledge regarding the radiations reflected from or emitted by objects, is

exceedingly inadequate. It follows from this that we can never have, in the play of colours, intricate æsthetic combinations and involutions corresponding to musical compositions in tones. The light-sensation elements are far too simple for that ; they are like what we should get from a primitive musical instrument with only four strings.

Provision for vibration-period quality being so inadequate as this, and spatial distribution upon the retina being correlated with the highly developed spatial consciousness of the visual sense, what is the physiological mechanism by which four distinct sources of colour-sense are communicated from retina to brain ? Scattered sparsely among the rods (the primitive organ for a non-differentiated luminous sensation) are the cones, which alone, without doubt, provide for the sensation of colour ; is a single cone the seat of all four colour-processes, and are all four sets of excitation conveyed from one cone along one optic nerve-fibre to the brain ? The physiologists are strongly of the opinion at present that all nerve-fibres convey one and the same sort of excitation, and that conscious distinctions of quality are brought about by different reactions in the cortical cells in which they debouch. But, (1) they have chiefly in mind the simpler structures, where there is nothing against such a supposition (muscle, pressure, auditory sensations)— it is *only* in the sense for colour that occasion arises for making a different assumption, and hence analogy from other cases is entirely without force ; (2) the only anatomical difference that exists between the rods and the cones (for the long, fine, closely pressed together cones of the fovea are not cone-shaped) is exactly this— that communication with the bi-polar cell is on the one hand by a simple knob, on the other by a group of distinct processes (Fig. 3, IV) ; this suggests that the difference between a black-white series, on the one hand,[1] and

[1] Black may well be the sensation attached to the resting-stage of the cortical visual process. A state of non-excitation from the external

sensations in four different tones, on the other hand, has its physiologico-anatomical basis in the provision for disjunct communication between cone and bipolar cell, which is had by means of the several different fibrillæ groups of the cone-base. If it were the case that one fibre could convey one form of excitation only, then the four simple colour-tones would have to be mediated by four different contiguous cones (three, in the original Young-Helmholtz theory, which was based solely upon physical, not at all upon psychological considerations). Helmholtz himself, in the second edition of the *Physiologische Optik*, has given up this view [for good reason—Isaacson], and regards the several photo-chemical processes which underlie colour as taking place all in a single cone. If one cone mediates one colour only, then a point of purple light, so small that its image falls upon a single cone, should look, as the image passes over the retina, now red and now blue according as it strikes one or another of the visual elements that are fitted to respond to it. This and similar phenomena were announced by Holmgren to occur, and were taken by him as being complete confirmation of the Young-Helmholtz theory; but later experiments from the laboratories of Hering and of König show that such loss of true colour does not take place. Schoute (*Zeitsch. f. Psychol.*, xix, 251) gives good reasons for believing that, in such experiments, the image formed is actually as small as calculation from the constants of the eye would imply. It is true that Graefe (who has examined two perfectly fresh human eyes with

world does not, in the case of the other senses, need to enter consciousness ; but in the visual sense the spatial attribute is of extreme consequence, and if we were unconscious of objects which send to us no light there would be lacunae in the retinal spatial field which would be most disturbing. This state of things actually occurs in the case of localized lesions in the cortical visual field ; the ophthalmologists distinguish between *negative* and *positive* scotomata—in the latter (disease of retina or optic fibres) a black spot is seen in place of a portion of the external field ; in the former, nothing is seen. This fact alone goes far to prove that black is purely a cortical excitation, which enters consciousness as a *mark* of the absence of retinal excitation.

the aid of the most modern methods of staining, etc.)
finds that the cross-section of a foveal cone is 2 μ; it
has usually been given as 4 μ, and hence it is possible
that the images formed were not small enough to affect
individual cones in the fovea. But, on the other hand,
images so small as this cannot fall upon more than one
cone at a time in the extra-macular region, and here, too,
the phenomenon of incomplete response does not take
place. The chief consideration by which the physiologists
uphold the similar character of all nerve-fibre trans-
missions is the fact that only one set of electrical reactions
occurs, no matter what nerve is involved; but it would
be as safe to infer that any two chemical reactions were
the same in kind because they were attended by the
same production or abstraction of heat (Hering). The
question is of fundamental consequence, and it is hardly
worth while to devise colour theories until after it has
been settled; nevertheless, the physiologists proper and
the physiologists for the eye rest content, seemingly, each
in his own belief, with very little counter-discussion. It
cannot be too much insisted upon, meantime, that the
question as it regards the eye must be settled upon its
own merits, and not from analogy with other sorts of
nerve-fibre, where the assumption of such complexity
is not demanded by the facts. (C.L.F.)

THE EYE [AS. *eáge*, eye]: Ger. *Auge*; Fr. *œil*; Ital.
occhio. The end-organ of vision; the mechanism by
which vibrations of the luminiferous ether are transformed
into the physiological stimulus of visual sensation.

A knowledge of both the anatomy and physiology of
the eye may be best attained by studying its development
in the animal series and in the vertebrate embryo.

Eye-spots in the Protozoa and lowest Metazoa are
collections of pigment granules, commonly brownish or
reddish, situated in the ectosarc, or (in the Metazoa) in
conjunction usually with the cerebral ganglia, or in groups
of epithelial cells on the surface of the body. These cells
may occur on a level with the general surface, as in some

cœlenterates, be raised into pigmented papillæ, as in the fringes about the mantles and siphons of bivalve molluscs, or drawn below the surface as pigmented sacs or pits, as found in echinoderms, many worms, and in the tips of the tentacles and papillæ of numerous molluscs.

It is often stated to be doubtful whether these simple eye-spots give rise to definite sensations of light ; the sensations which accompany their reactions to the rays of the spectrum [if any] may, for aught we know, be sensations of heat, though there are no known instances among the higher animals (where we can more reasonably infer by analogy their sensations from our own) of a special provision for the *absorption* of heat-producing rays.—It should be borne in mind that dark pigment is rather an accessory than an essential to vision, as is proved by its absence in albinos as well as in many of the lower animals that are still sensitive to light.

The formation of the eye as a pit lined by epithelial cells lends itself to the development of the accessory structures, lens, and other refractive media, iris, and cornea, which render visual images possible. Even a simple pit with pin-hole aperture is capable of forming images on the principle of the simple camera obscura. The secretion of refractive media by the cells forming the pit or sac, and the clearing up of the superficial cells to form a transparent cornea, and their convex thickening to make a corneal lens, are steps which are very easy and which are rapidly taken in the invertebrate series.

In the eyes of invertebrates generally, the cells of the retina, being specialized epithelial cells, retain their original position, i.e. the poles for receiving sensory stimuli point to the exterior, and the basal, or discharging, poles send fibres directly to the brain. In a few cases, notably those of Pecten (Patten) and of Onchidium (Carrière), the retinal cells are inverted and the optic nerve-fibres spring from their superficial poles and reach the brain by breaking through the bottom of the optic cup (Onchidium and vertebrates), or flow over its rim

and thus around to the brain (Pecten). These eyes are probably explained by a collapse of the primitive optic vesicle, such as occurs in vertebrates, to form a secondary optic vesicle with double wall. The cells of the external layer would thus be inverted ; lens, cornea, and all accessory structures are then formed, as in vertebrates, by cells of the surrounding and overlying tissues.

Position of eyes in the body depends rather upon the animal's needs than on any fixed laws of structural organization. Ability to see food and natural enemies being a most important factor in fitness to survive, eyes are commonly developed in close association with the principal nerve ganglia. Thus eyes may be scattered over the entire back (Onchidium), where the chief enemies approach from above, or arranged along the mantle-edge or about the siphons of bivalve molluscs, in which retraction and closure of the shell are the important reactions. In the free-swimming embryos of bivalves eyes are present in the head, but atrophy as the shell closes over them. This is generally true of all the higher animals that live in total darkness, in the deep sea, in caves, in burrows and holes in rocks, showing that they are descended from seeing forms and have been crowded into the darkness. With animals that possess a head and move actively about, eyes are situated uniformly in front, paired, or otherwise grouped (insects and arachnids) about the brain. Their positions in the worms are especially instructive as pointing to the relations obtaining in the vertebrates. In the leeches, for example, the eye-spots occur one pair in each of several of the anterior segments.

Morphologically the vertebrate retina is a specialized portion of the original wall of the primitive fore-brain vesicle. Since the neural tube in vertebrates is a strip of superficial epithelium folded in and covered over, its cavity represents the external world. The primary optic vesicles arise very early as paired outgrowths on either side of the first cerebral vesicle, carrying its cavity with

them. As they reach the skin, the front wall caves inward,
or is possibly pushed inward by the thickening of the
epidermis to form the lens, and the secondary optic
vesicle results with double wall and the cavity of the
primary vesicle is obliterated. The location of this cavity
is indicated by the surface of juncture of the two walls
of the secondary optic vesicle, and it must be remembered
that this surface between the rods and cones and the
pigment epithelium represents the external world to the
cells of the retina. The outer wall now thickens by growth
and division of its cells to form the distinctively nervous
layers, while the inner wall remains one cell thick and
constitutes the pigment layer of the retina classed with
the choroid by earlier writers. The choroid coat then
forms over the convex surface of the retinal cup,
homologous with the pia, and is continued in front with
the pigment layer of the retina, as the iris. The epithelial
cells immediately over the mouth of the optic vesicle
elongate, and sinking below the surface, first as a pit and
then as a hollow vesicle separated from the skin, give rise
to the fibres of the crystalline lens.

 Chromatic aberration, due to the refrangibility of the
rays of short wave-length of the spectrum being greater
than that of those of long wave-length, is one of the
many defects of the eye as an optical instrument. It
may be readily demonstrated by covering one-half of
the pupil, when a coloured fringe will appear along a dark
line through a bright field, a window-bar against the sky,
bluish on one side and reddish on the other. It is com-
pensated for by the fact that, when the eye is accom-
modated for the middle rays of the spectrum, the violet
rays (which will have crossed one another at a focus in
front of the retina) will be overlapped by the red rays
(which have not yet been brought to a focus), and hence
the dispersion circle around the focus of medium rays
will be approximately grey in colour, and so overlooked.
But if the upper half of the pupil is cut off, only the

violet rays from below and the red rays from above reach the retina, and hence coloured fringes are seen.

The retina, the innermost coat of the eye, extends over the posterior portion of the eyeball and forward almost to the ciliary body. Here the visual portion ends in a serrated margin, the ora serrata. The pigment layer of the retina extends over the ciliary body, and is continued over the back of the iris as the uvea. The blood-vessels, a central artery and vein, enter and leave with the optic nerve. They are distributed to all layers except the outer nuclear and rod and cone layers ; and since the shadows of the retinal capillaries are plainly visible, the actual mechanism for the transformation of light-vibrations into something which gives rise in the brain to visual sensations must lie within these layers. Structurally, the rods and cones are peripheral portions, receiving poles, comparable to sensory hairs or coalesced pencils of sensory cilia, of the originally superficial cells, whose nuclei are those of the external nuclear layer, and whose central, discharging, poles are fibres which break up into terminal brushes in the external plexiform layer. The rods and cones are thus, without doubt, the real transformers of visual stimuli, the specialized receiving organs for all sensations of light, chromatic and achromatic.

From the above description it is clear that light must penetrate six layers of the retina before reaching the rods and cones ; this is not of great consequence, since, when alive, the retina is nearly transparent. In animals generally a certain part of the retina is thickened either along a band corresponding to the image of the horizon line, as in some of the herbivora, or in a round or oval area near the axis of vision, where the retina is most used, the central area or *macula lutea* in man and primates. In man, primates, most birds, and a very few reptiles, amphibians, and fishes, a pit forms in the centre of the thickened area, in which the other intervening layers of the retina and all blood-vessels draw aside and leave the cones directly exposed to the light. The thickened portion

is generally known as the macula lutea, from its yellow
colour, and the pit or depression as the fovea or fovea
centralis. While the rods greatly outnumber the cones in
the peripheral portions of the retina, the cones grow

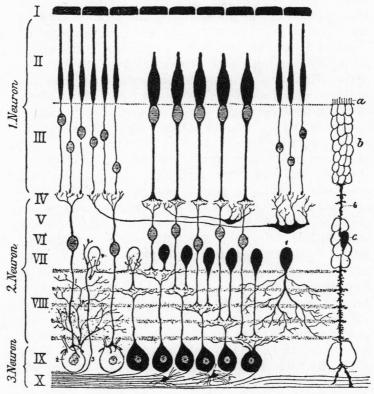

FIG. 3.—Structure of the human retina (schematic). (Greef.) I, pigment
 epithelium; II, rods and cones; III, nuclei of visual cells;
 IV, other plexiform layer; V, layer of the horizontal cells; VI,
 layer of the bipolar cells; VII, layer of the amacrine cells; VIII,
 inner plexiform layer; IX, layer of ganglion large cells; X, layer
 of fibres; 6, supporting fibre of Müller. (By the Golgi method.)

proportionately more and more numerous as we
approach the centre, and in the fovea itself only cones are
present. A number of birds, notably among the raptores
and swallows, have two foveas, a temporal fovea for

binocular vision and a nasal or median fovea for mono-
cular vision. It is now well established that moving objects
are more quickly perceived by the portions of retina rich
in rods, and in animals, like the frog, which apparently
only see objects in motion, the rods greatly predominate
even in the central portions of the retina. On the other
hand, minute vision of stationary objects is only possible
in the fovea.

Sömmerring (*Sm. Th.*, v, 1798) discovered the fovea
and considered it a foramen. Buzzi (1796) thought the
fovea to be a thin transparent part of the retina.

The optic nerve-fibres gain their medullary sheaths as
they pass through the lamina cribrosa of the sclerotic
coat. At this point, the porus opticus (optic disk, papilla),
all the layers of the retina are forced aside to admit the
passage of the nerve, and as vision is consequently also
interrupted here, the spot is known as the " blind spot "
(Mariotte's spot, 1668).

Some (Quain) still describe the optic nerve as spreading
out within the eyeball as the innermost layer of the
retina. This is true (His, Cajal) of but a very few of its
fibres, which have been proved to grow from the centres
to the retina as possibly motor or associational fibres.
Since the researches of His, Martin, and Mall (1890–3)
have demonstrated that the optic nerve-fibres, in common
with sensory nerves generally, arise as axones of the large
ganglion cells and grow centripetally to the optic centres,
it would seem advisable to reverse the older descriptions
and consider the optic fibres as gathering from all points
of the retina, uniting in the optic nerve, and distributing
themselves to the optic centres in the brain.

The optic fibres from the right-hand half of each retina
proceed to the right cortex, from the left-hand half to the
left cortex, but a small portion of the retina, about
coincident with the yellow spot, is doubly provided for,
and may preserve its function when either half of the
cortex is destroyed (Fig. 4).

The principal axis of the eye is a line joining the centres

of curvature of its refractive media. The axis of vision is a line drawn from the fovea to the point looked at. For the eyes at rest or while looking at a distant object the axes of vision of the two eyes are nearly parallel ; as the object approaches they converge, the sensations of strain from the oculo-motor muscles furnishing important data in judgments of distance. Additional advantages of binocular vision are increased size of visual field, perception of the depth of points not fixated upon by means of double images, and correction of errors of one eye by the other. If for the primary position we imagine

FIG. 4.—Scheme of the crossing of the optic nerve in the chiasm of man. The visual nerves with their retinal expansions are seen from above ; the optic tract of the right side is shaded, that of the left is white.

that the retinal cups be exactly superimposed so that one fovea lies over the other, each point in the superimposed retina corresponds nearly with the point directly beneath it in the other. These are known as " identical " or corresponding points. All images falling upon identical points of the two retinæ are projected into space as single points. The line or plane passing through all such points is called the horopter. All points out of the horopter, while we commonly disregard them, form images which are projected, or seen, as double. Standing erect and looking towards the horizon, according to Helmholtz, the horopter stretches out as a line coinciding with the

plane of the ground upon which we stand. With each
position of the eyes the form of the horopter changes.
With the eyes converged, the horopter is a circle passing
through the fixation point and the nodal points of the
two eyes. (C. F. HODGE, C.L.F.)

THE EYE AS AN OPTICAL INSTRUMENT

The eye is in effect a dark chamber, or *camera obscura*,
like that of a photographic apparatus, in which the light
from any object within its field is thrown by refracting
media upon a background so placed that the rays diverging
from any given point converge to the corresponding point
of a small inverted image. That the image is inverted
is of no consequence in our perception of objects. If an
arrangement of pins in the shape of an arrow be pressed
upon the arm, we can tell whether the head of the arrow
be pointed up or down, because we have always seen the
surface of the arm, and felt it with the other hand, and
hence we know it as an object, as well as by its subjective
local signature. But we know nothing about the back
surface of the eye, nor about the images that fall upon
it. We do, however, know about its front surface, from
the eyes of others, and from our own as seen in a mirror,
and the only apparent want of harmony that could exist
would be if our eye had to turn downwards in its socket
to see an object which we have to reach the arm up to.
Consciousness does not descend (like a person !) into the
eyeball along the optic tract and nerve, and view the image
upon the retina. If she saw anything as an object, it
would be, probably, the image which is transferred from
the retina to the occipital lobe ; in that, however, a re-
inversion takes place (Henschen), and she can there, if
she likes, gaze contentedly at a (chemical) image which
is right side up. But there is no more reason that she
should feel the inversion of the images upon the retina
than that she should be aware of the coming to a point
of all the direction-lines within the crystalline lens, or

of the semi-decussation of the visual currents in the optic chiasm.

All optical instruments for the formation of images must have power of adjustment, for objects at different distances, sending rays of light through a fixed system of lenses, form images at different distances. This adjustment may be secured by moving the receiving surface further back, as is done in the *camera obscura* of the photographic apparatus, or by increasing the index of refraction of one or more of the media, or by a diminution of the radius of curvature of one or more of the surfaces. The first of these means was formerly the one supposed to be made use of in the eye, the eyeball being assumed to be elongated for viewing near objects. But it is now known that the change takes place in the shape of the crystalline lens, brought about by means of the ciliary muscles ; from a teleological point of view the lens would be superfluous were it not for its performing this function, for the amount of refraction that takes place at its surface could be produced by a slightly greater curvature in the cornea. The far-point for the normal emmetropic eye (the furthest point at which objects can be distinctly seen) is at an infinite distance ; the near-point varies with age, and in early adult life is from 10 to 13 centimetres from the eye. No accommodation is necessary for objects more than two metres distant.

Action of Light on the Retina

That the retina of certain animals was sometimes red had been remarked before, but it was discovered by Boll (1876) that this red colour is bleached out by light, and that it becomes restored if the animal is kept in the dark. The green rays of light are those which are most effective in bleaching out its colour, corresponding to the fact that green light is most absorbed by a substance whose colour is a purplish red. In the human eye an intermediate stage in the bleaching out of this substance occurs in which it is yellow ; and the presence in the retina of varying

amounts of the visual purple and the visual yellow gives rise to a succession of colours—purplish-red, pure red, brick-red, orange, chamois, yellow. The regenerating purple does not go through the yellow stage. Regeneration takes place through the agency of the pigment epithelium ; it goes on in the dark, even in the extirpated retina, so long as its outer surface is in contact with the pigment epithelium, and even if it has been removed and then laid on again. If a sharp image be thrown upon an eye in a state of darkness-adaptation, the eye being held immovable if the animal is alive, the light reflected from the bright portions of the object will cause its visual purple to fade out ; images thus formed may be fixed and examined at leisure. They were called optograms by Kühne, who first prepared them. The visual purple cannot be seen in the ordinary eye, on account of the red colour of the background against which it is thrown ; but there are a few fishes which have a white retinal tapetum, by means of the reflected light from which it is easy to see the colouring matter of the rods in its various different conditions (Abelsdorff). On looking into the eye of such an animal after it has been kept in the dark, the retina is seen to be first of a rose-red colour and then to change by gradual stages into a brilliant white.[1] The relative absorption by the visual purple of the different radiations of the spectrum has been determined with great exactness by Professor König ; he finds it to coincide with the subjective relative brightness-values of the totally colour-blind, and also with the relative brightness-values of the normal eye in a faint light. The coincidence of the curves representing these last two brightness-

[1] [The visual purple (rod-pigment) is highly fluorescent even after it has become white—it is lacking in the centre of the eye and also in the periphery and hence this can be seen. This shows that it continues to be a definite substance even after it has been bleached out. [And *this* shows that it is not a *purple* substance that is the efficient *Sehstoff* (as Hecht supposes)—that its scotopic purpleness makes it a good *absorber* of the dull green light of forests—that is, a sensitizer.]]

spectra had already been shown by Hering and Hillebrand (*Sitzber. Akad. Wiss. Wien*, 1889).

Other changes produced in the retina by light are the descent of the small black crystalline granules of the pigment epithelium into the spaces between the visual elements, and also variations in the resting electrical current between the surface of the retina and that of the optic nerve.

COLOUR THEORY : HISTORICAL

Ger. *Farbenlehre, Theorie der Wahrnehmung der Farben* ; Fr. *théorie de la perception des couleurs* ; Ital. *teoria della percezione dei colori.* The ancients were struck by the fact that coloured surfaces reflect less light than white ones, and hence they regarded the colours as made up by mixing black and white together (Aristotle). This was the prevailing theory up to rather recent times, and it was even defended by Goethe. The solution of the problem of colour in the physical sense is due to Newton ; he proved that white light may be separated into light of different colours, that homogeneous spectral light does not have its colour further changed by a second reflection or absorption ; that rays have different refrangibility, and that the colours of natural objects are due to different ways in which they absorb and reflect different sorts of radiations. But Newton also was the first to lay down the fundamental principle of sensation in general, that it is of purely subjective character and has no necessary connexion in kind with the physical cause that brings it forth. Newton says : " The rays, to speak properly, are not coloured. In them is nothing else than a certain power or disposition to stir up a sensation of this or that colour . . . So colours in the object are nothing but a disposition to reflect this or that sort of rays more copiously than the rest." He supposed that the rays of light, " by impinging on stiff refracting superficies, excite vibrations . . . of various bigness ; . . . and there-fore the ends of the capillamenta of the optic nerve, which

pave or face the retina, being such refracting superfices,
when the rays impinge upon them they must then excite
these vibrations, which vibrations . . . will run along the
aqueous pores or crystalline pith of the capillamenta
through the optic nerve into the sensorium." It is difficult
to imagine that there can be a sufficient number of optic
filaments to respond in their vibration to all the different
sorts of light (especially as difference in position upon the
retina must be the physiological correspondent of
difference in spatial quality) ; this difficulty was met by
Thomas Young with the hypothesis that all the colours
may be simply combinations in various proportions of a
certain number of elements—" each sensitive filament of
the nerve may consist of three portions, one for each
principal colour." It was thus again a physicist and not
a physiologist who added to our knowledge this important
conception, that in the one-to-one correspondence between
external nature and internal sensation (and even between
external nature and physiological process) a series of
continuous differences on the one hand can be pictured on
the other by the union in a constantly varying proportion
of a smaller number of constituents. But it was the
physiological difficulty of imagining a sufficient number
of tuned retinal fibres for all the rays of light, and not the
deliverance of consciousness in regard to the unitary
character of certain principal colours, that gave foundation
for the constituent theory of light and colour. This
accounts for the fact that three colours instead of four
were considered to be a sufficient number of constituents
(yellow was regarded as a mixture of red and green,
although it is in no sense a reddish green or a greenish
red), and no separate physiological process was assigned
to the production of the totally different achromatic
sensation, white or grey.

The physical facts of colour-mixture were, of course,
known from the earliest times, and were brought into
special prominence by the painters. Pliny states that the
early Greek painters, who used only four pigments,

succeeded in getting better effects with them than the painters of his time, who made use of a larger number. Nevertheless, the hypothesis of Young fell on unappreciative ears, but it was revived by Helmholtz in 1860, and has been the favourite view of the physicists ever since. The failure to recognize the fact, first made plain by Helmholtz, that mixtures of pigments are not the same thing as mixtures of colour (the former are a phenomenon of subtraction and not of addition) was the cause of much confusion and error. In his first experiments with spectral lights, Helmholtz could make grey only out of yellow and blue ; this led Grassmann to a restatement of the fundamental principles of colour-mixture and of their graphical representation. A later series of experiments of Helmholtz by a better method removed the apparent contradictions. The principles of Newton's law of colour-mixtures were also proved experimentally by Maxwell in 1857.

The theory of Young, in so far as it posits a small number of colour-constituents, is still the accepted theory, but in so far as it takes no account of the fact that yellow and white are simple sensations and not a psychological blending of two or more constituents, it has never made any appeal to the psychologist ; we have in the purples an example of a sensation which *must* be a blend of several sensations, for there is no physical cause for their production except the combination of the causes of blue and of red ; we therefore know the character of a colour-blend, and we know that white and yellow are sensations wholly destitute of this character.

Endless confusion has arisen on account of the extreme ambiguity that prevails in the terms used in connexion with vision. *Light,* to begin with, is used indiscriminately for the light-sensation and for the photogenic radiations which are given off by bodies whose molecules are in a state of rapid vibration : it is impossible at present wholly to avoid this difficulty, but it would be desirable to use the terms *light-sensation* (Lichtempfindung) and *photogenic*

radiations where the context renders the meaning at all obscure. So *colour* should be used in its subjective sense, and *xanthogenic, kyanogenic, chlorogenic,* and *erythrogenic radiations* should be substituted for the physical cause of colour.

But perhaps the worst confusion has occurred in speaking of the facts of what is called colour-mixture, when it is intended to designate the mixing of different rays or regions of the spectrum. For instance, " orange " is sometimes a mixture of erythrogenic and chlorogenic radiations ; it is not, however, psychologically, a mixture of red and green, but of red and yellow. Just as important, on the other hand, is the fact that perfectly homogenous photogenic rays of wave-length λ 492 are, psychologically, a bluish green or a greenish blue. Again, a certain *physical mixture* of orange and olive radiations will give a pure (but whitish) yellow, which as a colour sensation is not at all a mixture. To escape from this ambiguity it is absolutely necessary to employ distinctive terms. *Mixture* should be used for the physical procedure only. The various different psychological effects of light-ray mixtures may then be referred to as : (1) *colour-blends*, when the elements of the mixture are still perceptible in the result, as blue and green in the blue-greens, or peacocks ; (2) *colour-fusions* (or *colour-extinctions*), when the elements of the colour have disappeared in the process of mixing, as red and green in making yellow, and yellow and blue in making white. This is not the sense in which Külpe uses the term *fusion* for sensations in general, but it is indispensable to have the word for the results of colour-mixture. We should then say that the spectral yellow-green, when produced by homogeneous light, is not a colour-fusion, but a colour-blend, and that yellow when produced by red and green light is not a colour-blend, but a colour-fusion.

VISUAL SENSATION OR LIGHT-SENSATION (WITH COLOUR-THEORY)

Ger. *Gesichtsempfindung, Licht- (und Farben-) empfindung*; Fr. *sensation visuelle, sensation de la lumière*; Ital. *sensazione visiva, sensazione di lume*. The term light-sensation is to be preferred, since it is better that the term " visual sensation " should include the spatial element. Visual sensations are of two very different kinds as regards quality—chromatic (the colours red, purple, yellow, etc.) and achromatic (the series white-grey-black). It is hard to find a good word for the latter series : (1) by an extension of its meaning (such an extension as is very natural to the mathematician) grey may be made to include the end members of the series black and white ; in fact, Kirschmann has shown that when looked at through a tube, so that there is no opportunity for comparison with surrounding objects, there is no such thing as black and white ; every achromatic surface is thought to be of some shade of grey ; (2) Fick has called the sense which mediates colour the *specific* light-sense, and the other the *absolute* light-sense or plainly the light-sense—the latter term is in agreement with the universal usage of the ophthalmologists, and the phraseology is to be commended ; (3) by Hering and his school the members of the achromatic series are spoken of as " brightnesses ". Müller has shown that any given grey represents at once a definite quality and a definite intensity, or stimulus energy. It is perfectly legitimate to speak of a given grey as a " brightness " when regard is had to the voluminousness of the sensation, that is, to the subjective aspect of the *stimulus energy* ; but to speak of its *quality* as a brightness is to introduce confusion, for it is impossible to give up the use of the terms bright, dull, brightness, darkness, in the other sense, and, in fact, no effort is made to do so by writers who make use of this language. By the brightness of the most saturated yellow-green

that we can produce, viz. that got by throwing yellow-green spectral light upon a portion of the retina which is already carrying a yellow-green after-image (even when Hering believed in the specific brightening and darkening powers of green and of yellow respectively he must have granted that there was a certain proportion of the mixture where neither took place), Hering means the amount of the black-white constituent. But there is no reason for believing, in this case, that there is any black-white constituent present at all. It is, however, quite impossible for one who does not accept the theory of Hering to understand the various meanings which he attaches to " brightness ".

This section in smaller type, by the late Professor Titchener, who followed Hering, has been retained for the sake of completeness.

(1) The brightness qualities fall between the limits of intensest white and deepest black. They form a one-dimensional manifold, and lie upon the axis of the tridimensional figure which represents the sum-total of visual sensations (colour-sphere, double cone, double pyramid, etc.). They are probably the earliest type of visual sensation.

(2) Colours fall naturally into four series : red to yellow, yellow to green, green to blue, and blue to red. The four terminal colours of this series are named principal or non-mixed colours ; the intermediaries, mixed colours.

An impression of " colour " is fully characterized by the statement of (a) its colour tone, (b) its brightness, and (c) its saturation. Colour tone is colour quality in the narrower sense —redness, blueness, etc. Saturation is the name given to the degree of distinctness with which a colour tone stands out from its attendant brightness quality ; it expresses the " distance " that separates the given colour from any quality of the brightness scale. Saturation is principally a function of the purity (homogeneity) of light ; it is secondarily dependent upon intensity and wave-length. Colour brightness is the grey equivalent of the colour impression, the brightness quality which the impression would show were colour tone abstracted without alteration of stimulus energy. For any given wave-length and state of adaptation of the retina, it is dependent

28 COLOUR AND COLOUR THEORIES

upon light intensity. König has compared the subjective
distribution of brightness in the spectrum with the objective
distribution of energy (Langley) ; he finds that a given

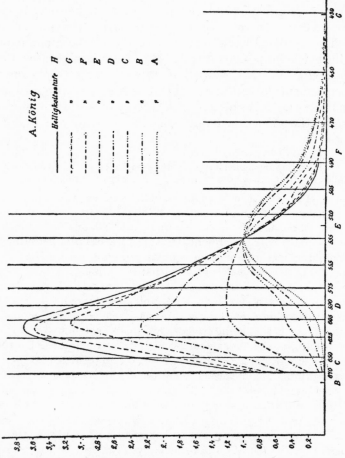

FIG. 5.—The relative brightness of the different parts of the spectrum
for various different illuminations : from *H*, a strong light, to
A, a very feeble light.

amount of energy of ether-vibration is by far the most effective
for the light-sense in the green, the maximum being at λ 505
(Helmholtz, *Festgruss*, 1891, 365). In Fig. 5 is shown the

subjective distribution of brightness in the spectrum at various different illuminations : for a strong light at the brightest part of the spectrum is in the yellow ; when the light is so faint that colours are no longer discernible, it is in the green.

The number of discriminable brightness qualities is estimated by König at 660 ; that of discriminable spectral qualities (conventional " colour tones ") at 160. The estimation of " mixed " colours varies in recent books from 40,000 to several hundred thousand.

The phrase " primary colours " or " fundamental colours " is of frequent occurrence. These colours differ, according as they are fundamental for colour-mixture, for the art of painting, or for a particular theory of colour-vision. The psychological primaries—those which appeal to introspection as of cardinal importance—are the four " principal " [or non-mixed (unitary)] colours mentioned above.

There are two chief theories of visual sensation. (1) The first is the Helmholtz theory, based on the theory of Young. Every light stimulus sets up three distinct and elementary processes of retinal excitation, which in isolation correspond to the " primary " sensations of red, green, and violet (or blue). The quality of a given impression depends upon the proportion of these partial excitations in the total excitation ; the nearer the balance the less saturated the colour—so that at equality we see simply white light. This theory explains the facts of colour-mixture, which originally led to its formulation ; it breaks down in face of the other facts of colour-vision. (a) So far from brightness sensations being dependent on colour, they persist after loss of colour : in indirect vision, in total colour-blindness, in extremes of illuminative intensity and duration. (b) Complementariness and its expression in partial colour-blindness can be explained on this theory only by the auxiliary (and highly improbable) hypothesis of a shift of the elementary excitabilities. (c) After-images cannot be explained as due to fatigue and recuperation.

(2) The second theory is that of Hering. There are three visual substances, each liable to assimilative and dissimilative excitation. These substances furnish the six fundamental sensations : green and red, blue and yellow, black and white. The black-white substance is more easily excitable and more plentifully represented than the other two. Light of different

wave-length affects the different substances differently (valence of stimulus). All light dissimilates the black-white substance ; its assimilation comes from within. Dissimilation and assimilation in the same substance neutralize each other (" antagonistic " processes).

These assumptions explain the distribution of brightness in the spectrum, the facts of colour-mixture, complementariness, indirect vision, after-images, etc. Contrast and Adaptation offer no difficulty ; they are explained by reference to the excitability of the visual substances and the indirect effect of retinal stimulation. There is, however, a serious difficulty in the fact that we have a black-white sensation (grey), but no red-green or blue-yellow sensation. " Antagonism " has two different meanings in the two contexts. The difficulty is removed [!] by G. E. Müller's hypothesis that black and white are retinally antagonistic, and grey a cortical sensation. Müller has given the Hering theory a stricter and more elaborate formulation in other respects : e.g. as regards assimilation and dissimilation, the mechanism of retinal adaptation, etc.

Other notable contributions to visual theory are : (1) the molecular dissociation theory of Dr. Ladd-Franklin ; (2) the visual purple theory of Ebbinghaus [since withdrawn, see *Mind*, 1893] ; (3) the hypotheses added to the Young-Helmhoitz theory by König ; (4) the reconstitution of the Helmholtz theory by von Kries ; (5) the periodicity or gradation theory of Wundt ; (6) the hypotheses of Göller, Donders, etc. (E. B. Titchener.)]

The first demand to be made upon a colour-theory is that it should posit some (otherwise known) physical or physiological process to account for the most extraordinary fact of colour-vision, that on mixing physically certain colour pairs in certain proportions, the colours disappear, and a grey sensation takes their place ; if this is not done, a theory is hardly deserving of the name. In the theories of Wundt and of Ebbinghaus there is no explanation given of this cardinal fact—complementary colour-processes are merely said to have " something antagonistic " about them. The theory of Wundt,

moreover, takes no account of the fundamental psychological fact of colour-vision, that we can distinguish between the intermediate elements of a colour-series which is constantly changing in the same direction— the blue-greens, the green-blues, etc.—and the end members of such a series. The theory of Ebbinghaus is based upon views in regard to the nature of the pigment of the rods (the visual purple and the visual blue) which were rendered impossible by our knowledge of the function of that pigment as made out immediately after the theory was proposed. The theory of König is very different from the others. He believed that the cones have nothing to do directly with the luminous sensation, but that they are catoptric instruments for the purpose of condensing light upon the cells of the pigment epithelium, where the photo-chemical processes take place which are the sources of the sensations of red, yellow, and green. The blue sensation is furnished exclusively by the visual yellow of the rods, and the sensation of a faint light (and that of the totally colour-blind) is also blue in quality, and is due to the visual purple ; hence the fovea, where there is no visual purple, is blind to blue ("Ueber den menschlichen Sehpurpur und seine Bedeutung für das Sehen," *Sitzber. Akad. Wiss. Berlin*, 1894). The blue-blindness of the fovea has not been confirmed by other observers ; it is difficult to think that the cones can be condensing-glasses, and at the same time contain fibres of the optic nerve, but that they would have to do in order that the effect of photo-chemical processes taking place in the pigment epithelium should be communicated to the brain ; rods and cones are so absolutely alike in structure (except for their basilar terminations, Plate I, Fig. 3) that it is unnatural to assign to them such unlike functions.

v. Kries is apparently in the anomalous position of believing that grey, when furnished by the cones, is a mental reconstitution out of the even red-green-blue sensations, but that, when furnished by the rods, it has its source in some distinctive physiological process.

Donders has a double theory—three-colour (with three different cones, to save the doctrine of specific energy) in the retina, and four-colour, with partial dissociation-processes, in the cortex. In his theory (as in Hering's) red and green are complementary colours, which is contrary to fact : green has for its complementary purple, and the complementary of red is peacock, or blue-green ; red and green mixed together make, not white, but yellow. [One cannot repeat this too often.] The followers of Hering are able to think of red and green as complementaries only by choosing a very bluish red (purple) or a very bluish green (a full blue-green in fact) as the elementary colours ; but this is to give up at once the beautiful reliance upon our power to distinguish, by immediate introspection, between a " mixed " and a " non-mixed " colour, which it is Hering's great service to have brought about.

The theory of Göller is one of great interest [it should always be mentioned when theories are enumerated] on account of the fact that in it a conception has been devised by means of which the process which underlies colour may be regarded as an epiphenomenon, so to speak, i.e. as something superimposed upon an achromatic light-process ; the theory makes use of the known highly refractive quality of the end member of a visual element, and of the existence of a peculiar transparent thin plate just in front of it, to account for light becoming circularly polarized within the cones ; the amount of disturbance corresponds then to degree of luminosity, and the plane of polarization to the colour. It is an impossible theory, because it requires us to suppose that molecular disturbances polarized in different planes can be propagated as such along the nerve-fibres ; but the conception of colour as an *aspect* of a non-specific light sensation is not bad. It is, in fact, just what is needed by Hering to enable him to regard all the brightness of a colour as due to its black-white constituent, and as wholly uninfluenced by the presence of the colour-character (his idea of the

specific brightening power of the colours was intro-
duced to account for the Purkinje phenomenon, and is
no longer necessary since that is known to be merely
incidental to the oncoming of adaptation to a faint light
(Tschermak) ; his own view, however, that chemical
changes are going on in colour-substances which are of
an exactly similar nature to those which take place in
the black-white substance, and that they nevertheless
contribute *nothing* to the total volume of the sensation,
is very improbable.

The main objection to the theory of Thomas Young,
an objection which is insuperable, and which lies upon the
threshold, is that it takes no account of the fact, patent
to the most cursory observation, that, while a mixture of
the *causes* of red, green, and blue is sufficient to occasion
the sensation white, white is nevertheless not a
red-green-blue sensation. The theory is good inasmuch
as it reduces the innumerable physiological colour-
processes supposed to exist in the visual organ by Newton
to a small number : it accounts admirably, for instance,
for the fact that all the successive homogeneous
light-rays between λ 505 and λ 470 furnish *no new sense-
quality*, but only a series of blue-greens gradually varying
in the relative amount of each constituent sensation : this
is just the sort of theory that the psychologist demands—
the physiological conception offered mirrors correctly
the deliverances of consciousness. And the same thing
holds for the bluish-reds and the reddish-blues. But
when we are asked to admit that in the third side of the
colour-triangle the case is still the same, that what we call
greenish-yellows and reddish-yellows are in reality, in
this same sense, greenish-reds or reddish-greens, con-
sciousness rebels ; and still more when we are required
to think that, under whatever circumstances we sense
grey, and even when we can get no *colour*-sense at all
(e.g. in the wholly achromatic sensation of a faint light,
and that of the totally colour-blind), we are really sensing
red and green and blue without knowing it, and making,

for no assignable reason, a totally different mental concept out of the congeries of colours felt together, the idea is so bizarre that it would seem as if to mention it were enough to show its inadequacy. The theory is a purely physical theory; so long as observers fastened their attention solely upon the *physics* of colour-mixing, it could play the rôle of a colour-sensation theory. For the physicist, the series, cold, less cold, indifferent, warm, hot, is also a continuous series, pictured in the gradual ascent of mercury in a thermometric tube; and so much did physics impose, until quite recently, upon psychology, that it required a distinct effort of discovery to establish the fact that heat is a sensation-*quale* wholly distinct from cold (and, by way of sure confirmation of the fact, found to be communicated to the cortex by a distinct conduction-path).

What is meant by those who insist upon it that there are four (not three) unitary colour-sensations, and that all other hues besides those four are of the nature of colour-blends, is well set forth by G. E. Müller (*Zeitsch. f. Psychol.*, x and xiv) in a discussion of the different sorts of quality-series. It is evident that we are capable of distinguishing whether a sensation which goes through a series of changes before our eyes is changing *in a constant direction* or not. Thus if we look at a red revolving disk, and an assistant (without stopping the wheel) puts in constantly a greater and greater proportion of blue, the series of sensations which we get is a very different thing from what it is if he suddenly begins to add yellow—in the first case the series is varying in a constant sense or direction, in the other there is a sudden change in sense or direction. Now, if we look through the whole circular gamut of colour-hues (the spectral colours completed by the lacking tones from red to blue) we find that it is not composed of a *single* series of this sort, but of several, interrupted by sharply marked points of breaking. As we approach the wave-length λ 505 on one side, the sensation is getting less and less yellow in character and

more and more green (this is a variation of a constant sort), but the moment we pass that point there is a distinct change in the character of the series—its successive elements get to look *less* and *less* like green, and more and more like something quite new, namely blue. The colour-gamut, which is physically, like the tone-gamut, *rectilinear* (that is consisting of a series of elements which differ one from another always in the same way, viz. by a constantly accelerating velocity of vibration), is, *for sensation*, not at all a rectilinear series (as is the series of subjective tones), but a series made up of several different stretches, with distinct inflections between them. This is not so well seen in the spectrum, where one

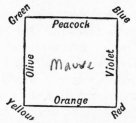

FIG. 6.—The psychological colour-square of Hering and of Leonardo da Vinci.

of the stretches is partly wanting (the purples), and where differences in brightness are excessive ; but if one takes a complete series of colour-hues in paper or in gelatine sheets (all equally bright and equally saturated), and arranges them in order upon the circumference of a circle, it will be impossible not to see that the series does not vary *in the same way*. throughout the scale (as two tones have the same *sort* of difference between each other, viz. that of higher or lower pitch, no matter from what part of the scale they are taken), but that there are distinct *breaks* in the series. If such a series were to be repre-sented in a diagram, that could not be fittingly done by a circle—a curve of constant curvature ; we should have to use a figure with sharp angles in it, and, since the number of constituent stretches as well as the number

of breaks is four, the proper figure is a square (Fig. 6). On one line of the colour-square, adjacent colours differ in respect to their relative blueness and redness ; on another, with respect to their relative yellowness and greenness ; it is as if, in one part of the tone-scale, two adjacent notes differed in respect of pitch, and in another part in respect of some other quality not the same as pitch. This is the way the colour-scale represented itself to the ancients, to Leonardo da Vinci, and to Goethe, and it was only after Newton's discovery of the phenomena of colour-mixture that this fundamental property of the colour-series became completely lost sight of. The psychologists (those who study the exact deliverances of consciousness) owe a great debt of gratitude to Hering for having restored to introspection its proper importance ; since his discussion of this question, it has been impossible for anyone except a person who attends solely to the physics of light to accept a three-colour theory, or one in which white is regarded as a mental construction out of any number of colours.

It was pointed out distinctly by Leonardo da Vinci that the colours red, green, yellow, and blue differ *in kind* from such colours as orange, violet, etc. Their important character is evidenced by the antiquity of their names ; these are so old, in many languages, as to have lost their original signification, while the inter-mediate hues, violet, orange, are still called by the plain names of the flower and the fruit which stand for them ; and, strange to say, we have hardly got any (commonly accepted) names for the other intermediate colour-hues, blue-green and yellow-green. (They might appropriately be called peacock and olive ; the latter in its ordinary sense is rather too dark and too greenish for the midway colour between green and yellow, but there is no harm in changing its signification a little for scientific purposes.)

The theory of Hering was accordingly a splendid advance upon the theory of Young ; it formed a good resting-place in the history of colour-theory.

But, on the other hand, the theory of Hering fails to take sufficient account of the facts regarding the mixing of colour. These facts are represented diagrammatically not only in the colour-curves, but also in the colour-triangle (Figs. 7, 10). The latter is a surface, and not, like the musical scale, a line (even a broken line is not sufficient), because it represents two modes of variation, hue and saturation (intensity may be represented also by extending the triangle into a solid body), and it is triangular because the assumption of three elements of mixture (or independent variables) is sufficient to produce all the colour-tones in nearly spectral purity. This is all that the colour-triangle represented in its

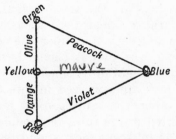

FIG. 7.—The physical colour-triangle, with indication of the primary character of yellow.

original arbitrary form ; the hypothetical colour-elements could be placed at the vertices of the least enclosing triangle (Fig. 7), or at any other points that were, for any reason, desirable. Some writers even suppose, apparently, that nothing is represented in the colour-triangle except the complementariness of the colours at the opposite ends of a line. But much more than this is represented by the colour-triangle of König.

For the mixing of colours, no method is of any scientific value in which there is no provision for the extremely accurate measuring of the wave-length and the intensity of several homogeneous constituents. By far the best method at the present time is that made use of in the

(very expensive) colour-mixing apparatus of Helmholtz (made by Hänsch and Schmidt, Berlin : for description see the *Physiol. Optik.*, p. 335). This is, in effect, a double spectroscope ; there are two collimator-tubes which throw light, after it has passed through a prism, into the two halves of a single telescope. The eye-piece of the telescope has been removed, and a plate carrying a narrow slit put in its place ; the effect of this is that an eye looking through the telescope sees, not a narrow image of the collimator-slit, but the whole surface of the prism lighted up by the homogeneous light. Each collimator-tube carries a double refracting prism of calcspar, so corrected by a prism of glass that each ray is undeviated in its course, and therefore still parallel with the axis of the tube. The two rays are the same as if they came from two images of the collimator-slit separated from each other by an amount depending upon the distance from it of the prism-pair ; as that is changed, any ray of the spectrum can be brought into coincidence with any other, and since the rays are polarized in directions at right-angles to each other, either ray can, by means of a Nicol prism also inserted in the tube, be modified in intensity at pleasure. The telescope faces symmetrically one edge of the main prism, and hence there is exhibited to the eye a field of view of conveniently large size, lighted up in the left-hand half by the combination of any two colours taken from the spectrum furnished by the right-hand collimator-tube, each present in any desired intensity, and in the right-hand half the same thing form the other collimator-tube, or, at pleasure, a single spectral colour, or white light. It will be seen at once that this apparatus offers facilities for making colour-mixtures with which no other method can be compared.

If one-half of the field of view of this apparatus is filled with a combination of two different lights, and the other half with a homogeneous light, or a different light mixture, or white light, and if the proportions and the character of the several constituents are varied until the

two half-fields are indistinguishable, we are said to have
before us a colour-equation. The colour-triangle is the
diagrammatic record of the results of a vast number of
such colour-equations. But it was only after the incor-
poration into it of the results of equations made by the
colour-blind that it acquired its present importance.

It readily suggested itself that the different qualities
of the sensation of light, being two dimensional continua
(abstraction being made of intensity) may be represented
by the points of a plane. For the simpler forms of vision
a smaller number of dimensions is sufficient. The totally
colour-blind person has one sensation only, a dull white
in different degrees of brightness; a single point is
sufficient for the representation of his sensation-scale.
The partially colour-blind see two colours only, yellow
and blue; these are for them the colours of the two halves

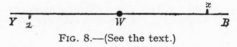

FIG. 8.—(See the text.)

of the solar spectrum; they are seen in full saturation up
to wave-length 630 $\mu\mu$ in the yellow, and beyond wave-
length 475 $\mu\mu$ in the blue. All spectrum effects between
these two points exhibit a constant variation in
saturation up to white itself, and all such spectral effects
can be matched by proper mixtures of the saturated
end colours, yellow and blue. For these defectives,
colour-mixture produces no new hue, but merely changes
in saturation; their sensation-scale can be represented
upon a straight line (Fig. 8), in which the co-ordinates
of any point x will be 9 : 1 if the (unsaturated) colour which
it represents can be got by mixing yellow and blue in the
proportion one to nine, or white and blue in the proportion
one to four, and this will serve to fix the position of the
spectral colour which this mixture matches. The wave-
length which corresponds to the colourless sensation, W,
is different for the two sorts of colour-defectives,
proteranopes and deuteranopes; and it is also a little

irregular on account of different amounts of absorbing matter in the yellow spot of the eye, if central vision is made use of. There is another way of representing colour-quality diagrammatically, which runs parallel to this one, and in which the amounts of blue and yellow to be mixed are represented by the ordinates of two curves, the abscissæ being the wave-lengths. The curves marked *K* and *W* in Fig. 8*b* show the relative amounts of the

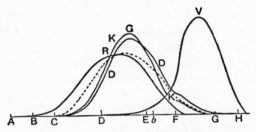

FIG. 8*a*.—The proportions of the three trial elementary colours required to match all the colours of the spectrum, for normal individuals.

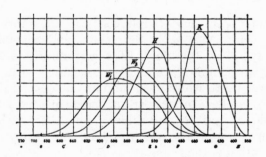

FIG. 8*b*.—W₁, *K*, curves of sensation for two deuteranopes ; *W*₂, *K*, those for two protanope individuals ; *H*, curve showing the intensity of the grey sensation for the totally colour-blind. (König.)

two end-constituents which must be mixed together in order to match the continuous spectrum for each of these two classes of colour-defectives.

We come now to cases of normal vision. For such individuals it is not possible to match the whole series of spectral colours by means of the two end colours only.

The ends of the spectrum are here, as before, for some distance, of unvarying hue, and differ in intensity only— the warm end up to 655 $\mu\mu$ and the cold end beyond 430 $\mu\mu$. Outside of these regions the spectral colours cannot be matched by the end colours, either alone or together, but it is necessary to take in a third constituent. This third constituent is in the first place chosen somewhat at hazard. (No single third constituent will give the spectral colours in full saturation, and hence a somewhat more saturated green than any in the spectrum is hypothetically taken as the third element of the sensation area.) With these arbitrarily chosen independent variables the colour-curves are laid down (Fig. 8a) : it is found that they do not coincide exactly with the curves of the two sorts of dichromates, the so-called red-blind and green-blind (Fig. 8b). But would they have coincided if *different* independent variables had been chosen ? The question is easily put to the test : it is a simple matter of mathematics (merely a change in the triangle of reference) to find out if there are independent variables, that is, unit quantities of lights of particular wave-lengths, such that the entire spectrum as seen by the three different classes of individuals can be built up out of like amounts of two or three of the several constituents. In fact, it was only necessary to substitute for the colours first chosen others mixed out of them in this way,

$$\mathfrak{R} = \frac{R - 0.15G + 0.1B}{0.95},$$

$$\mathfrak{E} = \frac{B + G}{1.25},$$

$$\mathfrak{P} = B,$$

to find that, with these new constituents, the warm-end curve of one sort of defective coincided with the red curve, and that of the other sort of defective with the green curve of the normal individual. In Fig. 8a are represented the trial curves for König and Dieterici ; in Fig. 9 the curves of coincidence for normal and semi-defective individuals. (In the dotted line of Fig. 8a is

given the green curve of a rather small class of individuals, first noticed by Lord Rayleigh and by Donders, who differ markedly from the normal ; they require, to make an exact yellow out of red and green, four times as much red to a given amount of green as the normal individual does.[1] Expressed in other words, this is the same as saying that all colour-matches formed by normal individuals are recognized to be such by both sorts of dichromates,[2] but that colour-matches formed by the proteranope need to be distinctly changed before they are

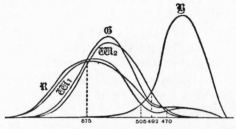

FIG. 9.—When λ 470 (blue), λ 505 (green), and a red a little less yellowish than the red of the spectrum are taken as the elementary colours, the colour-mixture curves of the normal individual become coincident respectively with those of the two sorts of partially colour-blind.

such for the deuteranope. This means that the colour-systems of both sorts of dichromates are undifferentiated systems—all their sensations are accounted for by supposing that one certain element (not the same for both) is absent in their case, but the colour of the element which remains is *yellow* and not either *red* or *green*. This result has been confirmed by v. Kries (" Ueber Farben-systeme," *Zeitsch. f. Psychol.*, xix, 1897). The theory of

[1] Colour systems of this kind are said to be anomalous, and they are of one or the other of two kinds, protanomalous or deuteranomalous, according as the first or the second of the two normal curves has been distorted in place—they are never *both* distorted at the same time. This fact is, of course, very illuminating when it comes to a discussion of theories of colour vision.

[2] The converse of this proposition is, of course, not true ; countless things which look alike to the semi-defective are of different colour to the normal eye.

Hering fails to take account in any adequate way of the
fact that the dichromates are of two different sorts, and
that nevertheless their colour-systems are both simply
[non-differentiated] systems of normal colour-vision.
On the other hand, the Young-Helmholtz theory offers
no explanation, of any degree of reasonableness, of the
fact that the two classes of semi-defectives, instead of
seeing red and blue, and green and blue, respectively (if
they had done this matters would have been very simple),
see, as a matter of fact, in both cases, *yellow* and blue.

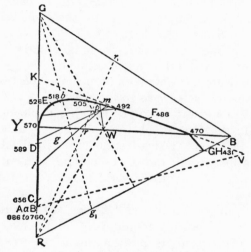

FIG. 10.—(For description see text.)

This is proved beyond question by the cases of uniocular
partial colour-blindness known since 1881 ; it was also
perfectly well established, in 1874, by William Pole
(the well-known authority on whist), by means of very
acute observations upon himself, a semi-defective.

Sir John Herschel, unconvinced by Pole, said :
" What the sensations of the colour-blind really are, we
shall never know," quite overlooking the possibility
of cases arising in which the defect should be in one eye
only. The theory of Helmholtz has imposed itself upon

writers on this subject to such an extent that even now it is hard to convince them that these defectives are not " green-blind " or " red-blind " alone (they always neglect to mention what becomes of yellow). The report of the British Association Committee on colour-vision, so late as 1892, contains coloured spectrum plates showing the spectrum in green and blue and in red and blue, as it is supposed to be seen by these defectives, and Abney prefixes the same plate to his Tyndall Lectures on colour-vision published in 1894.[1]

In its present form the colour-triangle constitutes a *vade mecum* for holding together for the eye a number of the facts of vision. (See Fig. 10.)

(*a*) Complementary colours are to be found at opposite ends of lines through the central point, W.

(*b*) The degree of whiteness of any non-spectral colour corresponds to its nearness to the point W.

(*c*) Any non-spectral colour may be made up out of spectral lights situated at the ends of any line, drawn through the point which represents it, mixed in the inverse proportion of the corresponding segments of the line, as indicated by the several lines drawn through p in the figure.

(*d*) The proportion of the " elementary " constituents in any colour, spectral or not, may be got by dropping perpendiculars from its position upon the sides of the triangle ; the perpendicular upon BG will give the amount of red, etc. (This is merely saying that we have here a representation of continuous quantities in terms of trilinear co-ordinates.)

(*e*) All the colours which for the normal individual lie on a straight line through R, as Rr, look exactly alike to the " red-blind ", and are represented for him by the point in which that line cuts the line BY. The reason for this is that the perpendiculars from any point of such a line Rr upon the two sides of the triangle, RB and RG,

[1] [This is a very interesting instance—a classical one—of the extent to which obdurate theory is capable of supplementing simple fact.]

are in a constant ratio to each other ; that is points of
such a line represent colours which contain the blue and
the green elements in a constant proportion, and as they
also contain no red, they are indistinguishable from each
other. In particular, the point in which the line Rr
cuts the curve of the spectral colours will give the wave-
length which is represented at the point r. The same holds
for the " green-blind " and lines through G.

(f) It is commonly said in the textbooks that in the
mixing of coloured lights " the nearer the homogeneous
lights are to one another the more vivid or more saturated
is the intermediate colour " (Külpe) ; this was a good first
approximation to the true state of the case, and the
colour surface was properly represented at first by a
circle. But it is far from being correct. All spectral lights
on either of the two nearly straight portions of the colour
curve can be matched, *with no loss of saturation*, by the
lights at the ends of these stretches, although they are
far apart. On the other hand, colours taken from *different*
stretches, when mixed, show rapid falling off in saturation.
All this is plainly represented in the shape of the triangle :
it is composed of two rectilinear stretches (λ 760 to λ 576
and λ 492 to λ 470) connected by a portion of rapid
curvature.

The theory of Hering (which was first sketched out by
Mach in 1865) is so vastly superior to the Young-
Helmholtz theory, that until it has fully displaced that
it is hardly desirable to discuss its demerits. Nothing is
gained for the theory by saying that opposite colour-
processes are due to assimilation and dissimilation of
photochemical substances ; the theory would be just as
good (and less open to objection) if the nature of the
antagonism in the chemical processes were left obscure—
if they were said to have " etwas antagonistisches " about
them. There would then be no occasion for saying that the
black and white processes have anything antagonistic
about them ; the sensations do not, as a matter of fact,
extinguish each other, like blue and yellow—they form

a quality-blend, like blue and green ; that is to say, the
distinctive sensation-*quale* of each does *not* disappear,
they both remain in the constantly varying series of the
greys.

Hering has done a great service in showing that a large
number of the phenomena of vision are physiological,
and not of the nature of mental errors, but it is too much
the custom of his school to consider that a phenomenon
has been explained by the theory when it has merely
been translated into the terms of the theory. Thus when a
patch of colour falls upon a bit of the retina, the sensation
which it gives is accompanied by a sensation of the
opposite colour-character furnished by the immediately
adjoining portion of the retina. This Hering explains by
saying that, if the original colour is caused by an
assimilation process, the effect of this is to start up a
dissimilation process in the adjoining region of the retina,
and if it is a dissimilation process, it arouses an
assimilation process there ; but this is nothing more than
to say (once it is admitted that the simultaneously
induced colour is retinal) that one process of a colour pair
has a tendency, in the interest of a restoration of retinal
balance, to start up all around it the opposite process ;
nothing whatever is added to the intelligibility of the
reaction by assuming that it is alternately assimilation
and dissimilation. That is to say, there is no special
reasonableness, derived from our knowledge of the nature
of these processes elsewhere, in a patch of growth of a
chemical substance in the retina becoming immediately
surrounded by a region of decay, or in a patch of decay
enclosing itself in a region of growth. It is none the less
a matter of great importance that Hering has shown by
a large number of simple and ingenious experiments that
the phenomena of the after-image and simultaneous
light and colour induction are physiological in their
character, and not of the nature of illusions of judgment.
To take an instance : if, while a constant fixation-point
is maintained, a number of different coloured objects be

introduced at different times upon a common grey background, each will be seen to go through with its own series of after-effects and border-effects exactly as if the others were not present. So complicated a series of disjunct but simultaneous acts of judgment as would be involved in carrying out all these changes, different in period as well as in character, is quite inconceivable. There is no doubt that Helmholtz was wrong in attributing these colour and brightness effects to errors of judgment to the extent that he did ; but it is also a great mistake to suppose that there is anything in an assimilation-dissimilation theory that is peculiarly fitted to explain them.

The objection to the Hering theory that black and white are attached to antagonistic processes, is one that he could easily remove if he saw occasion for it ; he would merely need to assume that those sensations are attached to photochemical processes in different substances, or that, for instance, white is retinal and black a mark of the resting-stage in the cortical portion of the total light-process. But the fact that it must regard red and green as a colour pair which, when combined, result in white, is fatal to his theory ; it is the most elementary fact of colour-mixing that real red and green make yellow. Red and green are made a vanishing colour pair in this theory only by choosing as fundamental colours (Grundfarben) tones which are, in fact, distinctly blue-green and blue-red.

The two rival theories, therefore, are able both to continue to exist only by means of the fact that each is content to totally ignore the central facts of nature upon which the other is built up. The Helmholtz theory has no word to say to the fact that yellow, made up of red and green, is *yellow*, and not reddish-green, and that white is *white*, and not a reddish-greenish-blue. The Hering theory exists in complete oblivion of all the facts of colour-mixture—the facts which, in the laboratory of the physicist, are almost exclusively the ones that come within his ken. It is small wonder that the same dividing

line separates the adherents of the two theories, and the adherents of the physical and of the physiologico-psychological sciences.

Again, neither of the two reigning theories pays any attention to the fact that the luminous function has probably undergone, like other functions of the body, progressive development.[1] But the structure of the retina points already strongly to this view. It has lately been put beyond question (Ramon y Cajal) that the rods and cones represent not simply accidental variations in the shape of elements that are in reality of similar character, but that they are fundamentally different, and in fact that the cones (which, in an early stage of development, are exactly like the rods) are differentiated out of the rods in the direction of a higher structural development. It is not the cone shape that is their distinguishing mark, however—the closely pressed together cones of the fovea do not differ in shape from rods. In internal structure of their outer members (the falling apart into plates or disks), in their highly refractive character, in the possession of a fine covering-substance, in the presence of a thin plate between outer and inner member, the rods and the cones are exactly alike ; but they differ markedly in the endings of the cell-fibre (see Fig. 3). The rods terminate in a minute expansion, or end-knob, which is grasped by the arborizations of the contiguous bipolar cells ; the cones end in a more complicated structure—an expansion of finger-like processes which enter severally into connexion with different bipolar processes. This distinctive structure appears late in the development of each cone, and is hence certainly late in phylogenetic development. It points to a provision for a less simple sort of excitation conduction than that of the rods. (It appears from this that the rods and cones have not been named from their most distinguishing

[1] In the ear we have an organ for perceiving the sense-quality attached to difference of vibration-periods (pitch), and persisting side by side with it an organ for noise only.

characteristic—they should rather be thought of respectively as the *knob-end* and *finger-end* retinal elements.) The structure alone, therefore, of the visual organ is enough (since the brilliant anatomical researches of Ramon y Cajal have been accessible) to make it plain that we have in the visual sense an instance of progressive development.

But our knowledge of visual function leads conclusively to the same view. The visual process is not everywhere so complete as it seems to us to be in everyday life, when we make use chiefly of the portion of the retina near the centre, and take peripheral stimulations merely as affording us a hint of what we are to look at next. If central vision is cut off, and we look at coloured surfaces with the extreme periphery of the eye, we perceive that their colour is no longer distinguishable — that all objects appear only in various shades of grey.[1] As images fall upon retinal regions somewhat nearer the centre, yellows and blues begin to be perceived, but reds and greens are still seen only as greys, in as far as they are of purely fundamental tone ; if they contain admixtures of blue or yellow light, this latter light is seen, but without any reddish or greenish tone. This zone of exclusive yellow-blue vision may be called the mid-periphery. Within this is the region of complete colour-vision, where all colours appear in their normal value. The boundaries of these regions are somewhat different, according to the size and the brightness of the test objects chosen, and to the time of their exposure.[2]

[1] Hellpach seems to have shown (*Philos. Stud.*, 1900) that in the ultra-extreme periphery, colour-vision is possible—that it is not there overlaid by the excessive white-contribution of the rods, as it is just within. This would be, however, confirmation of the theory, for in that region there are cones in the retina, and no rods (Greef).

[2] The space-sense of the retina is also incomplete in this external region : a circle half white and half black on a grey background, if brought into the extreme edge of the field of view, can be seen to be composed of black and white when the relative position of the two half-circles cannot be at all distinguished. Also, a certain duration of exposure is essential to correct space-perception ; if that is not sufficient, very

These several capabilities of vision, according to the portion of the retina which mediates it, can only be regarded as different degrees of development of the sense of sight. Exactly corresponding to these retinal regions of the normal eye are the most frequent cases of defective colour-vision. Ordinary partial colour-blindness consists of vision for yellow and blue only (xanthokyanopia) and total lack of sensation for red and green. It is still persistently said that these defectives " fail to distinguish" red and green ; they fail to *distinguish* them because they are totally blind to both ; they see in their stead various more or less whitish yellows.[1] And though they are comparatively rare, the cases are perfectly well marked, and have now been thoroughly well examined, of those individuals who see no colour whatever—to whom the world is like a picture in various tones of grey. [The cat belongs in this class of the totally chroma-blind.]

The molecular dissociation theory (theory of the differentiated chemical substances) [2] was devised with the intention of hitting upon a conception which should render intelligible *both* the facts of colour-mixture and all the psychological phenomena which the Hering school has done such good service in bringing to the fore, and which should at the same time take account of the probability which is now thrust upon us, that colour is phylogenetically a late acquisition—that the primitive sense was for the achromatic luminous quality only. If

different space-relations will be given from the actual ones (the physiological diffusion-circle : Exner, *Pflüger's Arch.*, 1898 ; Cattell, *Psychol. Rev.*, July, 1900). This is not strange, because it is a law of photochemistry that the amount of effect produced is proportioned not only to the intensity of the light, but also to its duration, and that intensity and duration can exactly replace each other. It is natural, therefore, that a stimulus which produces an insufficient amount of retinal excitation (whether from too short duration, too small extent, or too weak intensity) should fail to give sufficient material to the space-perceiving centres to enable them to work correctly.

[1] [See the good coloured illustrations in Köllner : *Störungen des Farbensinnes*. But better still in Chart viii.]

[2] *Zeitsch. f. Psychol.*, iv, 211 (1892) ; this book, p. 66

the retinal basis of the light-sense is a photochemical process, then this would mean that the eye which furnishes the colour-sense contains more complicated chemical substances than do the retinæ which are defective—or, if the cones only furnish colour-sensations, that the cones contain more complicated chemical substances than the rods ; at the same time the total effect of complementary colour pairs in the cones must be the same as in the rods, for we see whites in the fovea (where there are cones only) which are indistinguishable from the whites of the rods. It would be a difference of an adequate sort, therefore, if there were a chemical substance which in the cones underwent partial dissociation under the influence of light, and differently for the different regions of the spectrum, but which in the rods became completely dissociated at once, and alike for all sorts of light. It happens that there is immediate analogy for this conception of a photo-chemical substance which is, in primitive condition, dissociated at once, but, in more highly developed animals, dissociated in successive stages : the rod-pigment, which exists first in the form of the visual purple, is turned at once into the visual white in animals below man ; in man alone it passes through an intermediate stage, the visual yellow (Köttgen and Abelsdorff). A change of this sort, from a substance which is decomposed all at once (in the rods) to a substance which is decomposed in successive stages (in the cones), is just what it is sufficient to assume to account for the fact that from the rods we have colourless vision only, and from the cones distinction of colour, but such that there results, in the end, the same achromatic sensation in both. The existence of this analogy in the rods for a change in the character of a photochemical substance in the cones was not, however, known at the time this theory was proposed. The fact (for such it seems to be, although it has not been explained yet how other observers failed to notice it) was announced in 1895.

Corresponding, therefore, to the successively developed

powers of the retina for light-discriminations, this theory assumes a chemical substance which is, in the first instance, completely dissociated by light of all kinds (achromatic vision) ; then (owing to different synchronous intramolecular vibrations—in no other way can selective dissociation by light be conceived to take place : Ostwald) differently dissociated by the two halves of the spectrum (yellow-blue vision) ; and, finally, susceptible of partial dissociation in three different ways, but with the peculiarity that out of the products of the red and the green dissociation there is reconstituted at once the excitant of the sensation of yellow light.[1] The actual

[1] The essential elements of this theory have been stated as follows by Dr. Bowditch : " A colour-theory which is in some respects more in harmony with recent observations in the physiology of vision has been proposed by C. Ladd-Franklin. In this theory it is supposed that in its earlier periods of development, the eye is sensitive only to luminosity and not to colour—that is, it possesses only a grey-perceiving substance, which is affected by all visible light-rays, but most powerfully by those lying near the middle of the spectrum. The sensation of white (and of dull white) is supposed to be dependent upon the chemical stimulation of the optic nerve terminations by some product of decomposition of this substance. In the course of development a portion of this white visual substance becomes differentiated into three different substances, each of which is affected by rays of light corresponding to one of the three fundamental colours of the spectrum, viz. red, green, and blue. When a ray of light intermediate between two of the fundamental colours falls upon the retina, the visual substances corresponding to these two colours will be affected to a degree proportionate to the proximity of these two colours to that of the incident ray. Since this effect is exactly the same as that which is produced when the retina is acted upon simultaneously by light of two fundamental colours, we are incapable of distinguishing in sensation between an intermediate wave-length and a mixture in proper amount of two fundamental wave-lengths. When the retina is affected by two or more rays of such wave-lengths that all three of the colour visual substances are equally affected, the resulting decomposition will be the same as that produced by the stimulation of the white visual substance out of which the colour visual substances were differentiated, and the corresponding visual sensation will therefore be that of white. . . . The theory of Ladd-Franklin accounts for these phenomena (colour-blindness) in a still more satisfactory way ; for, by supposing that the differentiation of the primary white visual substance has first led to the formation of a blue and yellow visual substance, and that the yellow substance has

VISION

molecule of such a photo-chemical substance is certainly extremely complicated, but a molecule of complexity sufficient for the purposes of the theory is represented in the diagram (Fig. 11).

ACHROMATIC VISION

Under several different circumstances, vision exists only for shades of grey—the field of view is like an engraving (but in three dimensions) in black and white ; these cases are : that of total colour-blindness (congenital or from disease) ; that of the normal eye in the extreme

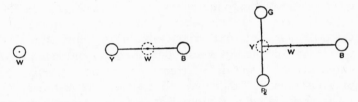

FIG. 11.—The colour molecule (hypothetical) in three successive stages of development.

periphery ; and that of the normal eye when the illumination is very faint (night-vision).

The adherents of the Young-Helmholtz theory ignore the existence of white as anything except a product of the reconstructing mind, and hence, in spite of plenty of evidence to the contrary, the sensations of those individuals whom they named " monochromatic " [what should, of course, be achromatic] (in distinction from ordinary vision, which is tetrachromatic, but which was called, under the dominance of the colour-triangle,

become in turn differentiated into a red and a green substance, colour-blindness is readily explained by supposing that this second differentiation has either not occurred at all or has taken place in an incomplete manner. It will be noticed that the important feature of this theory is that it provides for the independent existence of the white visual substance, while at the same time the stimulation of this substance is made a necessary result of the mixture of certain colour sensations " (Bowditch, in Howell's *Textbook of Physiol.*, 1st ed., 1894, 784).

trichomatic) were dogmatically affirmed to be vision
under the form of red or blue or green, it was uncertain
which ; and the colourless sensations of the periphery and
of a faint light, although they are patent to observation,
were wholly overlooked. Even so late as 1894 König
affirmed that the vision of the faint-light " mono-
chromates " was in quality blue, in the face of the
popular knowledge, " im Dunkeln sind alle Katzen
grau." [1] But as early as 1880 it had been put beyond
question by Becker's case of monocular congenital
total colour-blindness,[2] that the sensation that remains
is that of grey ; if the patient's vision is normal with one
eye it is impossible to doubt that he can describe correctly
what he sees with the other. Moreover, the numerous
cases of acquired total colour-blindness, which there is
no reason for putting wholly out of court, and especially
those in which the defect comes on in one eye only, or
in a circumscript region of the retina (for instance, in
tobacco and alcohol scotomata), had shown conclusively
the same thing.

The quality of the sensation-series in all these cases is
therefore white—the different regions of the spectrum
differ in luminosity only. Is the relative luminosity
of the spectral regions the same as for central
vision with the normal eye ? In the case of the normal
eye, estimations of brightness are difficult on account
of the disturbing colour-differences, but by the method of
the so-called flicker-photometry they can be made with
great accuracy. In 1884 Donders, and in 1889 König and
Dieterici, determined the distribution of brightness along
the spectrum (the luminosity-spectrum) for the totally
colour-blind ; it was found to be quite different from that

[1] [It is now known that the sensation in scotopic vision is in fact
distinctly bluish (Kroh). This is probably due to the blue light emitted
by the excited optic nerve fibers (p. 216). It would be very upsetting
to all our accepted views in regard to colour vision if this could not
be explained away.]

[2] *Arch. f. Ophthal.*, xxv (2), 205.

for the normal eye, the maximum brightness being in the green instead of in the yellow.

A most important advance in this subject was made in 1889, when it was found by Hering and Hillebrand that the luminosity-spectrum [1] of the normal eye after the Purkinje phenomenon has set in (night-vision, darkness-adaptation) is exactly the same as that for the totally colour-blind at all illuminations,[2] and at the same time, of course, very different from that of the normal eye in ordinary light. This is exhibited in Fig. 5 (where the scale on which the several curves are drawn is so chosen that green, λ 535, is taken as alike in all); there is a gradual falling off in the superior brightness of yellow until, at a certain low total luminosity, the maximum is in the green, and at this stage there is complete coincidence between the spectrum of the normal eye and that of the totally colour-blind. This made it look as if Hering's black-white " valences " had, indeed, a separate existence, and it spoke strongly against the theory of Helmholtz.[3] It required Hering, however, whereas he had formerly maintained that colour has no effect upon brightness, to set up the theory of the " specific brightening and darkening powers of the colours " (since given up : *vide* Tschermak). But the subject was soon afterwards put upon a very different footing by König ; he showed that the (objective) absorption-spectrum of the visual purple

[1] It is very desirable to use the word luminosity in place of brightness, in order to avoid confusion with the meaning which Hering attaches to the latter word.

[2] " Ueber d. specifische Helligkeit d. Farben," *Sitzber. Akad. Wiss., Wien*, 1889.

[3] König admits that this coincidence made him, at first, " ungemein betroffen," but he goes on to say : " aber zur Zeit der Epicyklen-Theorie hat man ja auch Sonnen-und Mondfinsternisse richtig im voraus berechnet " (*Helmholtz-Festschrift*, 354). This is a very acute remark. The ardent adherents of Hering are too much in the habit of protesting that every little coincidence furnishes a complete proof of the whole theory (Müller, *Zeitsch. f. Psychol.*, xiv). This particular one is not a little one, but what it proves is that white is a definite thing, alike under various circumstances—not that the Hering theory is true.

(that is, the relative amounts of the light of different wave-lengths absorbed by it when it is extracted by gallic acid from a freshly enucleated human eye, and examined immediately, in a dark room, by means of a spectro-photometer) is also coincident with the (subjective) luminosity-spectrum of the totally colour-blind and with that of the normal eye in a faint light (which had been shown, as has just been said, by Hering to be coincident with each other). This forced upon one the conclusion that it was the visual purple that was involved in both of these two sorts of vision, and that that acted propor-tionately to the amount of light of any given kind that it absorbed. (This is not always the case in instances of photochemical dissociation by heat and light : Ostwald.) It was not shown by this that the visual purple was the photo-chemical substance of the rods—it might equally well act simply as an absorbent of an additional amount of light, which would otherwise go through the rods and be lost in the pigment epithelium and in the choroid. The fact that it is of a slightly different colour in fishes (and in fishes only), whose darkness is the darkness of ocean depths (and hence of a different colour from that of the depth of the forest), points to absorption as its essential function. Still less was it shown that the *rods* function in the darkness only, as v. Kries supposes ; on the contrary, the *change* in the visual purple (regeneration in a faint light) is just what is needed to account for the *changed* values of night-vision. Again, it has been shown by v. Kries that the peripheral achromatic vision has a different distribution of brightness in the spectrum—the same, in fact, as that of the (heterochrome) brightness of the centre of the retina ; this points to the fact, not that the cones alone function in the periphery (they are too few for that), but that the rod-vision, *when it is not reinforced by the visual purple,* is the same sort of thing, as regards its brightness-values, as vision with the cones.

It had been shown meantime (1892) that Newton's accepted law of colour-mixtures did not hold at low

intensities ; its persistence under all circumstances had been affirmed by Maxwell, by Aubert, by v. Kries, and most vigorously by Hering. This fact had an important bearing upon the discussion.

In the remarkable case of congenital total colour-blindness of Raehlmann (*Arch. f. Augenh.*, ii, 1899), the distribution of brightness in the spectrum is quite unlike any other that has hitherto been observed : there was an extreme darkening in the part that is normally yellow, and blue was proportionally brighter than for the non-defective individual. But the abnormality in this case is clearly of cerebral origin, as is shown by the fact that foveal vision was retained.

THE DOUBLE STRUCTURE AND THE DOUBLE FUNCTION OF THE RETINA ; RODS AND CONES

Interest in the phenomena of visual sensation has centred for sometime in the question of the discrimination of function of rods and cones, and in questions intimately connected with it. It would be singular if organs of such very distinctive structure (knob-like or else dendritic connexions with the bipolar cells, Fig. 3), and of such very different chemical contents (presence or absence of the rod-pigment), should not play a different rôle in the visual economy. Neither of these objective differences was known at the time when Max Schultze first made the suggestion that the rods constitute an organ for black and white vision only, and that colour is mediated only by the cones (1866) ; but there was already sufficient ground for his view in the fact that in the retina of many night-animals rods are found exclusively, or nearly so. This view seems to have been very generally overlooked (though it has been better kept in mind by the anatomists : Ramon y Cajal), until Parinaud revived it (1881), being led thereto by the study of hemeralopia (daylight vision— night-blindness), a disease in which the power of seeing things in a very faint light, which the normal person

acquires after remaining for twenty minutes or so in darkness (a power which may, correspondingly, be referred to as *night-vision*), is wholly wanting, and in which there is also degeneration of the pigment epithelium, which is known to be the source of the visual purple (rod-pigment). As he pointed out, animals which lack the rod-pigment altogether (doves, chickens) are also night-blind—" se couchent avec les poules ". But this night-vision, which would seem thus to be rod-pigment vision, is a form of achromatic vision—in an extremely faint light all colour disappears, and objects are seen only in shades of grey. Hence it seemed probable that the rods (at least, when they contain the visual purple) are organs for colourless vision only. (Parinaud regarded—and still regards— the vision of a faint light as due to the fluorescence of the visual purple ; but that is impossible, for it is most fluorescent when it is in its completely bleached-out condition—the visual white.)

Other arguments were added by Parinaud. In the vision of approaching darkness-adaptation, differently coloured surfaces, before they wholly lose their colour, suffer a change of relative brightness (blues shine out brilliantly in a semi-darkness : this is the Purkinje phenomenon) ; but this change does *not* take place if the colours are looked at with the fovea only, and hence (since the fovea is lacking in nothing but rods) it must be a phenomenon dependent upon the rods, and, in fact, upon the regeneration of their visual purple.[1]

[1] This fact—the absence of the change in brightness-values in the fovea (in other words, the failure of the Purkinje phenomenon)—has been contested, but it is really quite beyond question. v. Kries finds the unchanging region to be, for the dichromatic person tested (such individuals are far better adapted to tests of this kind than are others, because many combinations of objectively different spectral lights can be found which look alike to them in colour), for the horizontal direction 1° 47′ in one eye and 1° 23′ in the other, and for the vertical direction 1° 21′ in both eyes. These dimensions are a little less than what Koster finds to be the diameter of the rodless region—2°. But (1) there are, no doubt (as appears from these two eyes of a single person), great individual differences, and (2) a few scattered cones

It is also Parinaud who first pointed out that it is only the achromatic constituent of the sensation that is affected by this change. In proportion as the blues become relatively brighter, they become also less saturated, and, still more, the greens, as they become bright, become finally wholly uncoloured. The reinforcement occurs, that is to say, not for colour in itself, but only by way of mixing in more white. (This is sufficient, doubtless, to account for the fact that in a very faint spectrum blue is not seen at all ; the spectrum looks simply red and green, and this in spite of the fact that the Purkinje phenomenon is usually considered to consist exactly in the brightening of this colour. The blue becomes, in fact, so much overlaid with the white constituent furnished by the rods that it is no longer visible as blue.) Again, this fading out into an achromatic sensation before becoming wholly extinguished—which is what the Purkinje effect really consists in, the change in brightness being an attendant phenomenon—does not occur in the fovea. If a spot of coloured light is so minute as to throw its image upon the fovea only, then, however faint it is, if it is seen at all, it is seen in its true colour, not first by means of its colourless constituent.

The argument in favour of a difference in function of rods and cones was thus already in the hands of Parinaud exceedingly strong. It happened, however, that it remained completely overlooked, and the several facts noticed by him were rediscovered by other observers— the fact that colours seen with the fovea lack the preliminary achromatic stage of rod-vision by König in 1894 ("Ueber den menschlichen Sehpurpur, etc.," *Sitzber. Akad. Wiss. Berlin*, 21 Juni, 1894 ; König did not, however, uphold the theory here in question—

may well exist further in than Koster detected them. The amount of change was very slight until a definite remoter region was reached, and here it suddenly became much greater ; this was, no doubt, about the place where the arrangement of one cone surrounded by a circle of rods is established.

he regarded the cones as catoptric instruments, viz. as condensers for throwing light upon the cells of the pigment epithelium, where he supposed all colour processes except that for blue to take place) ; the normal night-blindness of the fovea—that is, the fact that the extremely faint lights which the rod-adaptation exists for the sake of enabling us to see are wholly invisible in the fovea—and also the total *blindness* in the fovea of some of the congenitally totally colour-blind, a little earlier by Ladd-Franklin (ibid., 598, and *Proc. Amer. Psychol. Assoc.,* 1894) ; the absence in the fovea of any change in the relative brightness-values of different spectral lights, first made certain by v. Kries in 1900 by means of colour equations in which each member is made alike in colour, although different in light-ray constitution (*Zeitsch. f. Psychol.,* xxiii). This theory of the probable difference in function of the rods and cones had already been made (1892) the ground-work of the molecular dissociation colour-theory (or theory of the developed photochemical substances : *Zeitsch. f. Psychol.,* iv, 1892) ; it is so strongly suggested by the fact that night-animals—owls, rats, moles—have retinæ almost wholly deficient in cones, but containing rods which are exceedingly rich in the visual purple, that it would have been simply accepted ever since its first proposal by Max Schultze had it not been that it was wholly contradictory to the reigning Young-Helmholtz colour-theory. v. Kries, who is a warm defender of the theory (but in the form that the rods are altogether a " darkness-apparatus ", and that, although they outnumber the cones twenty to one, they are wholly functionless in an ordinary illumination), apparently holds now to the belief that there are two sorts of white—one physiological and brought about by a photochemical dissociation in the rods, the other psychical and due to a mental reconstitution of an even red-green-blue sensation into a sensation of indistinguishable quality from the first. From the laboratory of v. Kries have issued a number of important investigations which have

had for their object the establishment of the disjunction of function of the rods and the cones ; to refer to [this long-since well made out *fact*, however, as the *v. Kries duplicity theory* (as is still sometimes done) is to make use of a three-fold misnomer].

If the rods furnish colourless vision only, is it not possible that the vision of the totally colour-blind is vision solely by the rods ? If that were the case, these defectives should be *totally* blind in the fovea, where there are only cones. That was found to be the case in the first instance of the defect which was tested in this regard (*Sitzber. Akad. Wiss. Berlin*, 21 Juni, 1894, 593). A number of cases which have been examined since seem not to have had this defect, but the case of Uhthoff, which was first announced by him to be without it, has since been found, by more careful methods, to be actually an instance of total foveal blindness. But, meantime, there has been added to our knowledge of this subject the fact that a patient of Raehlmann's (*Zeitsch. f. Augenh.*, ii, 1899) had, with total colour-blindness, perfect visual acuity, which would not be possible without the functioning of the minute visual elements of the fovea. This case shows, doubtless, what was well known before from cases in which the defect is due to disease, that total colour-blindness may be caused by lesions or atavisms in the higher visual centres. At all events, the fact that there are well-marked instances of foveal blindness in conjunction with total colour-blindness is conclusive of the non-existence of normally functioning cones in those cases in which it occurs.

The luminosity-spectrum of individuals affected with either of the two forms of red-green blindness has been obtained with much exactness by Ferry by the method of flicker-photometry. He finds that the persistence of a colour-impression varies inversely with the luminosity, and is independent of the character of the colour. See Fig. 12.

NEWTON'S LAW OF COLOUR-MIXTURES

This law states that if there are two pairs of indistinguishable light-mixtures, the double mixtures formed by uniting them two and two will also be indistinguishable ; as a particular case, one pair of light-mixtures may be the same as the other pair, and hence the law covers the supposed constant equivalence of two

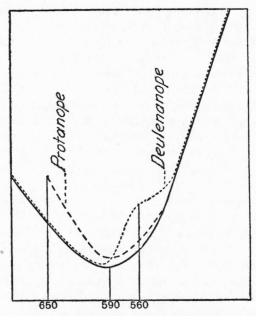

FIG. 12.—The persistence-values (the reciprocals of the brightness-values) of the normal eye, the " green "-blind . . . and the " red "-blind . . . (Ferry.)

like-appearing light-mixtures (whether coloured or colourless), under all variations of objective intensity of illumination. The case which is of especial interest on account of the bearing which it has had upon the theory of Hering is that in which a white (grey) is made, on the one hand, out of red and blue-green, and on the other out of blue and yellow, and the intensity of one or the other

combination is diminished until the two are equally
bright ; if, now, the illumination for both mixtures be
much reduced, do they continue to be of equal brightness ?
For an account of the history of this question see
Tschermak, " Ueber d. Bedeutung d. Lichtstärke u. d.
Zustandes des Sehorgans für farblose optische
Gleichungen," *Pflüger's Arch.*, 70, 297. The law in its
general form was tested experimentally and affirmed to
be correct by Maxwell and by Aubert by means of the
colour-wheel. v. Kries and Brauneck (1885) tested it by
spectral lights and again declared it to be valid. At the
same time Hering published the results of his own
investigation of the question, both by coloured papers
and by a colour-mixing apparatus, and declared the
" complete constancy " of colourless and of coloured
equations under changing illumination. The next year,
in his paper " Ueber Newton's Gesetz der Farben-
mischungen," he reaffirmed this result in the strongest
terms, and declared that any departure from Newton's
law would be wholly inconsistent with the nature of
things ; he maintained in particular that such equations
were not effected by the local condition of the retina,
by fatigue, nor, in fact, by anything that could affect the
temporary excitability of the eye. v. Kries also
announced, in two papers, of 1878 and 1882, that
equations of all kinds persisted, no matter what the
condition of the eye. Nevertheless, the law is now known
not to hold : two whites of different light-ray constitution
(red and blue-green as compared with yellow and blue)
differ greatly in relative brightness, according as they
are seen at a bright or a faint illumination (Ladd-Franklin,
Proc. Int. Cong. of Psychol., 1892 ; Ebbinghaus, *Zeitsch.
f. Psychol.*, 1893).

The phenomenon is readily explained as a result of the
growth of the visual purple, the connexion of which with
the supplementary vision of a faint light was affirmed by
me in 1892, and put beyond question by König in 1894 ;
this pigment is most effective for green light, and hence

that member of the equation which contains green as one element of the mixture shines out brilliantly when the illumination is very much reduced. The exhibition of this phenomenon is now a common laboratory experiment. This worked strongly against the Hering theory as held at that time, but Hering has now admitted the fact of the departures from Newton's law, and also of their being due to the regeneration of the visual purple.

<h2 style="text-align:center">THE AFTER-IMAGE</h2>

The phenomena of positive after-images (persistent retinal or nervous excitation) have been, of late years, very obscure, but the subject has been much cleared up by Munk. One thing that is plain is that the achromatic and the colour constituent of the image (whether positive or negative) run a different course, and even that the red-green and the blue-yellow portions of a mixed sensation do not alternate synchronously (Walther, *Pflüger's Arch.*, 1898). Another thing that is quite certain is that the Helmholtz explanation of the negative after-image is wholly inadequate. It was first shown by Maria Bokowa (*Zeitsch. f. rat. Med.*, 3, xvii, 161, 1863) that the wearing of coloured glasses, if side-lights are wholly shut off, will bring about temporary colour-blindness. Coloured objects, if gazed at with absolutely constant fixation, become colourless ; but they do more than that. There is one simple experiment, devised by Hering, which is alone enough to disprove at once the assumption of Helmholtz that the negative after-image is caused by a residual fraction of the self-light of the retina. If one stands in front of a window, in a bright light, and fixates for a while a patch of colour, say red, it is then only necessary to draw down a shade, or to go to a darker part of the room, to find that the patch, the eyes being still open and gazing at the red, has turned to a brilliant blue-green. This is quite incomprehensible on the view of Helmholtz ; he would have us believe that although the

eyes are open and gazing at red paper in light as intense as that of the ordinary room, nevertheless, the self-light of the retina pushes itself so to the fore as to counterbalance, even in its semi-reduced condition (fatigue for red), an excitation which should normally be red. That, if the eye should look at white, fatigue for red would cause it to see only green is conceivable ; but how can there be any sufficient cause for the production of green when the eye is looking at the most saturated attainable red ?— for red, on the Helmholtz theory itself (*Physiol. Optik*, 370), contains no admixture of white. That the self-light of the retina is wholly inadequate to the production of after-images has been shown in detail, with spectral lights, by Hess, but this simple experiment is sufficient to prove it to any unprejudiced observer. There are only two ways in which this intense green-vision during the looking at red can be accounted for : (1) to suppose that after excessive chemical action of one kind nature quickly goes to work to perform the opposite process in amount proper to restore the balance (the opposite process theory), or else (2) that a chemical substance having been partially dissociated by red light, the unstable residuum becomes in turn destroyed, in the interest of the restoration of the retina to a *tabula rasa* for the reception of fresh impressions (the molecular dissociation theory).

F

II

A NEW THEORY OF LIGHT-SENSATION

THE reasons which make it impossible for most people to accept either the Hering or the Young-Helmholtz theories of light sensation are familiar to every one. The following are the most important of them :—

The Young-Helmholtz theory requires us to believe : (*a*) something which is strongly contradicted by consciousness, viz. that the *sensation* white is nothing but an even mixture of red-green-blue *sensations* ; (*b*) something which has a strong antecedent improbability against it, viz. that under certain definite circumstances (e.g. for very ex-centric parts of the retina and for the totally colour-blind) all three colour-sensations are produced in exactly their original integrity, but yet that they are never produced in any other than that *even* mixture which gives us the sensation of white ; (*c*) something which is quantitatively quite impossible, viz. that after-images, which are frequently very brilliant, are due to nothing but what is left over in the self-light of the retina after part of it has been exhausted by fatigue, although anyone can see that the *whole* of the self-light is excessively faint.

The theory of Hering avoids all of these difficulties of the Young-Helmholtz theory, but at the cost of introducing others which are equally disagreeable ; it sins against the first principles of the physiologist by requiring us to think that the process of building up highly organized animal tissue is useful in giving us knowledge of the external world instead of supposing that it takes place (as in every other instance known to us) simply for the sake of its future useful tearing down ; it necessarily

66

brings with it a quite hopeless confusion between our ideas of the *brightness* and the *relative whiteness* of a given sensation (as is proved by the fact that it enables Hering to rediscover, under the name of the specific brightness of the different colours, a phenomenon which has long been perfectly well known as the Purkinje phenomenon) ; the theory is contradicted (at least the present conception of it) by the following (new) fact—the white made out of R and BG is *not the same thing* as the white made out of blue and yellow ; for if (being mixed on the colour-wheel) these two whites are made equally bright at an ordinary intensity, they will be found to be of very different brightness when the illumination is made very faint.

Nevertheless, the theory of Hering would have to be accepted, if it were the only possible way of escape from the difficulties of the Young-Helmholtz theory. But these difficulties may be met by a theory which has the following for its principal assumptions.

In its earliest stage of development, vision consisted of nothing but a sensation of grey (if we use the word grey to cover the whole series black-grey-white). This sensation of grey was brought about by the action upon the nerve-ends of a certain chemical substance, set free in the retina under the influence of light. In the course of development of the visual sense, the molecule to be chemically decomposed became so differentiated as to be capable of losing only a part of its exciting substance at once ; three chemical constituents of the exciter of the grey-sensation can therefore now be present separately (under the influence of three different parts of the spectrum respectively), and they severally cause the sensations of red, green, and blue. But when all three of these substances are present at once, they recombine to produce the exciter of the grey sensation, and thus it happens that the objective mixing of three colours, in proper proportions, gives a sensation of no *colour* at all, but only white.

This theory is found, upon working it out in detail,

to avoid the difficulties of the theories of Helmholtz and of Hering.

Its assumption of a separate chemical process for the production of the sensation of grey gives it the same great advantage over the Young-Helmholtz theory that is possessed by the theory of Hering ; it enables it, namely, to account for the remarkable fact that the sensation of grey exists unaccompanied by any sensation whatever of colour under the five following sets of circumstances— when the portion of the retina affected is very small, when it is very far from the fovea, when the illumination is very faint, when it is very intense, and when the retina is that of a person who is totally colour-blind. This advantage my theory attains by the perfectly natural and simple assumption of a *partial* decomposition of chemical molecules ; that of Hering requires us to suppose that sensations so closely related as red and green are the accompaniments of chemical processes so dissimilar as the building up and the tearing down of photo-chemical substances, and farther that two complementary colours call forth photo-chemical processes which destroy each other, instead of combining to produce the process which underlies the sensation of grey.

Of the first four of the above enumerated cases, the explanation will readily suggest itself ; in the case of the totally colour-blind it is simply that that differentiation of the primitive molecules by which they have become capable of losing only a part of their exciting substance at one time has not taken place ; the condition, in other words, is a condition of atavism. In partial colour-blindness, and in the intermediate zones of the retina in normal vision, the only colours perceived are yellow and blue. This would indicate that the substance which in its primitive condition excites the sensation of grey becomes in the first place differentiated into two substances, the exciters of yellow and blue respectively, and that at a later stage of development the exciter of the sensation of yellow becomes again separated into two substances which

produce respectively the sensations of red and of green. In this way the unitary (non-mixed) character of the sensation yellow is accounted for by a three-colour theory as completely as by a four-colour theory. A three-colour theory is rendered a necessity by the fact that it alone is reconcilable with the results of König's experiments for the determination of the colour-equations of colour-blind and of normal eyes,[1] experiments which far exceed in accuracy any which have yet been made in colour-vision, but which owing to the intricate character of the theoretical deductions made from them, have not hitherto been allowed their due weight in the estimation of colour theories.

The explanation which the theory of Hering gives of after-images and of simultaneous contrast are not explanations at all, but merely translations of the facts into the language of his theory. My theory is able to deal with them more satisfactorily ; when red light, say, has been acting upon the retina for some time, many of the photo-chemical molecules have lost that one of their constituents which is the exciter of the red sensation ; but in this mutilated condition they are exceedingly unstable, and their other two constituents (the exciters of the sensations of blue and of green) are gradually set free ; the effect of this is that, while the eyes are still open a blue-green sensation is added to the red sensation with the result of making it gradually fade out into white, and, if the eyes are closed, the cause of the blue-green sensation persists until all the molecules affected are totally decomposed. Thus the actual course of the sensation produced by looking at a red object—its gradual fading out, in case of careful fixation, and the appearance of the complementary colour if the illumination is diminished or if the eyes are closed—is exactly what the original assumption of a partial decomposition of molecules would require us to predict. The well-known

[1] A. König und C. Dieterici, *Sitzungberichte der Berl. Akad.*, 29 Juli, 1886.

extreme rapidity of the circulation in the retina would make it impossible that the partly decomposed molecules just referred to should remain within the boundaries of the portion of the retina in which they are first produced ; and their completed decomposition after they have passed beyond these boundaries is the cause of the complementary colour-sensation which we call simultaneous contrast.[1] The spreading of the actual colour which succeeds it would then be accounted for, as Helmholtz suggests, by a diffusion of the coloured light in the various media of the eye.

No effort has hitherto been made to explain a very remarkable feature in the structure of the retina— the fact that the retinal elements are of two different kinds, which we distinguish as rods and cones. But this structure becomes quite what one might expect, if we suppose that the rods contain the undeveloped molecules which give us the sensation of grey only, while the cones contain the colour molecules, which cause sensations of grey and of colour both. The distribution of the rods and cones corresponds exactly with the distribution of sensitiveness to just perceptible light and colour excitations as determined by the very careful experiments of Eugen Fick.[2]

Two other theories of light sensation have been proposed, besides the one which I have here outlined, either one of which meets the requirements of a possible theory far better than that of Hering or of Helmholtz ; they are those of Göller[3] and Donders.[4] The former is a physical theory. That of Donders is a chemical theory, and very similar to the one which I here propose. Every chemical theory supposes a tearing down of highly complex molecules ; Donders' theory supposes in addition

[1] But see p. 146 n.

[2] " Studien über Licht und Farbenempfindung," *Pflüger's Archiv.*, Bd. xliv, pp. 441, 1888.

[3] " Die Analyse der Lichtwellen durch das Auge," *Du Bois-Reymond's Archiv*, 1889.

[4] " Noch einmal die Farben-systeme," *Gräfe's Archiv. für Ophthalmologie*, Bd. 30 (1), 1884.

that the tearing down in question can take place in two successive stages. But Donders' theory is necessarily a four-colour theory ; and Donders himself, although the experiments of König above referred to had not at that time been made, was so strongly convinced of the necessity of a three-colour theory for the explanation of some of the facts of colour-vision that he supplemented his four-process theory in the retina with a three-process theory in the higher centres. The desirableness, therefore, of devising a partial decomposition of molecules *of such a nature* that the fundamental colour-processes assumed can be three in number instead of four is apparent.

But the theory of Donders is open to a still graver objection. The molecules assumed by him must, in order to be capable of four different semi-dissociations, consist of at least eight different atoms or groups of atoms. The red-green dissociations and the yellow-blue dissociations we may then represent symbolically by these two diagrams respectively :—

But it will be observed that the two completed dissociations end by having set free *different* combinations ; in the one case 1 is combined with 2 and in the other case 1 is combined with 8, etc. If, now, the partial dissociations are so unlike as to cause sensations of yellow and blue (or of red and green) it is not probable that completed dissociations which end in setting free *different* chemical combinations should produce the *same* sensation, grey. The difficulty introduced by Donders' theory is therefore (as in the case of Hering's theory) as great as the difficulty sought to be removed. It is the desire to secure the advantages of a partial dissociation theory, without the disadvantages of the theory of Donders that has led me to devise a partial dissociation of molecules of a different kind.

III

ON THEORIES OF LIGHT-SENSATION

THE two theories in regard to the sensation produced by light which have divided the attention of the scientific world for a long time are both thoroughly unsatisfactory. They have, in spite of this fact, together so completely gained possession of the field that time and effort are well spent in setting forth their weaknesses, and in endeavouring to make way for more reasonable conceptions.[1]

Let us consider for a moment what it is that a light-sensation theory has to do. Our knowledge of the nature of the external phenomenon, energy radiations, is highly developed. We are perfectly agreed as to the final sensation which the normal human being receives from a given wave-length, and from a given mixture of wave-lengths. We have, moreover, a good idea of the anatomical make-up of that very complicated structure in the back of the eye, the retina, which we know must be the

[1 While it is true that no inconsiderable number of theories have been proposed in later days, it remains a fact that every one of them falls into either the Helmholtz class or the Hering class : either (1) they accept *three* fundamental sensation-constituents, utterly ignoring the sensations yellow and white—all the physicists do this ; or else (2) while accepting *five* light sensations (both theories accept in addition the existence of black—the non-light sensation) they utterly ignore the splendid work of König which demonstrates the fact that vision is started up by *three* initial photo-chemical processes. As I have frequent occasion to point out, Hering refutes Helmholtz and Helmholtz refutes Hering. When, therefore, in the discussion that follows, the terms " Helmholtz theory " and " Hering theory " occur, it will be understood that what is said about them applies exactly to *all* the theories of the two classes of which Helmholtz and Hering were the original exponents. It will be found that there is one theory only in which any attempt has been made to take account at once of *both* the sets of facts that support respectively these two classes of theories.]

efficient agent in the transformation of light-waves into something capable of being conveyed along the optic nerve and of affecting consciousness as a sensation of light. But as to what it is that takes place in the intervening moment, we are absolutely in the dark. The function of a light-sensation theory is to make use of the scientific imagination to devise some sort of a process in the retina which shall constitute a reasonable connecting link between these two classes of phenomena—a process, namely, such that it shall plausibly and naturally *result from* the known properties of light, and shall have as its natural and simple *consequences* the known phenomena of light-sensation. As to the actual nature of that process it cannot be too much insisted upon that we have no immediate hope of gaining knowledge. In other words, the requirements which a light-sensation theory must meet are still largely of a logical nature, and the proper word for its designation is not theory, but hypothesis. The satisfaction which we should feel in a good hypothesis would be a satisfaction, not of the knowledge-loving, but of the logic-loving part of our emotional nature.

The retinal process which we feel ourselves called upon to feign may be of an electrical nature (we know that, when light falls upon the retina, electrical currents are produced), and it may be of a mechanical nature (Helmholtz' theory originally spoke of vibrations produced in the nerve-ends) ; a rather good theory by Göller makes use of our knowledge of circularly polarized light ; and it may equally well be that the process concerned is of such a kind that it has no counterpart elsewhere in nature, and that we shall never be in a position to comprehend it. But at the present time the assumption of some sort of photo-chemical process as a basis seems to furnish the most satisfactory results, and it is upon this assumption that the theories of both Helmholtz and Hering are now built up.

What, then, are the respective claims of the theories of Helmholtz and of Hering towards furnishing a logically

satisfactory connecting-link between ether-waves and light-sensation ? Let us refresh our minds, for a moment, as to the nature of a logically satisfactory theory by considering the theory of the sensation of sound. Here we have, externally, wave-motion, as in the case of light, except that it is wave-motion in a coarser medium and of much slower period. In the ear, we find a structure which is a very good reproduction of a musical instrument.

For this theory we owe a debt of profound gratitude to the incomparable Helmholtz. But has Helmholtz, following Young, been equally happy in his light-sensation theory ? Externally we have a very similar state of things to that which exists in the region of sound, namely, a simple series of vibration-periods. But if we question consciousness, we find something very different in the sensation-scale. For every vibration-period (within a certain degree of fineness of measurement) there is, as in musical sound, a distinct sensation ; but the converse is not true—it is not true that given the sensation one can predict the vibration-period ; on the contrary, the colour-tone produced by a given vibration-period can, in general, be exactly matched by a large number of pairs of vibration-periods, one more and one less rapid than the one which produces the required result. Moreover, there is a whole series of intermediate sensations between red and blue—the purples—which are produced by no *single* wave-length whatever. The fact that the purples *must* be mixtures led naturally to the hypothesis that other colour-tones (when they are plainly dual colour-blends—the blue-greens, etc.) might also be mixtures, and to the assumption of a least sufficient number (three or four) of fundamental sensations, and fundamental retinal processes, out of whose mixtures the whole continuum of colour-sensation might be produced. The colours which are, by Helmholtz, assumed as fundamental, are the colours corresponding to the wave-lengths λ 470, λ 505, and a slightly more bluish red than the extreme red of the spectrum. (By chance Helmholtz and Hering are in

close accord in respect to the fundamental red and blue.) So far as this character of sensation is concerned, the theory of Helmholtz is fully adequate to its explanation, and if our light-sensations had now been fully described, the theory would be beyond reproach. But that is not the case. Besides all the colour-sensations, including the purples, we have a whole series of sensations which we call colour-*less*, or white. How does the Helmholtz theory account for the sensation of white ? Helmholtz, as is well known, has been successful in explaining many of the deliverances of our consciousness to be of the nature of an *illusion of the judgment*. We think we " see " an object which we are not looking directly at to be near, and another to be far, when in reality the *sensation* is merely one of distance apart of double images ; but this sensation has been wholly merged into a sign for calling up in memory an idea of how far we should have to move the arms or the legs to reach that object. Again, we say that a given object feels wet; but an attentive analysis shows us that a feeling of wetness is, in reality, a fusion of feelings of smoothness, softness, and cold, and that its illusory unitary character is due to the fact that these three sensations always occur together when we have otherwise knowledge that water had been poured upon the object. In other words, several sensations which are in reality distinct are, to the inattentive observer, fused into a supposed sensation of wateriness, upon the general principle that our sensations are of interest to us merely as signs of external facts, and that a group of well-known sensations may easily seem to be a new single sensation when it has a single and constant cause, or when there is any other reason for the sensation-groups always occurring in conjunction. It is upon this principle that Helmholtz explains the sensations of white. There is no such sensation, he says : but, just as when red and yellow are present in certain proportion, we may call the sensation by a new name, terra cotta, so when red, blue, and green are present in equal amounts—that is, when a given

object looks just as red as it looks blue, and just as green as it looks red—then we suddenly jump to the conclusion that we have no coloured object at all before us, but a colour-*less* or white object. In reply to this hypothesis, it must be said, in the first place, that however accustomed we may be to calling a certain object terra cotta, we can never lose the consciousness that the colour in question resembles red and resembles yellow in a sense in which it does not resemble green, for instance ; but that the distinguishing characteristic of the sensation white is that the most attentive observation fails to enable us to detect in it the slightest trace of a resemblance to any colour whatever. In the second place, there is not another single quality that all white objects have in common, nor is there a common cause to which their whiteness may be attributed ; and hence it is impossible to assign any *ground* for the extraordinary illusion by which an even red-green-blue sensation seems to us to have wholly lost its redness, greenness, and blueness, and to have acquired a sensation-quality of a totally different kind. If white objects had a common smell, or a common temperature, it might be possible that we should always fuse three distinct sensations into one on their behalf, but that is not the case. What Helmholtz asks us to believe about colour would be paralleled in the region of taste, if it were the case that in every mixture two and two of pepper, vinegar, and oil, we could plainly taste the elements of the combination, but that when even mixtures of the *three* substances were offered us, the taste of all three constituents should suddenly vanish, and be replaced by a taste of totally different kind—say, by the taste of mustard. [And it is not Helmholtz only who has committed this error in thinking ; all the physicists (with hardly any exceptions) are still in the same boat.]

I maintain that so utterly groundless an hypothesis as this would never have obtained a moment's credence, had it not been that at the time it was proposed the science of the *psychology* of the organs of sense had hardly

an existence. From the fact that the *physical cause* of the sensation of white was nothing but the coincidence of the *physical causes* of the sensations red, green, and blue, nothing seemed easier than the leap to the conclusion that the *sensation* white was the *coincidence* of the *sensations* red, green, and blue. But this method of deliberately ignoring the deliverances of consciousness has fallen much out of fashion, and it has recently met with a particularly crushing blow ; there is a recent incident in the history of science which is of extreme importance for the psychologist, but which has not been sufficiently dwelt upon by him. The common man always stoutly maintained that heat and cold felt to him like two different sensation-qualities, incomparable with each other, and not (like heat by itself or cold by itself) like different intensities of one and the same sensation. But the physicist showed him the evenly rising and falling column of mercury in the thermometer, and kindly explained to him that his poor consciousness was thickly overlaid with judgment-illusions, and with that the common man had to be content. But in the progress of our knowledge it was discovered that there is a certain degree of energy of ether-vibrations above which the resulting sensations are conveyed by *one set of nerves* and below which they are conveyed by *another set of nerves*. There is, therefore, no reason for doubting that the physiological processes, and all the more the conscious sensations, of heat and cold are, in reality, distinct. This is a piece of science-history from which the physicist, if he is wise, will learn a much-needed lesson of humility.

But all these theoretical considerations, strong as they are and important as they are for the perfecting of our methods, are not essential to the discrediting of the Helmholtz theory. That theory is already rendered sufficiently improbable by its totally inadequate method of accounting for an important series of facts. On the margin of the retina of every human being, and throughout the retina of the totally colour-blind, there is no sensitive-

ness to colour whatever, but perfect sensitiveness to differences of brightness of the sensation-quale, white. Moreover, when the illumination is very faint, the normal eye sees even in the fovea no colour, but only different intensities of grey, and the distribution of brightness along the spectrum is exactly the same for the normal eye under these conditions as for the eye of the colour-blind. There is every reason to suppose that these cases of vision without colour are in the nature of defects—that the eye is in a less highly developed condition than usual. What explanation of these phenomena is offered by the followers of Helmholtz ? They ask us to believe that in these abnormal cases the three distinct *photo-chemical processes* exist in their original integrity, only that they have been so altered as regards their receptivity to the influence of light that every vibration of ether (throughout the visible spectrum) no matter what its period, excites them all in the same degree ; that whereas these three powers existed in the first instance merely for the sake of enabling us to distinguish between different parts of the spectrum, they are here, for no conceivable purpose, so altered that every part of the spectrum affects them all three exactly alike. They ask us to believe that all three fundamental sensations also exist in their original integrity, and that, while we can no longer see red, green, and blue separately, we can still see them in the mixture which we take to be white, with exactly the same perfection as before. Fick, to whom is usually attributed this so-called explanation of non-colour vision,[1] himself admits that so improbable a conception would not have been hit upon, if a theory

[1 Fick's explanation was, in reality, first suggested by Helmholtz, although Helmholtz himself seems to have forgotten the fact. The passage in question occurs in the Nachträge to the first edition of the *Physiological Optics*, p. 848 : " Man könnte denken . . . dass die Gestalt der Intensitätscurven, Fig. 119, für die drei Arten lichtempfindlicher Elemente sich änderte, wobei dann eine viel grössere Veränderlichkeit in dem Verhalten der objectiven Farben gegen das Auge eintreten könnte." This goes to confirm the remark which a certain German writer on these subjects says his efforts to gain attention are always met with : " Es steht schon alles in Helmholtz."]

were now for the first time to be made up ; and it must
be remembered that, at the time it was broached, the
facts were far less well known than they are now. No
cases of monocular colour-blindness, either partial or
total, had then been discovered ; and such cases are of
most critical importance for any theory. The original
supposition of the Helmholtzians was that one or the
other of the three sorts of fibres was either wanting or
paralysed [1] ; this had, in fact, already been suggested
by Thomas Young. A person who is green-blind ought,
upon this supposition, to see in white only its red and blue
constituents, and hence white ought to look to him as
purple looks to us. As long as his defect made him
incapable of explaining to us what he felt, this might
perfectly well, for aught we knew, have been the case.
But we know now that a person who is green-blind in
one eye only sees white with his defective eye exactly
the same as he sees it with his normal eye ; hence this
explanation can only be retained with the aid of an
excessively strong draft upon the illusion of judgment
doctrine. Nevertheless, Helmholtz himself seems not to
have given it up (*Physiol. Optik.*, pp. 373, 374, 2nd
edition). How it can possibly be made to work for total
colour-blindness, I am at a loss to understand. When
all three fibres are paralysed (or, as Helmholtz would say
now, when all three photo-chemical processes are in
abeyance), what remains out of which to make the red-
blue-green sensation mixture which we call white ? It
is true that total colour-blindness is rare, but it is of
critical significance, and cases of it have been thoroughly
examined both by König and by Hering. It is a singular
fact that Helmholtz, in the second edition of his book,
gives the briefest possible mention of total colour-blind-
ness (p. 367), and does not mention (so far as I can find)
monocular total colour-blindness at all.

[1] " It is much more simple to suppose the absence or paralysis of
those fibres of the retina which are calculated to perceive red." Quoted
by Helmholtz, *Physiol. Optik.*, p. 365, 2nd edition.

The indispensableness, for anyone who thinks upon this subject, of a theory which shall make provision for white as a distinct sensation, has caused the theory proposed by Professor Hering to have many adherents ; and his theory is, in fact, far more adequate to the requirements of the case than is the theory of Helmholtz. But at what a cost does he provide us with a separate process for white ! In order to accomplish it, he has attached to chemical processes, which, indeed, are well known to exist, functions which are absolutely without parallel in the physiological economy. Everywhere else the purposes of life—action, feeling, thought—are subserved by the tearing down of complex chemical structures, and these are afterwards built up by internal forces for the sake of their future useful destruction. But Hering would have us believe that, of the two halves of the spectrum, one acts constructively upon photo-chemical substance, and the other destructively, and that both actions are alike effective in giving us sensations of colour—that processes so widely dissimilar in their nature as assimilation and dissimilation are not only both the basis of sensations, but of sensations so like in quality as are two adjacent colours of the spectrum. And this is not the only fatal objection to the theory of Hering. Hopeless confusion is introduced into all our conceptions of colour when we are asked to believe that the entire brightness of every sensation of light is nothing but the brightness due to the white sensation which is mixed with it. This difficulty is not obviated by Hering's later view that colours of one end of the spectrum contribute something to the brightness, and those of the other take away something from it ; for there remain intermediate wave-lengths to which the objection applies in its original force. Can they be thinking beings who have allowed themselves to follow Hering into the intellectual vagary of supposing that a perfectly saturated red, for instance—that is, a red wholly free from white admixture—no matter what the amount of chemical activity which called it forth, would have no

brightness whatever, that there would be *nothing* in sensation corresponding to differences in amount of this photo-chemical process ?

As Professor Leber has well said, what people have found attractive in the theory of Hering is the fact that it assigns an independent existence to the sensation of white and *not* the character of the physiological processes by which the theory is carried out. Not only are those processes theoretically improbable, but there are also other reasons for not believing in them. Experiments by one of the older physiologists, Béclard, are at hand, which show that the effect of light of all colours upon the retina is to increase the amount of carbonic acid given off, and hence to increase the amount of assimilation which takes place. Whether these experiments have been repeated by later investigators or not I have not been able to find out. But it is certain that the forward motion of pigment-matter among the end-members of the rods and cones under the influence of light [1]—a motion which, without any doubt, takes place for protective purposes—becomes gradually more marked for the successive colours from red to blue ; that there is no indication of a departure, that is to say, from the steadily injurious effect of all portions of the spectrum. Again, strong light of every colour is painful ; but is it conceivable that active recuperation of a sensitive substance should be equally disagreeable to us with its rapid exhaustion ? None of these facts would be conclusive, perhaps, if it stood alone, but they are of such uniform nature that together they are not without weight.

A circumstance which has impressed people favourably

[1] See the plates at the end of Angelucci's *Unters. ü. die Sehthätigkeit der Netzhaut u. des Gehirns*, Giessen, 1890. The heliotropic effects recently investigated by Loeb are of the same nature ; " die stärker brechbaren Strahlen des uns sichtbaren Sonnenspectrum die heliotropisch wirksameren sind, wie bei Pflanzen " (" Künst. Umwandlung der heliotrop. Thiere, etc.," *Pflüger's Archiv*, Bd. xliv, p. 107). There is no trace here of opposing effects of different colours ; as always, the difference is merely a difference of degree.

with the theory of Hering is the belief that it furnishes an explanation of certain very important phenomena—those of contrast and of after-images. These phenomena the theory of Helmholtz can account for only by the aid of the much-overworked illusions of judgment, which Hering has shown by a large number of most ingenious experiments to be in this instance quite inadequate to doing what is demanded of them. But has Hering *explained* the phenomena of contrast, for instance ? We must pause for a moment to consider what an explanation is. It is frequently loosely said that a certain theory furnishes an explanation of a certain phenomenon, when what is meant is merely that it is possible to *express* the phenomenon in the terms of the theory, or, in other words, that the phenomenon admits of being translated into the language of the theory. But it is a simple principle, which needs only to be stated to be accepted, that it is only in case the process which, in the theory, corresponds to the phenomenon is a *necessary*, or, at least, a *probable*, consequence of the other assumptions of the theory, that the explanation is of a kind by which the theory is at all confirmed. For example, the belief that the phenomena of simultaneous contrast have been *explained* by the theory of Hering, and that this furnishes a strong confirmation of this theory, is wholly erroneous. Hering has shown, indeed, that contrast is not sufficiently accounted for as an illusion of the judgment, and that it must correspond to *some* physiological process in the visual substance. Since now the processes that underlie vision, in his theory, are assimilation and dissimilation, the physiological process which produces the contrast-effect must necessarily, in any instance, be dissimilation or assimilation. as the case may be. So far, this is the simple *translation* of the phenomenon. We have now to ask ourselves, what is the degree of probability of this process taking place under the given circumstances ? After a little patch of retina has been undergoing assimilation or dissimilation under the influence of coloured light, what

renders it probable that surrounding portions of the retina should immediately be excited to the performance of the antagonistic process ? There is a slight difference between the two cases. When a given portion of the retina is undergoing rapid dissimilation, we have a vague feeling, perhaps, that it may seem a little natural that in the surrounding portions more than the usual amount of building up should be going on (and this is the instance of his explanation which Hering usually advances). But how is it in the other case ? If a given portion of the retina is undergoing a rapid assimilation, does that seem to be a sufficient reason why, all around it, a *tearing down* of the visual substance should immediately begin to take place ? The improbability of the process in this case far more than counterbalances its slight probability in the other, and hence we ought to say that the phenomena of contrast admit of being *translated* into the language of the Hering theory, but *not* that they do anything whatever to strengthen that theory, nor that they have been, in the proper sense of the word, explained by it.

But in spite of the difficulties of the theory of Hering, it would, perhaps, be necessary to continue to make use of it as a temporary means of holding together a large and complicated body of facts, provided it were impossible to form any other conception of a separate white-process, consistent with the fact that when certain pairs of colour-sensations act together, all sensation of colour vanishes.

1. In the earliest stage of its development, the visual sense consisted only in the sensation of grey (if we agree to include in the word *grey* the whole black-grey-white series of sensations). This sensation of grey was brought about by the action upon the retinal nerve-ends of a chemical substance set free by means of the dissociation of a certain kind of molecule, which we shall call, for the sake of brevity, the grey-molecule. This molecule is composed of an outer range of atoms, somewhat loosely · attached to a firmer inner core or nucleus, and having various different periods of vibration. The dissociation

of this molecule consists in the tearing off of the outer portion, which then becomes the exciter of the nerve-ends, and the immediate cause [when this excitation reaches the calcarine fissure of the cortex] of the sensation of grey. This tearing off is brought about by the ether-vibrations of the entire visible part of the spectrum, but in the greatest amount by the vibrations somewhat near its middle part, corresponding to the fact that to the totally colour-blind (and to all eyes when the illumination is faint) the green is the brightest part of the spectrum ; the number of molecules decomposed in a given time by the different vibration-periods is naturally assumed to be proportional to the corresponding ordinates in the curve which shows the brightness-distribution in the spectrum of the totally colour-blind.

2. In the course of the development of the colour-sense, some of the grey molecules become differentiated into colour-molecules, and in the following way : The atoms of the outer range segregate themselves into three different groups having three different average velocities. Then the adaptation between the present structure of the retina (as regards colour) and the constitution of physical light consists in the fact that the mean vibration-periods of the electrons of each group are synchronous with certain vibration-periods of light—namely, the vibration-periods of the three fundamental colour-tones. Hence when light of a fundamental colour-tone, say green, falls upon the retina, it will have the effect of tearing off from a large number of molecules those atom-groups whose periodicity is such as to render them peculiarly exposed to its shocks, and hence that special chemical substance will be set free which is the exciter of the sensation of green.

3. When the wave-length of the light which falls upon the retina is anywhere between the wave-lengths of two fundamental colour-tones—blue and green, for instance—then a certain number of molecules lose their blue constituents, and a certain number of molecules

lose their green constituents, and the resulting sensation
is that of a mixture of blue and green. But this effect is
exactly the same as that which is produced when the
retina is acted upon by a mixture of pure blue light and
pure green light ; hence we are incapable of distinguishing
in sensation between a single intermediate wave-length
and a mixture in proper amounts of two fundamental
wave-lengths.

4. There will be certain mixtures of objective light,
however, which will have the property of setting free
all three kinds of nerve-exciting substance in equal
amounts. But these three substances *are* the chemical
constituents of the exciter of the grey sensation : hence
when they are present in the right amount they recombine
to form that substance, and the sensation produced is
exactly the same as that caused by the complete dis-
sociation of the grey molecules [namely the sensation of
white].[1]

5. [These are the essential facts of colour vision.
What v. Kries has, very happily, called the " subsidiary "
facts are also perfectly well interpreted by this theory.]
In all of the five cases in which we are incapable of
receiving any sensation but that of grey, it is the grey-
molecule which, for one reason or another, is alone
decomposed. In the very eccentric part of the retina, the
differentiation of the colour-molecule out of the grey-
molecule has not taken place ; these parts of the retina
are chiefly useful to us in warning us of danger from in-
coming objects, and for this the power to detect
differences of brightness in a white sensation is sufficient.
In the case of the congenitally totally colour-blind, the
retina is in an atavistic condition—here, also, the grey

[1 A beautiful analogy has lately been found for the assumptions
here made for the purpose of accounting for the facts of colour vision.
There is a certain dye stuff (no longer much used because it is
" dissociated " too rapidly)—a carboxylate rosaniline—whose three
different cleavage radicles form exactly the combinations required to
parallel the case of the colours red and green (which make yellow) and
yellow and blue (which make white).]

molecules are the only ones which exist. When the portion
of the retina affected is very small, or when the illumination
is very weak, we may suppose that the colour-molecules
are not decomposed in sufficient quantities for their
specific character to be detected. When the illumination
is very intense, it may be that the colour-molecules have
become exhausted sooner than the grey-molecules, or
that a strong energy of radiation affects all of the colour-
constituents in equal degree without reference to their
periodicity. The important thing in all these cases
is the *capacity for independent existence of the substance
which excites the sensation of white.*

6. The explanations which I have just given of the
colourlessness of very bright or very faint sensations are
merely translations into the language of the theory, and
add nothing to its strength. But the case is very different
with the explanation which this theory is able to give of
after-images and of simultaneous contrast. When red
light, say, has fallen for some time upon the retina, a
large number of molecules have lost their red-
constituents—they have become partly mutilated
molecules. But in this condition they are extremely
unstable ; they gradually go to pieces completely, and
the setting free of their remaining constituents, the blue
and the green producing parts of the molecules, causes
a sensation of blue-green. The red sensation, therefore,
in cases of careful fixation, becomes paler and paler ;
if the objective illumination is weakened, it may even be
overpowered by the blue-green sensation [1] ; and if the

[1] This occurs in the following interesting experiment. Put bits of
bright coloured paper in a box held vertically in the hand, in such
a way that a strong light falls upon them. After a few moments' fixation
turn around ; the papers will now be shadowed by the walls of the box,
and the difference in illumination is enough to cause them to be spread
over with a bright layer of the complementary colour. That is, the after-
image of the first bright impression is strong enough to blot out com-
pletely each actual paper, although it is still looked at with open eyes,
and in a not faint illumination. [By choosing a proper brightness of
the papers and duration of the fixation, each may be made to look

eyes are closed or directed upon a darker grey surface, the blue-green sensation alone remains, after a few seconds, and continues until the injured molecules have all become completely destroyed. Since, as is well known, the circulation in the retina is extremely rapid, the half-mutilated molecules are, in large numbers, dragged across the border of the original image, and there their complete destruction causes the phenomenon of simultaneous contrast.[1]

These are the explanations which this theory offers of what may be called the critical points of colour-vision. It also furnishes an explanation of the following phenomena, which have not hitherto been explained.

A. The retina contains elements of two sorts, which present a very different appearance—the rods and the cones. It has not hitherto been possible to attribute different functions to these elements ; the difficulty of doing this comes from the fact that the cones must be *sufficient* for vision, since they alone occur in the spot where vision is the most acute, while the rods must play *some* important *rôle*, because they resemble the cones very much in structure, and in the periphery the cones are almost wholly wanting. But if we assume that the cones contain colour-molecules, and hence give us sensations both of colour and of grey, but that the rods contain only the undeveloped white-molecules, and hence give white sensations only, the distribution of rods and cones in the retina becomes perfectly comprehensible. Very interesting experiments of Eugen Fick [2] permit us to lay down the following relation between retinal structure and light-sensation for just perceptible excitations :—

entirely white.] To attribute this to a residuum in the self-light in the retina, as Helmholtz does, is to be utterly oblivious to the relations which ought to hold between the magnitudes of cause and of effect.

[1] [An alternative explanation of simultaneous contrast by Fröhlich, in which it is shown to be merely a form of the after-image, is doubtless better than the one which is given here.]

[2] *Plüger's Archiv.*, Bd. xliv, 1888.

I	II	III
In the fovea, only cones; maximal colour-sense and non-maximal " grey sense ".	In the next following zones of the retina, a gradually increasing number of rods and diminishing number of cones ; an increasing sensitiveness to grey light, and a diminishing sensitiveness to colour.	In the remote retinal zones, almost exclusively rods, and almost no colour-sense.

A better case of the application of Mill's concomitant variations it would be difficult to find. The retina of a totally colour-blind person has never yet been examined. If it should turn out that it contained rods only and no cones, that would be a very pretty confirmation of this supposition ; but if not, one might still suppose that the cones in this case contained only grey molecules, and that the atavism consisted in the non-development of molecules and not of retinal elements. It remains to be mentioned that if this distribution of functions of retinal elements is a correct one, then the structure of the eye offers in this respect a perfect analogy with that of the organ of hearing ; in the ear also we have apparently a very simple apparatus for conveying sensations of noise only, persisting by the side of a more highly developed apparatus adapted to the discrimination of different vibration-periods of the affecting medium.

B. That green is less saturated than the other two fundamental colours is again a necessary consequence of the fact that in this part of the spectrum the amount of grey process reaches its maximum, as is proved by the brightness-curve of the colour-blind and that of the normal eye when the illumination is very faint.

C. But there is also an explanation of a third phenomenon—of the fact, namely, that the sensitiveness of the eye to change of colour per change of wave-length is much greater in the yellow and the blue-green than in any other part of the spectrum ; it is at these points that the three distribution curves intersect.

To resume : the principal points of difference between the theory of light-sensation here proposed and the now commonly accepted theories are the following : While the Young-Helmholtz theory supposes that the judgment picks out all the even red-green-blue *sensations*, and deceives itself into thinking them to be a new sensation, white, this theory assumes *an independent retinal process* as ground for the sensation of white—a process which, in early stages of development, existed by itself, but which is of such a nature that the three colour-processes, when they do arise, flow together, and by a simple chemical reaction reproduce the *process* which corresponds to white. After-images and simultaneous contrast, instead of being an affair of the judgment, are due to the gradual complete destruction of molecules whose capacity to exist for a time in a partially decomposed state has made it possible for us to distinguish between the different parts of the visible spectrum.[1] The theory differs from that of Hering, in that it assumes processes which are physiologically conceivable, and allows us to conceive of brightness as the amount, per unit of time, of the physiological process—colour-process and white-process being combined in our estimation of the total amount. Moreover, it assumes that two complementary colour-processes unite to produce a certain amount of white-process, and not that they destroy each other, and merely leave behind a white-process which, although it is impossible to detect it, was present all the time.

This last assumption of Hering's would seem, indeed, to be distinctly contradicted by the following fact, which is new. If two different greys are composed upon the colour-wheel, one of blue and yellow, and one of red and green, and if they are then made of exactly equal brightness by adding black to that one of them which happens to be brighter, the two greys ought to be under all circumstances indistinguishable, if it be true that the

[1] [The alternative explanation by Fröhlich of contrast is now to be preferred. *Ztsch. of Psychol.*, 1921, p. 89.]

colour-processes have simply destroyed each other. But they are not indistinguishable. If the objective illumination is made very faint it will appear that the grey composed of red and *green* has become *very much* brighter than that composed of blue and yellow It is necessary, under certain circumstances, to add a white sector of 25 degrees to the grey composed of blue and yellow, in order to restore the equality in brightness. I was led to the conclusion that this should be the case (after having been long in search of some difference between two differently constituted whites) by a comparison of Professor König's elaborate measurements of the Purkinje phenomenon in the Helmholtz *Festschrift* (Hamburg and Leipzig, 1891) ; upon trying the experiment in his laboratory I found that my prediction was verified. The fact is quite incompatible with Hering's theory, as Hering at present conceives it.

The nature of most of these considerations is not such that their significance can be perceived without close study, and hence it is not surprising that proper weight has not hitherto been attributed to them. On the other hand, the dictum of consciousness as regards the non-mixed character of yellow is something which no one can fail to see the moment he looks at it. It is the great merit of Hering to have insisted upon this. It is, as we have seen, readily explicable in the light of the development of the colour sense ; it is therefore possible to take account of the independent character of yellow *without giving up* the conception (made absolutely indispensable by König) of an initial three-receptor process. By means of this theory we are also able to take account of the observations of Hess, which show that the blue sense and the yellow sense are developed together at a definite distance from the fovea, and that the red sense and the green sense are added to them at another definite and smaller distance from the fovea.[1]

[1] For a reply to the criticism of Ferree and Rand on this work of Hess, see p. 272, and also Engelking and Eckstein, *Kln. Mbl. f. Augenhk.*, 1921.

All theories of light-sensation (with slight exception) suppose the dissociation of chemical molecules. My theory shares with that of Donders the characteristic that it makes use of the conception of a possible *partial* dissociation of molecules. It was while I was engaged, a year ago, in writing an article to show that the theory of Donders was incomparably more efficient in furnishing a reasonable connecting link between external fact and internal sensation than either that of Helmholtz or of Hering, that it suddenly occurred to me that the required task could be accomplished in a yet better way. As the theory of Donders has met with no attention, and as I hope that my own will chance upon a better fate, I do not stop here to point out the differences between them ; I am content, in the first instance, if either should awaken interest. I have, however, pointed out (see pp. 70–1) a fundamental difficulty in his theory (*Proceedings of the Congress of Experimental Psychology*, London, 1892, p. 107). The theory, moreover, is necessarily a four-colour theory, and he was himself so strongly convinced of the necessity of a three-colour theory for the explanation of some of the facts of colour-vision (although the experiments of König above referred to had not at that time been made) that he supplemented his four-process theory in the retina by a three-process theory in the higher centres—just the opposite of the order which should be taken. The awkwardness of this supposition doubtless did much to prevent his theory from arousing attention. The explanation of selective dissociation by light as a result of synchronism in vibration-periods is not possible to his theory. To Donders, however, is due the credit of having first insisted upon it that the colour-sense is a later addition to an earlier existing light-sense.

IV

NORMAL NIGHT-BLINDNESS OF THE FOVEA

Disproof of the König Theory of Colour [1]

WHEN the fact that the retina contains a substance which is chemically acted upon by light was first announced, it seemed that the secret of the transformation of energy of radiation into something capable of being transmitted along the nerve fibres and affecting the conscious organism as the sensation of light had been definitely, at least in its rough stages, unravelled. But immediately difficulties appeared : the substance could not be detected in the cones, and it was therefore apparently wanting in the fovea, the spot of most acute vision ; and, moreover, certain classes of animals had retinae which contained none of the substance. It was therefore certain that the visual purple was not essential to vision, and the intense interest which it had at first aroused fell wholly into abeyance.

Professor Ebbinghaus has recently returned to the subject and has proposed to account for the apparent colourlessness of the cones by assuming in them a second substance of such a colour as always to mask the presence of the visual purple. The visual purple (or visual blue, as it must be considered for this purpose, although its real colour is only a very slightly bluish red) and its product, the visual yellow, are the source of the sensations of yellow and blue respectively ; the imaginary substance is, in

[1 In this paper (1895) I gave a detailed account of the circumstances attending my discovery of the " normal night-blindness of the fovea ". This was by way of claiming priority for a discovery for which König was, by this time, not giving me sufficient credit—in fact, none at all. v. Kries even now attributes this discovery to " König *und seine Genossen* ", 1927.]

its two stages, the source of the sensations red and green, and is for that purpose first green and then red in colour. Now a green and a purple substance, when present together, might, it is true, produce a colourless mixture, since purple and green are complementary colours ; but a moment later these two substances have become respectively yellow and red. What becomes of the complementariness then ?—or when one is green and the other yellow ?—or when one is red and the other purple ? Or must we suppose that, although thousands of eyes have been examined, first and last, after every possible degree of exposure to light, and to colour, still chance has brought it about that no stage of this series of processes has ever been lighted upon except the first ? So short-sighted a theory as this—one in which we must so carefully refrain from going beyond the first step of the imagined process—has probably never before been seriously proposed for acceptance.

But the suggestion of Professor Ebbinghaus has had this good effect, that it has induced Professor König to undertake an accurate determination of the relative absorption of the visual purple for different kinds of homogeneous light.[1] He proposed the question as a subject of investigation to Dr. Abelsdorff and Frl. Köttgen. A spectro-photometer especially designed for the purpose was constructed, and it was hoped that the skill and experience gained in the study of the visual purple of the frog they might, in course of time, be able to apply to a human retina, if good luck should throw one in their way. But, as it happened, the apparatus was no sooner set up in one of the dark rooms of the laboratory than they received word that a human retina was to be at their disposal ; and Dr. Abelsdorff being suddenly called away, the study of it was carried out by

[1] " Ueber den menschlichen Sehpurpur und seine Bedeutung für das Sehen. Nach gemeinschaftlich mit Frl. Else Köttgen ausgeführten Versuchen." *Sitzungsber. d. Akad. d. Wissensch. zu Berlin*, 21 Juni, 1894.

Professor König and Frl. Köttgen. The patient to whom the eye belonged remained in absolute darkness for twenty hours before the operation. The eye was extracted by the light of a sodium flame, put at once into an intensely black box, and rapidly conveyed to Professor König's laboratory. Here it was opened, twenty minutes after leaving the living body, with all the necessary precautions, by an oculist who had already made himself familiar, by means of the ophthalmoscope, with the exact position of the melano-sarcoma which had caused the eye to be extracted. The entire retina, with the exception of the diseased portion, was put into a solution of gallic acid, and after filtration a sufficient amount of the extract was obtained to fill twice the minute absorption-box of the spectrophotometer. With the first filling the absorption of the visual purple was obtained and compared with the absorption of the (not absolutely clear) solution which remained after the purple (crimson) colour had been wholly bleached out ; the second filling sufficed for a redetermination of the absorption of the visual purple, and for that of the visual yellow, which was obtained after the purple had been bleached for that colour. (The two determinations of the absorption of the purple substance are in close agreement with each other.)

It was at once evident that the absorption distribution in the spectrum of the purple substance coincided roughly with the spectral distribution of brightness for the congenitally totally colour-blind, and also with the spectral distribution of brightness for the normal eye (as well as for the partially colour-blind) at a very faint degree of luminosity. The suggestion was a natural one that it is the vision of the totally colour-blind, and of the normal eye in a faint light, which is dependent upon the absorption of light by the visual purple. The curves of sensation in these two cases were reduced to a spectrum of equal distribution of energy by means of Professor Langley's determination of the distribution of

energy throughout the spectrum. Correction was also made for the absorption of the macula lutea and for that of the crystalline lens (freshly determined for an individual of the proper age). It then became evident that the coincidence between the three curves is remarkably close. (That the two curves of sensation referred to are in close agreement with each other had, of course, already been shown by Hering.) It was evident, that is, that the absorption in the purple substance is very exactly proportional to the value of light as an exciter of sensation (1) in the totally colour-blind, and (2) in all eyes at an intensity so faint that colours are no longer visible.

But the difficulty still remained which had originally caused the visual purple to fall into neglect—the substance is apparently wanting in the cones, and therefore in the fovea. To meet this difficulty two assumptions were possible : either, that the cones do contain the purple substance, but in so decomposable a form that it can never be detected objectively, no matter what the precaution used in extracting the eye ; or, that the eye is actually blind in the fovea in the two cases in question. In favour of the first assumption was the fact that, if the yellow substance is really the source of the sensation of blue, then it must be supposed to exist in a *less* decomposable state in the periphery of the eye to account for the fact that we are there nearly blind to blue [1] ; it therefore " lies near " to assume (when some assumption is absolutely necessary) that it exists in a *much more* decomposable state in the fovea, and that it has for this reason hitherto escaped detection. But I was most anxious to put the second of these assumptions to the test—the more so as I had already made the prediction that the cause of

[1] Gad, in his criticism of the papers of König and Zumft, about to be mentioned, implies (p. 499) that Professor König found the blue-blindness of the fovea forced upon him by his hypothesis regarding the function of the visual purple and of the visual yellow. That was not the case ; Professor König had adopted the first of the two assumptions here affirmed to be possible, and it was only some six weeks later that I discovered the night-blindness of the fovea.

total colour-blindness is a defective development of the
cones [1]; and also that the function of the visual purple
is to render possible that form of vision which does not
exist until after a delay of twenty minutes or so in a dark
room [2]; both predictions being naturally suggested by
my theory of light-sensation. I had also pointed out,
in the last-mentioned paper, that the visual purple
cannot exist in the cones, even in a bleached-out state,
because the visual purple is fluorescent, and the more
so the more it is bleached out, while the fovea remains
as a dark spot in the ultra-violet rays of the spectrum ;
and the more strikingly dark the more the rods in the
neighbourhood have become fluorescent (loc. cit., p. 100).
On the other hand, Professor König pointed out to me
that even if vision should be wholly wanting in the fovea
of a totally colour-blind individual, it would hardly
be possible to detect it, for he would unquestionably
have acquired the habit by avoiding the use of this
spot. This suggestion was, therefore, not immediately
carried out. But it was arranged that I should take for
the subject of my investigation for the summer a re-
determination of the threshold of sensation for different
parts of the retina and for different kinds of mono-
chromatic light. A plan of work was built up in two of
the dark rooms of the laboratory, and I have to express
my gratitude to Professor König for his untiring patience
in assisting me to overcome the difficulties which one
after another presented themselves.[3] The preliminary
observations for eliminating the sources of error consumed
some time, and I then made a first determination of the
variation in the intensity of light necessary in order to be
just perceptible, or of its inversion—the sensitiveness
of the eye to faint impressions—at different distances
from the fovea. I even drew the curves, and found them

[1] *Zeitsch. f. Psych. u. Phys. der Sinnesorgane*, Bd. iv, S. 9, p. 72.
[2] " Professor Ebbinghaus' Theory of Colour Vision," *Mind*, N.S.,
vol. iii, p. 103.
[3] The full results of this investigation will be published later.

to present a maximum at a distance of about 25°, at which point the sensitiveness of the eye is about four times as great as at the fovea, while at a distance of 50° the sensitiveness is still about twice as great as at the fovea. E. Fick found the maximum to be at about 15°, but that was without making correction for the diminished area of the pupil of the eye when light enters it very much from the side. The shape of the curves is not noticeably different for different parts of the spectrum. These curves are a representation of the diminished sensitiveness in the region of the fovea, which has long been known, and which has been especially forced upon the attention of astronomers when looking for faint stars with the naked eye. I had been in the end for several weeks at work in my dark room for the express purpose of finding that the fovea is *blind* to impressions so faint as those with which I was occupied, before I found it ; although, after it has once been seen, it seems incredible that it can ever have been overlooked. It finally dawned upon me—not that the bright point directly looked at was invisible—but that by giving what I can only describe as a certain curious twist to the eye, a certain bright point could be caused to disappear.[1]

The reason that the " normal night-blindness of the fovea ", as this insensitiveness to the faint-light sensation may best be called, has been completely overlooked by all other observers, and also by E. Fick and by Kirschmann, who have made a special investigation of the threshold of sensation for different parts of the retina, is very plain ; the unconscious ego, which takes so large a part in regulating the action of even the voluntary muscles, is well aware of this blindness, and takes pains that an image of a small object shall almost never fall

[1] This motion of the eye can be facilitated if one brings in the aid of a strong desire not to see the point. This would seem to show that the knowledge of the existence of this blind spot, while almost wholly below the level of consciousness, is yet not altogether withdrawn from an interaction with the conscious content of the organism.

upon this spot. In a faint light, *to look at*, which is usually a phrase of two-fold significance, meaning, namely, to turn the eye in such a way that its power of seeing is a maximum, and also to turn the eye so that the image of the object looked at falls on the fovea, has now the two elements of its significance disjoined ; when vision is at a maximum (or when it is possible at all), it is necessary that the image should fall a little to one side of the fovea, and that is the motion with which the subjective feeling of fixation is associated. Not only did the faint object which I was engaged in observing disappear, but also the two (much brighter) spots of phosphorescent paste (which are used in order to secure a fixation-point half-way between them) could be made to completely vanish by " looking at " them, in the new sense of that phrase. This phosphorescent matter gives a spectrum which is almost wholly blue.

Having convinced myself of the existence of this faint-light foveal blindness, it was necessary to devise a method by which the total blindness of the fovea of the totally colour-blind patient, who was soon to return to Professor König's laboratory, could be demonstrated. It was not permitted to subject his eyes to any strain, and it was not probable that a rather feeble boy of thirteen could easily learn to execute a motion which had hitherto been absolutely avoided, not only by him but by all the rest of the world ; and which, besides, there was no possibility of describing to him. But it naturally suggested itself to me very soon that it would only be necessary to give him a group of closely contiguous isolated bright points to look at, and that chance would see to it that one or the other of them should now and then fall into the dark hole of his fovea. The same device has proved effective for exhibiting the normal faint-light blindness to a person who has not yet learned to execute the motion of the eye necessary to cause a single spot to disappear. Professor König at once made use of this method to show that even the most intense

blue that could be thrown into the field of his spectro-photometer, by the light of the oxyhydrogen blow-pipe, is insufficient to cause any sensation whatever in the fovea. No difficulty was experienced in demonstrating the total blindness of the totally colour-blind boy in this spot, although it was quite impossible to get him to experience the invisibility of a single bright point when only one was in the field. This individual had a definite spot at one side of the fovea, which he constantly made use of as a fixation-spot ; the nystagmus, which is a common accompaniment of total colour-blindness, is readily explained as the expression of there being no such favoured substitution fovea. The remarkable diminution of visual acuity on the part of such patients, which has not hitherto been understood, is seen to be very natural when it is known that their fovea is not in a condition to perform its function.

To the facts already described, Professor König adds a contribution recently made by himself and Dr. Zumft,[1] by which they would seem to have shown that light of different colours is perceived in different layers of the retina, and blue distinctly in front of green, yellow, and red. The method consists in throwing two shadows of a blood-vessel upon the back of the retina, by means of two holes in a card, which is constantly moved to and fro in the front focal plane of the eye. The distance apart of the two shadows they were able to measure, and they found it to be different for differently coloured homogeneous light ; and the calculated distance of the blood-vessel from the layer of retina which is affected by the light, they found to be, for several portions of the spectrum examined :—

$$\lambda \; 670 \qquad . \qquad . \qquad 0\cdot44 \text{ mm.}$$
$$590 \qquad . \qquad . \qquad 0\cdot44$$
$$535 \qquad . \qquad . \qquad 0\cdot41$$
$$486 \qquad . \qquad . \qquad 0\cdot38$$
$$434 \qquad . \qquad . \qquad 0\cdot36$$
$$\text{White,} \qquad . \qquad . \qquad 0\cdot41$$

[1] " Ueber die lichtempfindliche Schicht in der Netzhaut des Menschlichen Auges," *Sitzungsberichte d. Akad. d. Wissench. zu Berlin*, 24 Mai, 1894.

Professor König interprets this to mean that the space between the layer in which blue is perceived, and that in which red is perceived, is *greater* than the thickness of the end members of the rods and cones, and hence that one must infer that the pigment epithelium also is a layer sensitive to light. It would seem, however, that there must be something about these experiments the meaning of which is not yet wholly cleared up, for the length of the outer member of a rod is only ·025 to ·03 mm., and that of an epithelium cell is only about half as much again. They do not, therefore, together form a layer of sufficient thickness to take in the difference of ·08 mm., which the observations require. The experiment, therefore, proves too much. Again, Professor König's interpretation of the facts here enumerated, as meaning that the visual yellow is the source of the sensation of blue ; that green, yellow, and red are all perceived in the pigment-epithelium, and that the *cones* are merely lenses for concentrating light upon the epithelium cells, makes no provision for the nerve-conduction of any effect of light in the epithelium. In the fovea there would be absolutely no means of such conduction except by way of the cones, and it is difficult to conceive that organs which are performing the part of lenses should also be able to function as conductors.[1] Again, the recent brilliant work of Ramon y Cayal and others on the minute anatomy of the retina discloses such close similarity (together with a perfectly definite difference) between the rods and the cones, as regards structure and connexions, as to make it very unnatural to assign to them functions of a widely different nature. Professor König says (p. 4) that the results here communicated " are in contradiction (1)

[1] Professor Gad objects that only the first surface of the pigment-cells would be available, because light cannot pass through even a very thin layer of the fuscine which gives them their dark colour. But he apparently forgets that, under an ordinary degree of illumination, the pigment grains are nearly all heaped up *between* the visual elements, and that the body of the pigment cell is left almost free from them (" Der Energieumsatz in der Retina," *Arch. f. Anat. u. Phys.*, 1894).

with the theories of Hering and Ebbinghaus, according to which a single substance forms the basis of the red and green sensations on the one hand, and of the blue and yellow sensations on the other hand ; and (2) with the theories of Donders, Wundt and Franklin, according to which all colours are perceived in a single substance ". It is true that all these theories would be rather hard hit by these results, if the results themselves were not involved in some obscurity. As it is, however, it may perhaps be safe to wait until the discrepancies pointed out have been cleared up.

There is yet one more recent contribution from König's laboratory which has an important bearing upon the new facts already mentioned. Brodhun, and more recently Tonn, have shown that the Purkinje phenomenon consists in a change in the blue constituent of white light—the red and green remaining unchanged ; this would seem to indicate that the increased amount of colouring matter in the rods, as the intensity of light begins to diminish, furnishes a means for an increased amount of absorption, and would seem to point, it must be confessed, to the rods as the seat, at least in part, of the sensation of blue.[1]

Further elements of the theory of light-sensation now advocated by Professor König are these :—

1. The visual purple is the photo-chemical substance whose decomposition causes the faint light sensation. That sensation is in reality blue, although we are not easily aware of it.

2. The visual yellow is the source of the sensation of blue at ordinary intensities.

[1 Brodhun and Tonn both failed to notice that the high-frequency end of the spectrum, as it becomes *brighter* when the illumination is diminished, becomes also *whiter*. It is a singular thing that I had not yet noticed at this time that the " Purkinje phenomenon " is explained by the coming in of the rod-vision (which is whiteness-vision) constituent of the total sensation.—There are so many Purkinje phenomena that this one ought to have a more specific name, as : Change in Luminosity-Distribution when Scotopic Vision (rod plus rod-pigment vision) Comes in ; or, The Scotopic Vision Change in Luminosity-Distribution. (In German one readily forms compound words ; we ought not, in English, to neglect as much as we do the use of hyphened words.]

3. The white and the dull whites of an ordinary illumination are of a very different origin from (*a*) the sensation of grey in a faint light, (*b*) the sensation of the totally colour-blind, (*c*) the sensation of the normal eye in the periphery ; they are (as in the original Young-Helmholtz theory) a synthesis in "judgment" of the sensations red, green, and blue.

As regards Professor König's interpretation of the new facts, the following observations remain to be made :—

(*a*) There is no occasion for assuming that the visual purple is, by its decomposition, the source of the sensation. All that is forced upon us is that absorption by the visual purple acts as a means of *reinforcement* at a time when light would be too feeble to perform its function without the presence of a special agent for absorbing it, a sensitizer.[1] That the visual purple and the visual yellow should, by their decomposition, furnish the same sensation (blue) is very hard to believe, in view of the fact that the visual yellow is, beyond all question, itself one of the decomposition products of the visual purple, and that their decomposition products can therefore not possibly be the same.

(*b*) There is no doubt whatever that the eye has a perfectly unimpaired chromatic vision for the whole length of the spectrum when the light is so strong that the rod-yellow has been completely bleached out. That can, therefore, not be the photo-chemical substance for blue. The eyes of the totally colour-blind undergo adaptation.[2] The rod-purple in their eyes, therefore,

[1 My present explanation of the faint blue quality of scotopic vision (which is a fact—Kroh) is, of course, that this blueness is contributed by the " visible radiation of the excited nerve fibers ". *Comptes rendus,* 1927.]

2 Just before leaving Berlin in September I made a journey to the place where the colour-blind boy above referred to was spending the summer, in order to determine this point. Hering mentions that his case could see better in a dark room than those having normal eyes, but he does not say whether his vision improved with time (" Untersuchung eines total Farbenblinden," *Pfl. Arch.,* Bd. 50, S. 10).

suffers changes in its quantity exactly as we should expect it to do from what we know of the substance elsewhere. There is, therefore, every reason to believe that it is, like all rod-purple which we have ever examined objectively, completely bleached out in a bright light, and hence that it is not the sensation-producing substance, but merely a means of reinforcement for waning light.

(c) The fact that the adaptation-substance is purple in colour serves a useful purpose. The most common faint light of nature is the faint light of dense forests, which is green. The rod pigment is therefore especially adapted to the absorption of the only light which penetrates them. How completely the light at the bottom of forest trees has been sifted of the light which their leaves absorb has been shown quite recently by an investigation into the growth (or rather non-growth) of nearly all ground plants after the foliage has fully come out in the late spring.[1]

(d) Almost the only function of the extreme periphery of the eye is the *detection of motion*—that is, the detection of changes in the distribution of light and shade. The changes in the rod-pigment bring about a constant complete adaptation to the *existing* pattern of light and shade—build up a counter-pattern, so to speak, upon the surface of the retina—and only a *new* distribution of light (i.e. the entrance of an enemy upon the field) causes any sensation. This function of the periphery is facilitated by the fact, made out by Ramon y Cayal, that there are numerous large horizontal connecting cells which must play the part of reinforcing a sensation by spreading it over a wide area, at the same time that they diminish the sharpness of its localization ; the indistinctness of vision in the periphery has long been known to be much

[1] Klebs, " Einfluss des Lichtes auf die Fortpflanzung der Gewächse," *Biol. Centralbl.*, xiii, 641.

greater than the indistinctness of the image formed there
would account for.[1]

[1 These considerations are quite sufficient to show the futility of
the so-called König theory of colour—and in fact he did not take it very
seriously himself. It is a pity that he ever proposed it—for it was
doubtless the reason that led Nagel and v. Kries to make the first edition
instead of the second of Helmholtz' *Physiological Optics* the basis of
their third edition. In the second edition (brought out while Helmholtz
was still living) the views of König had full play—and, of course, most
of them were extremely valuable and have been proved to be perfectly
correct. See my appendix to the English translation (which may
count as a fourth edition), reprinted as Essay No. XII in this volume.]

V

DOUBLE STRUCTURE AND DOUBLE FUNCTION OF THE RETINA: THE RODS AND THE CONES [1]

WHAT I have proposed to call the normal night-blindness of the fovea (*Psych. Rev.*, 1895), in parallelism with what has long been known as the (abnormal) night-blindness which is a symptom of *Retinitis pigmentosa*, a disease of the pigment epithelium, one of whose effects is to prevent the formation of the rod pigment and consequently of that surrogate vision which the normal eye acquires in a faint illumination, has not been admitted by all observers to be an actual phenomenon. Tschermak and Sherman, in particular, have denied its existence, while that has been as vigorously affirmed by v. Kries and his assistants. A fresh series of experiments has now been devoted to the question by v. Kries and Nagel [2] (the latter a dichromate). They point out in the first place that the retinal area tested by other observers was altogether too large ; even though it did not exceed the size of the rodless region, it was certainly fully equal to it, and there is no possibility of securing such absolute fixation as would be necessary to confine a retinal image for any appreciable time upon a given exact portion of the retina (even if it was not for the fact that focal fixation in a faint light is anyhow an exceedingly difficult matter on account of the fact that we have for practical reasons carefully learned to avoid it). They also desired to meet the objection of Tschermak to their former work (*Ztsch. f. Psychol.*, xii, 1)—that they had

[1 " Duplicity theory " is an unsatisfactory name for this. I have called it recently the Double Structure and Double Function of the Retina.]

[2 " Weitere Mittheilungen über die functionelle Sonderstellung des Netzhautcentrums," J. von Kries u. W. A. Nagel, *Ztsch. f. Psychol. u. Physiol. d. Sinnesorgane*, xxiii, 161–186, 1900.]

not secured a sufficiently long adaptation, and moreover
to determine more carefully than they had done before
the exact extent of the non-adaptable region.

The dichromate, and especially the deuteranope
(" green-blind "), have great superiority over the non-
defective individual as experimenters in subjects of this
nature. A difference in brightness is hard to distinguish
with accuracy when it is overlaid with difference of colour
also. But for the dichromate, who sees the entire warm
end of the spectrum in yellow, it is easy to make an
equation between red rays and green rays (to give them
their normal names) such that the two fields compared
are absolutely indistinguishable. The reinforced vision of
twilight, which exists hardly at all for the extreme ends
of the spectrum, will then exhibit itself in an excessive
brightening of the " green " field (the difference may
amount to a hundredfold), and its failure in the fovea
will be evidenced by the fact that for that area the fields
remain alike. Instead of exhibiting the two fields side
by side, the authors found it much better to use the
now familiar " spot " method—one field is seen through
a small hole in the other, and complete likeness of the
two is recognized by the disappearance of the hole.
(Acuity of vision is so great in the centre that the boundary
line does not become absolutely invisible throughout its
whole extent as it does in the periphery, but there is,
nevertheless, perfect certainty as to the equality of the
fields.) The size of the hole was in the first instance
sometimes $\frac{1}{4}°$ and sometimes $\frac{1}{2}°$. Tried by this method,
and with all imaginable subsidiary precautions, it was
found that in the exact centre of the retina the Purkinje
phenomenon does not occur ; when the adapted eye is
first opened, the spot (which has first been made equally
bright with the surrounding " red " field for the daylight
vision of the observer) is seen to shine out with an intense
brightness, but as soon as the (minute, black) fixation-
point in its centre is secured the difference between spot
and field absolutely vanishes. There was also no falling

off in the saturation of the " green " spot when viewed centrally, as there would have been if the achromatic twilight vision had overlaid it.

Experiments were also made by v. Kries himself (that is, with normal vision) by means of comparing two colourless mixtures of different light-ray composition— that mixture which contains green shines out brilliantly in comparison with the other after adaptation (what I have called " the extended Purkinje phenomenon "), and here also the phenomenon was found to be wholly wanting in the centre. The same result was obtained, again, when an equation was established, for v. Kries, between the spectral lights red and green on the one hand, and yellow on the other. In one and all of these methods, it will be noticed, the two things to be compared differed not at all in quality, and there was nothing therefore to confuse the judgment of equal intensity ; they are much to be preferred to that of the simple estimation of the relative brightness of two adjacent heterochrome fields, as red and blue. Blue, it should be remarked in passing, is not the colour to be chosen in making these comparisons with red. The " Purkinje phenomenon " is usually stated to consist in the intensification of blue in a faint light (all mention being omitted of the fact that the blue becomes less saturated at the same time, and that the real phenomenon is a *whitening* of the blue), but this is surely only an intermediate stage, corresponding to that in which the rods are filled with the visual *yellow*, an absorbent for the blue portion of the spectrum. After adaptation is complete, it is green that has become the most intensified, not blue. The first stage may be called by its historical name, the Purkinje phenomenon ; the final stage may better be known (for the sake of distinction) as the *extended Purkinje phenomenon*. The gradual change from one stage to the other is exhibited in a diagram in Tonn's paper (*Ztsch. f. Psychol. u. Physiol. d. Sinnesorgane*, viii, 280), and the fact that the cause of the change is probably to be found in a mixture of

two absorbing media gradually changing in relative amount (the *Sehroth* and the *Sehgelb*) is indicated, for the mathematician, in the fact that the several curves have a nearly common point of intersection. The visual yellow is a less marked stage in the regeneration of the visual purple than in its degeneration, when the substances are studied objectively ; it would be interesting to know if there is any difference between the subjective brilliancy of blue, according as it is seen in a condition of semi-adaptation following upon the daylight condition or upon the night condition of the eye. This simple experiment has not, I believe, been tried. This intermediate state of vision might well be called twilight-vision, and to the state of complete adaptation the name night-vision might be applied ; our ancestors have already made for us the proverb, " in the *night*, all cats are grey." Discussion is so voluminous just now in regard to all these new ideas that it is of extreme importance that a good and sufficient phraseology should be adopted as one goes along.

v. Kries and Nagel also made careful experiments to determine the exact size of the adaptationless area by varying the apparent size of the spot by moving it forwards and backwards ; it was readily found that the apparent size at which it just fails to undergo a brightening on its outer border is, for the two eyes of a single individual which were tested, $1.40°$ or $1.8°$ horizontally, and 1.35 vertically ; they also found that at a slightly greater distance from the centre there was a sudden sharp access of brightening. They suggest that this latter distance is that at which the arrangement of one cone in a complete circle of rods begins, and that a few scattered rods may occur up to the region of no adaptation, in spite of the fact that Koster gives the rodless region as $2°$ in diameter. v. Kries thinks it possible that the rod-pigment when outside of the rods, when just formed out of the substance of the pigment epithelium, may be effective upon the adjoining cones. This suggestion is very lacking in

probability, but it is a satisfaction to find that v. Kries begins to attribute to the rod-pigment its evident rôle of being the source of night-vision ; he has been speaking even quite lately as if the rods had no daylight-vision at all, and as if the achromatic vision of the normal periphery were necessarily to be assigned to the cones. But this is to overlook the fact, which stares one in the eyes, that the most striking feature of the whole situation is the coincidence between a gradually oncoming rein-forcement of vision, most effective in *green* light, and an equally gradual regeneration of the *green* absorbing substance in the rods.

But there is a still more marked coincidence between function and apparatus adapted to meeting it, which goes very far toward confirming this view that the visual purple acts as an absorbent medium for an insufficiently strong light. All vertebrates except fishes have a visual purple of exactly the same absorption spectrum ; in the eye of the fish the maximum absorption is farther toward the blue (Köttgen and Abelsdorff). The difference is perceptible to the naked eye—the colour in fishes is plainly more bluish. Now in what respect do fishes, on the one hand, and mammals, amphibians, and birds, on the other, differ as regards their faint-light vision ? Plainly in this : the dark recesses that other animals have to enter are the depths of forests, the shadows of overhanging plants and grasses. But fishes find their darkness at great depths in the water, and water has its maximum absorption in the yellow (Spring : *Bul. Acad. roy. de Belg.*, 1896 (3), xxxi, 251). The bluer absorption stuff of fishes is, therefore, just what is adapted to the retaining of the yellower light of the depths of the ocean. There is another curious feature in the visual apparatus of certain fishes—the retinal tapetum, a white surface of guanin, in the upper half only of the retina, whose evident function is to give preponderating reflection to the light which comes from regions down below, while the too bright light of the external upper half of the visual

field is still moderated by the absorption of the black pigment of epithelium and choroid. This is an instance of an absolutely special provision in the eye of the fish for the darkness of ocean depths which is quite analogous to the distinctive colour of their visual purple, and hence lends probability to the view that that too is a differentiation in the interest of adaptation to life under special conditions.

It is a very great satisfaction to have established, at last, beyond question, the fact of the failure of night-vision in the fovea (meaning by night-vision that form of vision which is acquired after the rod-pigment—the visual red or the visual yellow—has had time for regeneration, and which is recognized subjectively by the great change which takes place in the relative brightness of the different portions of the spectrum). Experiments on this subject which are made by estimating the brightness of two fields of different colour are not to be compared in value (even if they had not been done with too large a field, and by an inadequate method) with those in which the observer is merely required to detect the *disappearance* of a spot in a surrounding field with which it is absolutely identical both in brightness and colour. This necessary condition can be secured in two ways : (1) By the method of the *achromatic colour equation*, as it may be called, for the normal eye ; in this method the distracting effect of the colour-aspect of the fields to be compared is obviated by making each consist of a pair of complementary colours mixed in the right proportion to produce grey, and therefore indistinguishable for sensation when equally bright, though physically of very different constitution. The field which contains green will be the one to brighten up in a faint light, for twilight-vision (being due, as we may suppose, to the absorption into the rods of green light by means of the visual purple) is predominantly vision for the green portion of the spectrum. (2) The same result, that of offering to the observer a difference in brightness only, though the light

wave constitution of the two fields compared is very different, can be had with no difficulty throughout either half of the spectrum in the case of the partially colour-blind. It was by this method of the achromatic colour-equation that Hering's hypothesis of the specific brightening power of the colours (or Hering's complete colour theory, if he had not quickly modified his views— *vide* Tschermak) was overthrown : if twilight vision was a new form of vision, mediated by the visual purple of the rods, and for that reason achromatic, and if its changed brightness values were completely accounted for by the character of the visual purple absorption, then there is no room left for a " specific brightening power of the colours ". Hering's theory is now, therefore, again in its original extraordinary position, in which spectral red, e.g., which most observers regard as being absolutely saturated, owes all its brightness to a black-white process (whose presence at all is a purely gratuitous assumption) and is not affected in its brightness in any degree by the voluminousness of the photochemical process which underlies the sensation of red.

With this definitive result of v. Kries is removed every difficulty that may have existed in granting (what is a starting point for my theory of colour-vision) that the rods and cones play a different part in the retinal economy—viz. (to give it accurate expression) that *the rods are the organs for nothing but achromatic vision, and that colour (chroma) is mediated by the cones only*. This result may be regarded, therefore, from now on as a distinct acquisition to our knowledge of the sense for light and colour.

This view would have been rendered still more certain, perhaps, if it had turned out that all the cases of congenital total colour-blindness show also total blindness in the fovea. The first case of that kind to be discovered (the defect does not exhibit itself without some device for making it apparent, on account of the fact that the patient learns carefully to avoid fixating with a spot in

the retina with which he can see nothing) was that of the totally colour-blind boy in König's laboratory upon whom I applied (1894) the method [1] of showing that some one of a *group of spots* is sure to disappear if such defect exists, when the effort is made to see them all at once—a method which I had just devised in order to render readily perceptible the total lack of the Purkinje vision in the fovea of the normal eye, which had just unexpectedly revealed itself during some experiments which I was carrying out in a dark room in Professor König's laboratory (*Psychol. Rev.*, ii, 143, 1895). Since then there has been much discussion as to whether this total blindness in the fovea of the achromate is the general rule. Uhthoff first announced that in a patient of his it did not exist, but since then he has found (using a modification of my method—the person tested endeavours to hold one spot fixated in the exact centre of a ring of others) that this same patient can in fact not see anything with the centre of the retina. Hess and Hering, Pflüger of Berne, and v. Hippel, have all contributed cases in which this foveal blindness is lacking (they have not yet, however, used the last described method). But the extreme interest with which the final settlement of this question was regarded is now set at rest by means of the case of Raehlmann (described in the September number of *Psychological Review*). This case has been known of, as a matter of fact, for many years—that is, though foveal blindness was not expressly looked for, not having been hitherto suspected, it was known that Frau Professor R. had perfect visual acuity, which is incompatible with the fovea being thrown out of function—but it has hitherto failed, through some accident, to be accorded its proper logical weight in the discussion. What is placed beyond dispute by it is that congenital achromasy *may be* a defect of the cortical centres ; this has long been known

[1] I had already predicted, as a deduction from my theory, that the vision of the congenitally totally colour-blind would be found to be vision with the rods only.

to be very frequently the sole cause in cases of acquired achromasy (see Förster's case, among many others, *Arch. f. Ophth.*, xxxvi, 194), and since retina and cortical cells are both essential links in the chain of causation in question, and since it is quite certain that there are separate centres for colour-vision, there is every reason to suppose that mal-development, as well as disease, may sometimes cause the latter to fall out of function. But, on the other hand, the undeniable cases in which total lack of colour-vision is accompanied by total blindness of the fovea, even though they are not exhaustive of all cases, still point as strongly as before to the cones of the retina as being, *in these instances*, the source of the defect. What is rendered certain by the case of Raehlmann is that there is nothing forced in the referring of cases of a different sort from these to a different seat of the physio-logical lesion, namely, the cortex.

There is now, therefore, nothing that stands in the way of believing that : (1) *The rods are the organ for nothing but achromatic vision ;* (2) *chromatic colour is mediated by nothing but the cones ;* as I maintained, following upon Max Schultze and Parinaud, in 1892.

VI

THE THEORY OF COLOUR THEORIES

I HAVE no doubt that a very profound and original paper could be written on the theory of theories in general : the subject has not yet been adequately treated, and in a scientific world where theories are constantly being constructed, it is of great importance that the general principles which govern their efficiency—if such there be—should be thoroughly understood. So also in the more limited subject of the theory of colour-theories, I doubt not that there is ground for a discussion going very deep into the fundamental principle of knowledge. But I shall not attempt a discussion of this character to-day, because there is not, in this case, any occasion for discussion of a recondite kind. The crimes which the current theories of colour commit against fundamental principles are so patent, so flagrant, so open to the comprehension of the simplest intelligence, when once it gives its attention to the subject, that a discussion of any profundity regarding these principles would be wholly thrown away.

Hence I shall put before you only some very simple considerations which will nevertheless be sufficient to show that not the theory of Helmholtz, nor that of Hering, nor any of the recent modifications which they have undergone, has any claim to be considered a colour-theory at all. So hopelessly beyond the pale of reason, in fact, does each of these principal theories seem, to anyone who is not already blindly committed to it, that no fruitful discussion seems possible between their rival adherents—and practically no discussion has, indeed, of recent years, taken place. Each side has settled down to the simple plan of using the phraseology of whichever theory it chooses to adopt, content that its

writings should remain not even comprehensible to the adherents of the other side.

I shall therefore simply enumerate in a few words the basic principles regarding theories, so far as they are applicable to colour, and then I should proceed to show, if I had time, in more detail, how they are violated in the existing theories. That these principles are simple to the last degree is no fault of mine, but that of the simple-minded holders of these theories.

1. In the first place, it is not desirable that any theory should resolutely ignore a large proportion of the plain facts which hold in the region which it seeks to cover. For instance, the followers of Hering are required faithfully to shut their eyes to the fact that red and green, as every artist, and every schoolboy, knows, are not complementary colours. So the Helmholtz theory has no word to say to the fact that while blue and green make the bluish greens, and red and blue make the reddish blues—red and green, which play an exactly corresponding part in the theory, do *not* make the reddish greens nor the greenish reds—that there are no such things as those colours in existence, nor conceivable even, as it happens, to the mind of man—but that they produce a perfectly new, *sui generis*, sensation, yellow. The followers of Helmholtz, in fact, may be described as being psychically colour-blind, incapable of apperceiving yellow.

2. It should be the first object of any good theory to provide itself with a suitable terminology for the facts which lie within its domain. This terminology would not, of course, in general, be the same for different theories when interpretation comes in, but at least a common language should be provided for the patent, the admitted, facts of the subject—it should be possible for two contestants to at least begin a comprehensible discussion of the facts with which they are concerned.

3. For any theory regarding the connexion between a series of psychical facts and a series of physical facts,

the principle of psychophysical parallelism must obtain. Any theory of colour-sensation is, of course, a theory of this kind. Strange as it may seem, there is actual occasion for laying down this principle explicitly. v. Kries, for instance, says (in Nagel's *Handbuch*) that we are " einen *gewissen* Parallelismus anzunehmen berechtigt ". As if a simple straight-out parallelism were not the basis of all our attempted psychophysiological theories ! No start in a colour-theory, of course, can be made without it. But, also, a half-way application of it is not sufficient—it must hold religiously throughout the whole domain.

4. In particular—what is merely the principle of psychophysical parallelism in more precise terms—one must not (1) make use of one and the same conception to explain two totally different sets of phenomena ; nor, obversely, (2) must one and the same conscious experience be attached, in any theory, to two different physiological hypotheses. This pair of precepts is violated, for example, when, on the one hand, Hering explains by one hypothesis (a mixing of assimilatory and dissimilatory chemical processes) two such different phenomena as a black-white series (in which both the constituents always appear in consciousness) and a yellow-blue (or a red-green) series, in which the two constituents never appear together, but are always replaced, one or the other of them, by an admixture of white (or of yellow). Phenomena of a totally different kind, like these, require a *different* chemical conception, not an *identical* chemical conception. On the other hand, the other half of the principle is violated by v. Kries and his followers, when, to one and the same conscious phenomenon, the sensation white, they attach a certain unitary chemical process in the rods, and a combination, by consciousness, of the results of three different colour processes in the cones. A very little reflection on the nature of the grounds which we have for theorizing at all, ought to have obviated the possibility of either of these two opposite errors.

5. A minor principle, but one which I believe is in urgent need of enumeration, is this : No constituent element of a theory is of any great positive value unless it explains more than one phenomenon at once ; negative value it would still have, inasmuch as a phenomenon which cannot be explained consistently with a given theory, of course, upsets that theory. But in order to be able to claim for itself much consideration, it must be able to explain at least two things at one blow ; if (like the little tailor of Grimm) it can kill so many as seven difficulties at one blow, that adds of course immensely to its prestige. But there should be, in estimating the value of theories, a distinct difference made between those which fit in with a large scheme of conceptions, all working together, and those which are purely—we already have the phrase— *ad hoc*. Schenck, with his hypothesis of *Reizempfänger*, gives an example of a weakness of this kind. Conceptions of this description are of so little consequence, one way or the other, that they should always be discriminated from consistent theory, and should be carefully designated as " *ad hoc* hypotheses ".

I have no time, in fifteen minutes, to show in detail how sadly the two rival colour theories violate, between them, every one of these elementary principles. But I add a few words especially on colour-terminology, and then call your attention to a theory of my own, which is not, I believe, open to such fatal objections.

There is something inherent in the petals of the rose which, when examined spectroscopically and measured mechanically, gives us what we interpret as a certain vibration period of the ether, but which, when it affects us through the eye, we call the colour-sensation *red*. Now our early ancestors, in making up their various languages, had no knowledge of light wave-lengths, on the one hand, nor of the efficient physiological chain— lens, retina, nerve-fibre, cortex—on the other hand. To them it seemed that the sensation red resided in the rose also as redness. So we, though more learned,

continue, through laziness, to speak of the red portion
of the spectrum when we should speak of radiations
850 λ—and of blue when we should say radiations 430 λ.
[See note at end.]

The same thing exists in the case of sound. There is
something in a hypothetically external world which is at
once the cause, through one set of sense organs (the space
sense of eye and skin), of our experiencing a definite
vibration period of air, and through a different sense organ
(the ear) of our becoming aware of a definite thing which
we call pitch. To call two such different experiences by
one and the same name, *sound*, shows a hopeless poverty
of language. In sound, no very serious trouble results
from this ambiguity ; but in the region of colour the
corresponding confusion of terms is constantly the source
of a lamentable confusion of thought. There is absolutely
nothing to do but to drop entirely (when speaking
scientifically) both the word *colour* and the word *light*.
We should say, on the one hand, when we refer to the
things in their objective signification, light (or colour)
vibrations or (better) radiations, and on the other hand
when we refer to them in the immediately subjective
sense—the other is subjective too, of course, in the last
instance—we should say light sensations, or colour
sensations. The Germans, fortunately, already use the
last two terms very constantly ; other languages should
follow their example.[1]

But it would also be a good plan to drop altogether
from the scientific vocabulary the wholly ambiguous
words *light* and *colour* (when unmodified), and to substitute
for them *vibrations* or *radiations*. Then objective lights
(radiations), which give a blue-green sensation, would be
called, invariably, blue-green radiations. When we wish
to particularize farther, we may describe them as either

[1] The Germans, however, unfortunately, use these two terms
uncorrectly : they should say that the light (colour) sensations are
of two sorts—achromatic and chromatic. *Red light, blue light*, etc.,
are just as much real existences as is *white light*.]

homogeneous, or, if they are any one of the thousand light-ray combinations (either dual or very complex) for which the blue-green sensation is *dominant* (to use the good word of Abney), then we should call them a blue-green radiation group. But we must never (when scientific) speak of blue-green *light*.

Still more conducive to clearness would it be if we should say, instead of red radiations, *erythrogenic* radiations, and for the other colours *chlorogenic*, *xanthogenic*, and *cyanogenic* radiations. For a *white-light* combination, *leucogenic* would be the right word, and for the light waves in general, *photogenic*. These names may seem rather far-fetched for constant use, but it is only with the aid of exact terminology that exact thought can be attained to ; they are nothing compared with the terms the chemist has to make use of—and it is certain that chemistry would never have reached its present state of development if chemists had balked at hard names. This distinction, though it may seem to be inessential, is in reality of very great consequence ; it enables us, for example, to make, at once, these two important statements : There is *no* Helmholtz theory of colour-sensations, but there is a collection of Helmholtz facts regarding colour-radiations (viz. that of the equivalence, as *causes of sensation*, of a large number of different radiation-mixtures—all the facts, indeed, that are embodied in the colour-triangle—the facts which Hering and his school completely ignore). On the other hand, there *is no* Hering theory of colour-radiations, but only a theory regarding colour-sensations—a theory which would be of great importance, were it not that it is wholly contradicted by the facts of colour-radiations—the fact, to begin with, that red and green radiations do not, when mixed, give occasion for a *white*, but for a *yellow*, colour-sensation.

*　　　*　　　*　　　*

The fact that there are two colour-theories, diametrically opposed to each other, which divide the scientific world,

is not so very strange—for the facts of colour-vision are singular in the extreme. If the colour-gamut had been like the tone-gamut—if one colour had always differed from another by a difference of a like kind, as one tone differs from another always in respect of pitch—a subjective variation which proceeds exactly *pari passu* with the objective variation of rapidity of vibration—then this endless contest of the colour-theories would not have arisen. But instead of a *rectilinear* sensation-series, to use the indispensable term of G. E. Müller, in one-to-one correspondence with a rectilinear physical series, we have, for the colour-sensations, a series which completely changes its character at four definite points of the scale—inflectional points, we may call them, to borrow the term of the mathematician. In correspondence with a simple change of velocity in the ether-radiations, we have, for sensation, what can only be described as a growing more and more yellow, then suddenly more and more green, etc.—four distinct rectilinear series, separated by points of homogeneity. The difference in character between a colour of the one sort and of the other is extreme, and needs to be distinctly marked out in language ; the term *mixture* for the intermediate colour-tones produces hopeless confusion with the *radiation-mixtures* ; the term *fundamental* for the others commits one at once to a colour-theory. There is absolute need here for two new terms characterizing directly the phenomena in question. I have proposed colour-*blend* for the intermediate colours of the four rectilinear series, and *unitary* colour for the colours of the four inflectional points. The use of some such term as *colour-blend*, at least, is indispensable, in order to obviate—if that be possible at this late day—the hopeless confusion that exists between the objective and the subjective aspects of colour.

We should then say that a mixture of blue and green radiations gives a blue-green colour-blend ; of red and blue radiations, a red-blue colour-blend. (The word purple should be dropped altogether, and also orange ;

simple colour names should be reserved for the unitary colour-sensations ; the Esquimaux, with their immensely long word—twenty-seven syllables—for bluish-red (or reddish-blue) have been absolutely scientific in this respect, as other races have not been.) But a mixture of *red* and *green* radiations gives not a colour-blend, at all, but a unitary colour, yellow. I take the term colour-blend from the domain especially of teas ; what looks to the plain man like a plain tea will be detected by the expert, who is in the habit of analysing sharply his sensations, to be a blend of a certain number of definite constituents ; so to the introspective psychologist—the phrase is not a pleonasm—a purple will (in spite of its unitary name) be seen to be a colour-blend, viz. of red and blue, as much as is the explicitly named blue-green, or greenish-yellow.

There are many more defects in current nomenclature which I cannot mention here. Thus, to describe normal colour-vision as trichromatic is an absurdity—it is in reality *tetrachromatic*. What is true—and is being made out more and more conclusively by Nagel and his school, much to the discomfiture of the followers of Hering —is that three specific wave-lengths are a sufficient stimulus to produce all four of the *colour-sensations*. To explain this fact, an adequate theory is required. On the other hand, to call the vision of the totally colour-blind *monochromatic*, as writers do still, is equally absurd, and could only be persisted in by those minds (the description is Schroeder's) in which the law of contradiction does not hold.

<center>* * * *</center>

The two existent theories are theories which make comprehensible, each, some of the facts of colour vision, but at the cost of turning a deaf ear to the others. The one which I have proposed, and which Schenck has lately done me the honour to appropriate (as v. Brücke has pointed out), claims to do justice to both of the two sets of facts which it has seemed so difficult to reconcile. The main points of this theory are these :—

That rod-vision is colourless vision (or, to give it its due sensation-*quale*, whiteness vision) I maintained already when I brought forward my theory in 1892—a year before the first paper of v. Kries on the subject, although this view is usually attributed to him ; it forms an important constituent element of my colour theory. I assume, in fact, that the rods give rise to a primitive form of vision, colourless vision, and that the photochemical substance contained in them is capable of only one form of decomposition, the product of which is the excitant of the sensation white, or grey. In the course of evolution of the visual sense, the photochemical substance in the cones becomes more highly developed, and becomes capable of selective dissociation by light— the product of dissociation brought about by the rapid light radiations giving rise to the sensation blue, that of the slow radiations to the sensation yellow. This conception is not far-fetched, for Ramon y Cajal has, since my theory appeared, demonstrated that the cones are, exactly, in structure, more highly developed rods. But when both sorts of radiations fall upon the retina at once, the original decomposition product results ; hence blue and yellow when seen together give the sensation white, or grey. This represents the stage of visual development of the partially colour-blind (or of the yellow-blue visioned, as I prefer to call them), and also that of the middle zones of the normal retina. With the next stage of differentiation, the yellow-producing portion of the photo-chemical substance becomes itself capable of two partial dissociations, that is it becomes *synchronized*, in its internal vibrations, to *separate* portions of the spectrum, and gives rise thus to two different colours, red and green. But when both sorts of radiations strike the retina at once, the original sensation, yellow, occurs. When this last development has not yet taken place, we have the defective vision of the partially colour-blind. Selective dissociation by light radiation can only be conceived of as occurring by means of this synchronism

between its different vibration rates and those of the
internal electron vibrations of the substances affected—
as Ostwald has quite lately maintained. It is to account
for this selective dissociation that Schenck introduces
his separate visual elements, the Reizempfänger, or
excitation-receivers. But the final visual substance
must itself be timed to receive the vibrations of the
Reizempfänger, and if this is so, it can just as well be
selectively receptive to the vibrations of the light itself.
These Reizempfänger *can* be nothing more than a *façon
de parler*, and it is, in fact, just as easy to speak without
them. This is the only addition which Schenck makes
to my theory, and it is the gain of a loss, for theories
should not be overburdened unnecessarily. On the other
hand, he has overlooked my method for accounting for
the unitary character of yellow and white ; in fact, he
feels no psychical necessity for doing that—he is, in a
word, still in the prepsychological, and unenlightened,
stage of v. Kries and his followers.

Upon my theory, contrast, after-images, and all the
other phenomena of vision receive an easy accounting
for, which I need not go into here.

The theory of the differentiated photo-chemical visual
substance, the genetic theory of colour vision, I maintain,
solves the very difficulties which severally make impossible
the theories of Helmholtz and of Hering. It ought,
therefore, to be acceptable to all students of the colour-
sensations.

NOTE TO THEORY OF COLOUR THEORIES

[If one looks at a real image of a very bright diffraction
spectrum one sees a spectrum which is not distorted, as is
the refraction spectrum, by being stretched out some six
or seven times too much at the high frequency end. When
the intensity is high, the dual colour blends which usually
separate the unitary colours are very inconspicuous—one
sees three good blocks of blue, green, and red, with a

narrow but brilliant band of yellow between the green
and the red (see Fig. 14*a*). For experiments with spectral
light, the refraction spectrum is for some purposes to be
preferred, but for a picture of the real spectrum it is
entirely wrong—that represented in Fig. 14*a* is the one
that should always be used. It has another point of
superiority—its negative after-image (residual image)
is also very illuminating. White light is made up,
physically, of Blue, Green, and Red. We have only
to bear in mind the colour-triangle (Fig. 13) to see at once
that the colours of the *residual* images of R, G, B, are

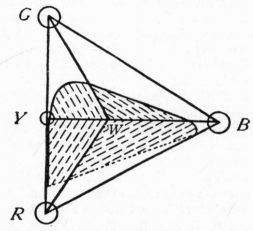

FIG. 13.—The *quadrigeminal* colour area—*triangular* in shape.

respectively BG, BR, RG (which is yellow), with B as
the after-image of Y. But when one looks at this
simplified (scientific) spectrum, one sees that it is easy
to give purely physical (that is correct) names to the
specific lights that make it up—we have only to call them
lights of High, Low, and Middle Frequency, and we have
then the compound name, Low-Middle, for Yellow (which
is appropriate, because Yellow is a secondary product—
it is made up out of Red and Green). This we have repre-
sented in Figure 14*b*. Of these names, High, Low, and
Middle Frequency are all that the physicist needs

(because he ignores the existence of yellow anyhow);
but the tetrachromatist will add Low-Middle to his list,
because he can see the yellow which takes the place of what
would naturally be the series of the red-greens. If the
physicist could be persuaded to use these names, he would

FIG. 14.

be well on the way to recognizing the fact that the
colour-sensations are not the same thing as the physical
light-frequencies.]

THE EVOLUTION THEORY OF THE COLOUR-SENSATIONS (THE LADD-FRANKLIN THEORY OF COLOURS)

A QUESTION OF PRIORITY

IN respect to most of the characters found in the human animal, one has only the lower animals in which to study the course of their gradual development, but in considering the colour-sense one has the unique advantage of being able to perceive its successive stages spread out upon one's own retina. It has been found that anatomically the structure of the retina is of a high form of development in the centre, and that it gradually becomes less highly developed towards the periphery; of the retinal visual elements, the cones alone (which have been shown by Ramon y Cajal to be more highly developed rods) are found in the fovea, and they occur more and more sparingly farther out until there are practically none in the extreme periphery. Corresponding with this fact of structure is the fact of sensation that we get full tetrachromatic colour vision only in the central portion of the retina, and nothing but achromatic vision (that in which all objective light, of whatever light-ray constitution, looks white in quality) in the extreme periphery. This fact, together with the circumstance that the retina of night birds-of-prey (who have no occasion for colour vision) is very deficient in cones, led Max Schultze to form the hypothesis that chromatic vision is mediated by the cones only, and that the rods furnish nothing but achromatic vision. This view was further strengthened when it was advocated independently by Parinaud, upon reasons based on the facts of hemeralopia, a disease which consists in the non-functioning of the mechanism for darkness adaptation. The disjunction of function

of the rods and cones—the specific rod-cone function (Ladd-Franklin)—was rendered indubitable by certain discoveries made in König's laboratory in Berlin in 1892. They are : (1) The exact coincidence of the distribution through the spectrum of the subjective intensity of night-vision in the normal individual (which coincides with that of night and day vision in the achromatic defectives) with the objective spectral absorption of light by the visual purple. The latter substance appears only—or at least in vastly greater quantity—after adaptation has taken place (König). (2) The following two closely connected facts (Ladd-Franklin, *Sitzber. Akad. der Wiss. Berlin*, 21 Juni, 1892, p. 362) : first, *the normal night-blindness of the fovea*, viz., the fact that that form of substitute vision which the normal individual acquires after twenty minutes in a dark room—night-vision, as it may be called, or scotopia—he does not acquire in the fovea ; and, second, *the complete blindness in the fovea* of those individuals who have the typical (non-cortical) form of total chroma-blindness (achromatopia).

It must be repeated here that the ambiguous word *colour* should be used to include the colour grey (white), and that for colour proper one should say *specific colour* (Hess), *toned colour* (Hering), or *chroma* (Ladd-Franklin). It would be, for example, absurd to suppose that when we are discussing a *colour*-theory we are discussing a theory which accounts for the chromatic sensations only and not for the achromatic ones as well.

A remarkably good evaluation of these (then newly-discovered) facts of colour vision is given by Burdon-Sanderson (*Nature*, 14th September, 1893, p. 469). He discovered that all these complicated new facts are " best understood " in terms of my colour theory.

In the mid-periphery, vision is dichromatic and the colour-defect is likewise dichromatic ; the colours seen are blue and yellow, the colour-sensations lacking are red and green. The limits of these colour-fields are

not at all definite, because much depends upon the size and brightness of the coloured objects used for testing. The colours prepared by Hegg, of Berne, in which a bluish-green and a bluish-red (the zonally stable colour-tones) are made, by reduction of their chromaticity, such that they vanish together, should always be used by ophthalmologists and in psychological laboratories for investigations of colour fields. In this mid-periphery of the retina no structural difference can be made out; the atavism of the colour-sense which is here exhibited is evidently due to a non-development in the light-sensitive chemical substances in the cones.

In human vision we have, besides the normal colour defects of the non-central retina, many cases (congenital and acquired) of partial colour-blindness; these, in their typical forms, consist in seeing the whole spectrum as yellow in the long-wave end and blue in the short-wave end, with an intermediate point at which vision is achromatic. This colourless point is not at the place where the normal individual gets the pure green colour (the unitary green), but at a place which to him is blue-green. Those who have this yellow and blue vision only are of two distinct types, protanopic and deuteranopic, according as the distribution along the spectrum of their undifferentiated yellow-vision coincides with the normal distribution of the green constituent or of the red constituent. The blue-vision of all these cases coincides with that of normal vision.

Partial colour-blindness is a sex-linked character (Morgan).

Total defect in the chromatic sensations occurs much less frequently; the distribution along the spectrum of the achromatic sensation (which is all that is left in such cases) is sometimes the same as the intensity distribution of normal (tetrachromatic) vision; but more frequently it coincides with that of normal scotopia—the maximum is in the yellow-green. The former cases are doubtless instances of cerebral defect (the fovea is not

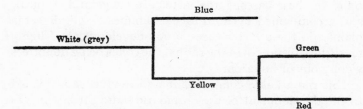

FIG. 15.—Development of the Colour-sense.

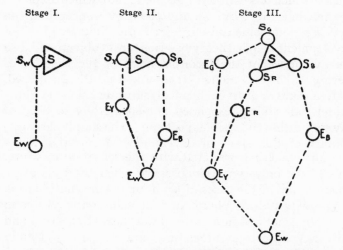

FIG. 16.—The Development Theory of Colour (Ladd-Franklin). S_N, the colour-sensation receptors (resonators, side-chains, light-sensitive electrons, or whatever the current photo-chemical theory may demand), in three successive stages of development. E_N, the several specific nerve-excitant substances for the five specific light-sensations.

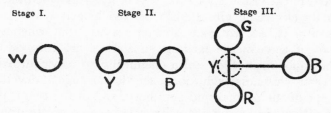

FIG. 17.—A different (simpler) representation of the development colour theory. Both, of course, are purely diagrammatic, and intended for mnemonic purposes only (Howell's *Physiology*).

K

blind in these cases) ; the latter are congenital, typical, and accompanied by total foveal blindness. The defect is plainly, in these latter cases, a non-development of light-sensitive substances in the retina, the cones being doubtless wholly out of function.

This remarkable congruent mass of evidence in regard to the development of the chromatic sensations, which is here briefly summarized, evidently demands a colour theory which takes it into account, and which explains at the same time, by one and the same conception, the facts of complementation. (See the diagrams.) The development colour theory has this for its object, and also the avoidance of the inconsistencies of the theories of Hering and of Helmholtz. It assumes that there occurred, first, a light-sensitive chemical substance in the (low-grade) rods which responded non-specifically to light of any sort within the visible spectrum. The simple cleavage-product of this stage of development forms the nerve-excitant which is correlated with the sensation of white. This is the only sensation possible when the rods alone function, i.e. in the cases of (a) normal achromatic vision in the extreme periphery, and of achromatic vision in (b) the normal eye in a state of darkness-adaptation and with low objective intensities, and in (c) the totally chroma-blind defectives. Development of the colour-sense takes place in the form of the acquiring of greater specificity in that part of the colour-molecule which undergoes cleavage. Instead of responding alike to all parts of the visible spectrum, part of it, Sy, is synchronous in its electronic vibrations with the longer waves, and part of it, Sb, with the shorter waves ; but whenever *both* of these nerve-excitant substances are torn off at the same time, they unite chemically to constitute the former whiteness-excitation. This is the stage of development of the normal mid-periphery, and of the two types of yellow-blue vision. In Stage III the complete differentiation of the light-sensitive molecule in the way of greater specificity has taken place, and red and green

are added as specific sensations. But the nerve-excitant substances, EG and ER, when they are both dissociated out together, reconstitute the yellow nerve-excitant, EY. Again it is plain that yellow and blue nerve-excitants re-unite to constitute the original nerve-excitant, Ew, whose sensation effect, when the cortex is reached, is white in quality.

After images are explained as a "residual" phenomenon, due to the completed dissociation of a molecule which in its partially dissociated condition is, like other such substances (Cannon), unstable. [Contrast has been shown by Fröhlich to be the after-image of diffused light within the eye-ball.]

This theory has been adopted in part by Schenck (Pflüger's *Archiv.*, 1907), but he leaves out an important feature of it—the explanation of chroma-extinction in the case of the formation of a plain yellow out of red and green, and also of white out of yellow and blue. Schenck is apparently not aware of the psychological fact that yellow and white, being distinctive unitary sensations and not, like the blue-greens, etc., colour blends, are in need of being accounted for. Schenck adds many hypotheses for explaining the details of colour-blindness, but they are too speculative to be of much interest. [v. Brücke has pointed out (*Centrlbl. f. Physiol.*, Bd. 20, Nr. 23) that Schenck did not, in his first paper on this subject, give me proper credit for my theory.]

VIII

ON COLOUR THEORIES AND CHROMATIC SENSATIONS

A CRITICISM OF PARSONS'S "COLOUR VISION"

" COLOUR Vision," by Dr. Parsons, is so good in itself
and so well adapted to bringing to the fore the
crucial difficulties of the Helmholtz and of the Hering colour
hypotheses that it invites extended discussion. It is not
to the physicist and to the follower of Helmholtz that the
book is especially calculated to be beneficial ; they—
alas !—will be too apt to be confirmed in the present
error of their ways, for the psychological point of view,
which demands explanation of the yellowness of yellow
and of the whiteness of white, is a point of view which
Dr. Parsons attains to only fleetingly and superficially.
Nevertheless, the space which is given to the work of
Hering, and the recognition of the widespread acceptance
accorded to his views, will perhaps have a subconscious
effect in laboratories where his name and his splendid
fight for the psychology of colour are practically unknown.
It is to the adherents of the other school—the followers
of Hering—that the book is destined to be invaluable.
It is an attractive piece of book-making—a fact of no
little importance ; it is freely provided with diagrams—
which act as *aide-mémoires* far better than columns
of figures, and which are not, in this instance, like the
diagrams of Hering, free-hand drawings based purely
upon the imagination ; and it offers a thoroughly well-
informed and acutely criticized summing-up of the facts
regarding colour-sensation, especially those facts which
have their origin in the laboratories where Helmholtz
is still followed, and which are therefore *res non gratæ* to
too many of the psychologists. Hereafter (on account
especially of the evident effort at fairness of this book)

it will not be possible for the facts which plainly contradict it to be utterly ignored in the schools where the Hering theory is made a matter of religious faith. (I am personally particularly glad to welcome so strong a defender of some of the doctrines which I have long been preaching.)

In order to obtain clearness of vision in the present situation as it regards the visual sensations it is necessary to keep constantly in mind the sharp distinction between the Helmholtz *theory* and the Helmholtz *facts*—the facts which are supposed to support it. The Helmholtz theory has very properly long ceased to be an existent thing in the mind of the psychologist, but he has too often made the mistake of throwing away the baby with the bath—the mass of facts which have issued from the Helmholtz laboratories are held by him in as bad odour as the theory itself. These facts group themselves, in good part, about the so-called colour-triangle, and the extent to which it has been of recent years possible to ignore them is evidenced by the circumstance that the very existence of the colour-triangle has been, in certain laboratories, practically forgotten. But this is a great mistake; there is no necessity for ignoring these facts; it is perfectly possible to conceive of them as compatible with the great discovery of Hering (re-discovery rather—the fact was never doubted from the time of Leonardo da Vinci until the coming in of the Young-Helmholtz fallacy), namely, the tetra-chromatism of the visual sensations and the independence of the sensation of whiteness. It was, of course, expressly for the sake of taking account of *both* these sets of facts, supposed by their respective defenders to be irreconcilable with each other, that I was forced, some time ago, to devise a different hypothesis—a conception which not only takes them both in, but which also accounts, at one blow, for the fundamental mystery of vision—the vanishing of the opposite colour-pairs—and for the fact that the development of the colour-sense is by way of

a middle stage of blue and *yellow* (the poor, unowned colour of the physicist !). (See Fig. 15.) In other words, this theory, the Development Theory, harmonizes and unifies, by means of a single, simple hypothesis, these four things : the "colour"-triangle (what should be called the three-stimuli triangle or the three-receptor triangle—Fig. 7), tetrachromatism, complementation, and colour development. My theory, in fact, succeeds in being, like that of Helmholtz, a three-stimulus theory, at the same time that it is, like that of Hering, a theory of tetrachromatism. The main value of Dr. Parsons's book lies in its forcible presentation of the three-stimulus view (which the followers of Hering are obliged to absolutely ignore), but he has not got psychological considerations sufficiently in the blood to perceive how indispensable it is to adhere to a theory which *unites* with that view the fact of tetrachromatism. I have discussed this aspect of my theory elsewhere.[1] That Dr. Parsons feels the necessity of having some adequate theory in terms of which to express the vastly complicated facts of vision is evidenced by his devoting the last hundred pages of his book—a little more than a third of it—to the explicit discussion of colour theory (what ought rather to be called colour hypothesis). It is, indeed, a disgrace that the two rival older theories should still have each its ardent defenders who are incapable of seeing that the views which they uphold, respectively, have been again and again wholly annihilated by the party of the other part. They may be said to parallel the two forms of colour-blindness, each incomprehensible to the other, where one set of defectives is able totally to ignore the existence of red and green, the other the existence of blue and yellow. But it is to be hoped that this book of Dr. Parsons will have the effect of forcing each party to recognize the existence of the other—of bringing the rivals to grips. Certainly

[1] See *Mind*, 1892 ; *Dict. of Phil. and Psychol.*, Art. "Vision"; *Am. Encycl. of Ophthalm.*, 1913, Art. "Colour Theory"; this book, p. 72.

no college professor, whether in physics, in physiology, or in psychology, can hereafter lecture to his students on colour without being aware that this fatal volume may easily be in their hands.

Dr. Parsons professes to give in the first and second parts of his book an account of facts only, and to treat theoretical considerations (together with such facts as are closely bound up with theory) only in Part III. This is, of course, an illusion. The two theories which he has chiefly in mind have each its own language, and no one can write, or speak, for five minutes on the subject of colour without giving away that he does or does not accept certain of the fundamental assumptions of one or of the other. Thus the view of Hering that the subjective intensity of, say, a whitish bluish green is due solely to the subjective intensity of its whiteness component, either is or is not a part of the speaker's mental furniture. This curious view of Hering's is, of course, a consequence of his having adopted the belief that the vanishing chroma-pairs, say yellow and blue, are antagonistic instead of white-constitutive. The chromatic sensations certainly vanish, and white appears in their stead : that they vanish may, in the first instance, just as well be supposed to be due to their having annihilated each other (as for instance an oxidation and a reduction would do) as to anything else. But whence comes the substratum of the sensation of whiteness which takes their place ? Either it is a residual matter, left behind, and present already in the blue and the yellow separately, or it is something which is constituted out of the processes of the blue and the yellow (just as, if there happened to be present at once an acid and a base, a salt would be formed and the acid and the base would both disappear.) The destruction view looks good enough, at first sight, for yellow and blue—already it excites question for red and green, because those colours are not white-constitutive but yellow-constitutive. (It is for this reason that the physicist—a lover of truth—

has never been able to give a moment's consideration to the theory of Hering.) But the strain upon one's powers of belief when one is asked to think that all the intensity of, say, a wholly saturated red is due to the intensity of its whiteness component, when there is no reason to suppose that it has any whiteness component whatever, is certainly very great. Dr. Parsons is of course not capable of this logical *tour de force*, and it is only the fact that he cannot really, even for a moment, think himself out of the common-sense view that brightness is brightness, that enables him to imagine that he is not committed against all the vagaries of Hering from the beginning.

Dr. Parsons's work exemplifies in a striking degree what I have elsewhere insisted upon—that the hopeless *impasse* that exists regarding colour would be in a great measure obviated if we were to adopt a more accurate terminology.[1] What I have proposed is, in part, that the term *colour*, now hopelessly ambiguous, should be used rigidly in that one of its two present senses in which it *includes* the achromatic sensations, and that for the sensation of colour proper we should use the term chromatic sensation, or, simply, *chroma* (pl. *chromata*). We should then have the terms chromaticity and achromaticity for " degree of saturation " and " degree of non-saturation " respectively. Toned and toneless colours (the Hering terms) are also perfectly correct.— Physical light rays should not be said to be red, green, etc., but to be erythrogenic, chlorogenic, leucogenic, etc.[2] They get their colour only *after* they have been passed through the retinal receiving station.—Instead of " brightness " (made wholly ambiguous by Hering's use of it) *subjective intensity* should, at least at present,

[1] *Psychol. Bulletin*, February, 1913, abstract of paper on " Colour Terminology ".

[2 Or the physical spectrum should be said to consist of blocks of high, low, and middle light-frequency, with a narrow but intensely bright band of low-middle frequency, yellow, p. 273.]

be used, or luminosity, or even, for the sake of freshness, the term of Hess, *lamprosity*.

As regards the term *colour*, since language affords us the two terms uni-colour and monochromatic—colour and chroma—of Latin and of Greek origin, why should we not at once particularize their meaning ? To *préciser* the meaning of superfluous words is to secure progress in accuracy of speech, and in this case nothing could be simpler than to use *colour* regularly in its extended meaning, and *chroma* for the specific meaning, colour proper (as is done in real life). There is no *colour* theory which does not include a discussion of the achromatic sensations. Is it not an absurdity to say, in the present loose meaning of the terms (as is constantly done in his book), that the sensations of the totally *colour-blind* are *monochromatic* ? The light sensations of the defective in question (and of the normal individual under various special conditions) are. of one *colour* only, it is true— the quality of the spectrum is white, in such cases, throughout its whole extent ; but they are not *mono-chromatic*—no chromatic quality is perceived at all, but only an achromatic one.

But the real seriousness of a defective terminology occurs in connexion with the discussion of the facts which are represented diagrammatically in the so-called " colour "-triangle. These facts and their significance are given their proper importance in this book, but they would be far less open to misconception if the language in which they are expressed were more carefully guarded. —To mention, preliminarily, a minor criticism in con-nexion with this topic, it is a pity that the two triangles which are represented in diagrams (pp. 39, 40) are differently drawn about an axis of symmetry—this obscures their resemblance to the cursory reader. In fact, the colour triangle, no matter how it is laid down by the original experimenter, ought always to be drawn about the yellow-blue line as a horizontal axis of symmetry (Fig. 18) ; in this way is made patent to the eye the unique-

ness of the *R Y G* side of the triangle, the fundamental
character of yellow-blue vision, and also the peculiar
mode of development of the colour-sense—the primitive
character of the colour system : yellow, whitish yellow,

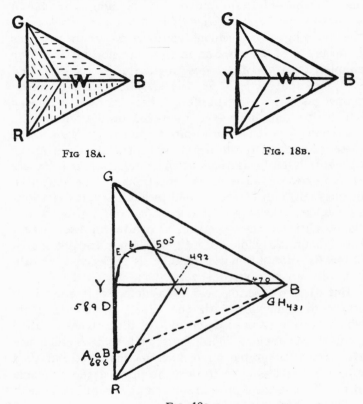

FIG 18A.

FIG. 18B.

FIG. 18C.

The so-called " Colour-Triangle ", quadrigeminal in character to repre-
sent tetrachromatism, but triangular in shape as expressing the
facts of matching by light-ray mixtures. The chromatogenic
radiations are here represented, in trilinear co-ordinates, as
functions of three independent variables.

white, bluish white, blue. Thus on the line *Y W B* are
represented *all* the yellow-white-blue sensations of the
red-green blind of either type ; and the " confusion "
colours (so mysterious to those who bother with the

CHROMATIC SENSATIONS

Holmgren wools), are one and all depicted upon lines
which pass through the points R and G respectively
and cross the line Y B.[1] Hence the convenience of
making the line Y W B a conspicuous line in the figure
is apparent.

The pivotal statement in Dr. Parsons's book, about
which his argument mainly centres, occurs when he says,
speaking of certain lucubrations of Edridge-Green, that
they are an inadequate explanation " of the trichromatism
of normal vision, *which is a fact, not a theory* ". (Italics
mine.) Now it is perfectly true that what Dr. Parsons
here intends to refer to is a fact and not a theory ; but
it is not trichromatism, and it will never be generally
accepted as a fact so long as it is called by that name.
" Trichromatism " is nonsense. Every psychologist
knows (and many a physiologist, but no physicist)
that vision is *tetrachromatic*, that there are four distinct
chromatic sensations, Red, Yellow, Green, and Blue.
(I adopt the use of capital letters to indicate the exact,
simple, unitary, chroma-sensations, while red (*e.g.*) with
a small letter, may still be used loosely, as in real life,
for a sensation which, though it may be slightly bluish
or yellowish, a little " off colour ", still has redness for
its predominant quality.) The fact which Dr. Parsons
is here referring to is (if expressed in the terms demanded
by our present knowledge of photochemistry) that the
resonance curves which represent the response of the
receptor substances of the visual apparatus to light are
three in number, that the activity of the receptor
apparatus can be expressed as a function of three
variables, and that an area which gives point-to-point
representation to distinct functions of stimuli is triangular
in shape. In Fig. 18*a*, the triangular character of
light-ray mixtures is represented roughly ; in Fig. 18*b*,
the exact spectral curve is reproduced. While the
shape of this figure is triangular, as representing the
facts of " matching by mixtures ", that the result is

[1] See Essay No. 1 in the present volume.

tetrachromatic may be very simply but quite adequately represented by the four-fold character of the striations (or by four actual pigments). I have called this the quadrigeminal (but triangular) colour area—it unites in one diagram the beloved colour facts of Hering and of Helmholtz. (Quadrigeminal is meant to be reminiscent of the *corpora quadrigemina*.)

The tridimensional figure, of which this is a cross-section, is usually given as a double pyramid, but that is a total misrepresentation of the real state of things.

Fig. 19.

There is no reason why the accompanying achromatic process and sensation (present, as is now well known, in the cones also together with the chromatic one) should not be represented. The correct diagram for this has been given in longitudinal section by Wundt,[1] and it is so important that I reproduce it here (Fig. 19) in the hope that it may come to take the place, in textbooks, of the erroneous double pyramid. After objective light has reached a certain (low) intensity an achromatic (pre-

[1] *Phys. Psychol.*, 4. Aufl., S. 537.

chromatic) sensation sets in, and increases from b to w. The chromatic constituent of the total sensation begins at c and takes the course $c\ r$. The dotted line indicates the chromaticity of the complex sensation—it reaches a maximum at m, and then approaches zero. Wundt has represented the chromaticity as a difference; it should, of course, be a ratio, but the principle is the same. A cross-section at any point of the solid of which this is the longitudinal section would give the colour triangle at a given intensity.

Exactly the same state of things as is depicted in the colour triangle is given again, by another method of representation, in the three distribution curves of König (Fig. 20). The fact that Dr. Parsons has searched well the literature of colour is evidenced by his giving these curves in their latest form—that required by the fresh determination of the intersecting points (which are also the points where change of objective intensity causes no change of colour tone) by F. Exner.[1] These curves differ from the similar, quadruple, curves of Hering, of course, in the circumstance that, while the latter are the pure work of the imagination, these are the result of the most exact measurements. This diagram ought to be adopted as the classical representation of these facts. Fräulein Steindler's determination of the four points of maximum discriminability for colour tone (page 32) makes them coincide rather closely with these inter-section points.

It is on the side $R\ G$ of the Helmholtz colour-triangle that is exhibited the character of colour vision which makes the Helmholtz colour theory impossible : while on the other two sides light-ray mixtures are simply correlated with sensational colour blends (the blue-greens and the blue-reds), as the theory requires, on the side $R\ G$ what should be the red-greens are replaced by blends with an entirely new sensation, yellow. This has to be accounted for *without giving up* (as Hering does)

[1] *Sitz. d. Wiener Akad.*, 1902, cxi, iia, 857.

the absolutely established laws of light-ray mixture, and the fact that the sensation systems of the dichromates are undifferentiated forms of those of the normally visioned. It is here, therefore, that it is absolutely necessary to distinguish sharply between the visual stimuli, with the dissociation processes which they produce in the receptor substances of the retina, and the resulting nerve-excitations which end in sensations. But the curious thing is that Dr. Parsons himself is, upon occasion, perfectly aware of the necessity for noting this distinction. He knows well, and he explicitly states it in one good passage, that the specific light radiations are not yet

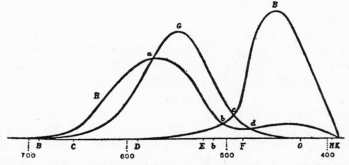

Fig. 20.—*R, G, and B*, resonance curves. These are the curves of König and Dieterici corrected to new determinations of the points of section, *a, b, c, d*. Abscissæ, wave-lengths of the interference spectrum of the arc light; ordinates, arbitrary scale. (F. Exner.)

chromata, but that a chroma is the conjoint effect of a specific, correlated, photo-chemical substance in the retina—the receptor mechanism—together with a nerve-end excitation and a nerve-fiber conduction, doubtless specific also, and excitable cortical (or sub-cortical) nerve cells. He says that it is only in a " broad " sense that you can speak of objects, or of radiations, or radiation-groups, as being colours—he should say that it is only in a popular and wholly inaccurate sense that you can speak of them as such; they are really nothing but red-producing, chromatogenic, erythrogenic, xanthogenic, etc., objects and rays. The confusion which is here so fatal

we owe, of course, to our primitive ancestor, the naïve realist. The situation is, however, equally fatal to every form of realism, as has often been pointed out. In most of our interests, both scientific and non-scientific, this ambiguity does not trouble us, but occasions may at any moment arise when (as in the present instance) it is of very great import. One should, therefore, even if one does not at once use it for every day, have an adequate terminology at hand for those occasions when to distinguish between sensation and the physical correlate of sensation is an absolute necessity.

The very discreditable state of colour discussion which has been kept up for fifty years may then be summed up in a word in this way. The theses maintained by the adherents of the two rival schools are these :

<div style="text-align:center">

Helmholtz *Hering*

" Trichromatism " is a fact. Tetrachromatism is a fact.

</div>

These are evidently two absolutely contradictory statements, but both true. *Que faire ?* At this point I felt myself obliged to interfere, with (1) a reformed terminology, and (2) an adequate colour theory. I substitute for the above two statements this :

<div style="text-align:center">

The Development Theory

</div>

Tri-receptorism is a fact and tetrachromatism is a fact, and these two facts are reconciled in the development colour theory—indeed, they constitute its groundwork.

To reproduce, in a word, my colour theory (for which Fig. 18 offers mnemonic support) : a light-sensitive substance in the visual elements (the rods), in primitive times, when vapour-laden skies and phanerogamic plants afforded no chromata to be seen, responded indifferently to all parts of the spectrum ; W, the mass of ions thrown off (photochemical reactions are now supposed to be a form of ionization), became a nerve-end excitant to which was attached in the cortex the sensation of

whiteness. In more highly developed animals—as in the bees (v. Frisch)—this cleavage product became more highly differentiated, and was capable of responding specifically to the warm end and the cold end of the spectrum, furnishing respectively the sensations yellow and blue ; but when both of these cleavage products are dissociated out at once, they reunite to form the whiteness nerve-excitant, W, out of which they were formed, after the analogy, for instance, of an acid and a base, which, being the constituents of a neutral salt, cannot (except in solution) exist separately. This form of vision persists in the partially colour-blind and in the mid-periphery of the normal eye. A further specialization of response to light-rays provides " red " nerve-excitants and " green " nerve-excitants, but, as before, red-greenness fuses into the yellowness *out of which it was developed*, while the blue-greens and the blue-reds persist as simple chroma-blends. An exact chemical analogy for this situation can be given.[1]

It will be seen that my theory is built about the evident consideration that the lack of the power to perceive the yellowish blues and the reddish greens of nature—the extinction of yellow-blue and of red-green into white and yellow respectively—is a *defect* in the visual mechanism—*un défaut de ses qualités*. The best thing that could be done, given the problem of developing light-sensitive substances in the way of making wavelengths discriminable, has been done, subject to the restriction that the whole process must be carried out in a single visual element ; physically adjacent cones (unlike the mechanism for auditory specificity) needed to be utilized for a highly specific space-sense. Any colour theory therefore (Preyer, Bernstein, Troland) which devises a special mechanism for the *express purpose* of making us blind to the yellow-blues and the red-greens is by that circumstance *von vorn hinein* condemned.

[1] See *Am. Encyc. of Ophth.*, Art. " Colour Theory ".

Some criticisms which Dr. Parsons makes of my colour hypothesis may be replied to briefly as follows :

1. Nowhere in his book does Dr. Parsons make a more thorough-going mixing up of fact and theory than when he says that my theory is an " offspring " of the Helmholtz *theory*. My theory takes in the Helmholtz three-stimuli *facts*—why should it not, when it was expressly devised for the purpose of bringing under a single, simple, physiological conception both those facts and the facts of tetrachromatism ?—but it is as far removed as possible from the Helmholtz *theory*, which is incompatible with tetrachromatism. It might just as well be said to be an offspring of the Hering theory because it takes in the Hering facts. But every theory which deserves the name must, since Hering wrote, take in *both* the fundamental facts which are made much of by Hering and those which are made much of by Helmholtz.

2. The connexion between my theory and that of Donders I have already discussed very fully.[1] As I have just said, no theory can be proposed (since Hering's) which fails to take in both the three-stimuli view and the tetrachromatic one. Donders' theory is much more like Hering's than like mine, for a fundamental point of mine is the unique character which it assumes for yellow. Yellow is beyond question, of course, a unitary chromatic sensation, but it is far from being in all respects the same sort of thing as the other unitary chromata, any more than it is the same sort of thing as the product of the other light mixtures, the green-blue and the blue-red chroma-blends. For one thing, there are occasions (McDougall) when red and green light-stimuli effects do not fuse completely, but give rapidly alternating, or possibly simultaneous, red and green sensations. In my theory the fusion of the red and the green nerve-excitants is a secondary phenomenon and there is no

[1] *Johns Hopkins University Circular*, 1893, *Science*, 1893, and Report of the Intern. Congress of Psychologists, London, 1892. See pp. 70-1, this book.

reason why, under certain conditions, it should not fail to take place—exactly (to return to a perfect analogy) as a salt in solution is now regarded as being always partly in a state of dissociation. [There seem to be some rare individuals—one case is that of a trained scientific man whose observation ought to be trustworthy—who regularly see yellow as red and green, and white as red and green and blue.]

3. Hering's explanation of simultaneous contrast is purely a verbal explanation. No one states more forcibly than Dr. Parsons that theoretical explanations in regions where facts have not yet been completely made out are waste of time. Simultaneous contrast over wide regions is possibly an electrical phenomenon of some sort, attendant upon the main events of nerve fiber excitation (as suggested by Troland). Tashiro's brilliant discovery of the increased giving off of CO_2 during the passage of a nerve current may be suggestive in this connexion, and so may the subjective vision of the nerve current in the nerve fibres of the retina [1]—that remarkable fact which has had half a dozen independent discoverers, Purkinje the first, and which is still nevertheless almost unknown.[2]

4. Dr. Parsons suggests the " addition " of a core of undifferentiated atoms to my assumed light-sensitive molecule. One thinks of selective dissociation by light now, of course, in terms of side-chains, or electrons, or probably, by this time, in terms of magnetons attached to a residual substance. But even at the time I wrote my first article on this subject my assumed molecule had already a " core " for the support of its resonating attachments, as Dr. Parsons would see if he were to look at my original diagram, and in fact I expressly mention

[1 The reddish blue arcs and the reddish blue glow, which I show to be due to the emission of physical light by the excited nerve fiber.]

[2 I have now adopted the good explanation of contrast that has been made out by Frölich—it is the simple after-image of scattered light in the eye-ball. *Zschr. f. Psychol.*, 1921, p. 89.]

its importance.[1] But the real answer to the supposed objection here intended (an objection which shows complete failure to understand the theory) is that (to repeat an easy analogy) if a salt were added to something in a test tube the effect would be the same as if there were added to it the acid and the base out of which the salt is constituted. It is, in fact, the theory of v. Kries (not mine) which is made impossible by the circumstance that there is no reason why his foveal white should look like his rod white, since their supposed physiological substrates are entirely different. My criticisms of his views on this point have been explicitly accepted by Professor Hering.[2]

Dr. Parsons's book, however, in spite of fundamental points in which it is very much open to criticism, can be safely recommended as indispensable in any place where the science of colour-sensation is under serious consideration.

[1] *Zsch. f. Psychol.*, 4, p. 6, 1892. That my light-sensitive molecule consists (like other complex molecules) of a *necleus* and of cleavable radicals has been, of course, from the beginning. an indispensable part of the assumption. The cleavable radicals are, in number, in the three stages of development, one (white), two (yellow and blue), and three (red, green and blue). Without a nucleus in Stage I there would be nothing to be dissociated out by light—there would be no workable hypothesis at all.

[2] *Pflüger's Archiv.*, 1907.

IX

THE NATURE OF THE COLOUR-SENSATIONS [1]

PROFESSOR CATTELL, in reviewing for *Science*, in 1898, the second edition of Helmholtz's *Physiologische Optik*, said that this work is " one of the few great classics in the history of science ". This very just judgment holds still at the present time, although it is now nearly sixty years since the first edition, which had been some ten years in coming out, was finally issued. Whoever looks over this splendid example of acute scientific thinking and brilliant experimenting will be grateful to the Optical Society of America and to the editor in charge of the translation, Professor Southall, for having decided to bring out even now (what ought to have been done long ago) an English translation of this great work. Some of the facts here recorded will, it is true, have been superseded by later work, but on the other hand much will be found in it which has been, by accident, simply overlooked in later times. The scientist in the subject of physiological optics will therefore be amply repaid if he reads this translation, and not simply secures it for his bookshelves.

[1] The writer of this Appendix [to the English translation of Helmholtz's *Physiologische Optik*, vol. ii, pp. 455 sqq.], as everybody knows, is particularly well qualified to discuss this subject. One of the sessions of the International Congress of Psychology in London in 1892 was devoted to new theories of colour-sensation. That evening the papers which had been read in the morning were being discussed privately by a group of scientists of whom Helmholtz happened to be one. He had spoken rather disparagingly of one of the contributions, when somebody asked him what he thought of Dr. Ladd-Franklin's colour theory. " Ach," said Helmholtz, " Frau Franklin,—*die* versteht die Sache ! " (J.P.C. Southall—the editor.)

I. The Helmholtz Theory

Helmholtz was a great psychologist as well as a great mathematician, a great physicist, and a great physiologist.[1] If his work were to be brought out now for the first time it would undoubtedly be called Psychological Optics instead of Physiological Optics—there is far more of psychology in it than there is of physiology, and the psychology is (for the most part) of an extremely acute, as well as of a highly original kind. Organized (non-philosophical) psychology was not definitely in existence when Helmholtz began issuing this book (1856) and he is, very properly, regarded as one of the first investigators in this field. It is, therefore, one of the most inexplicable of psychological occurrences that so great a scientist paid no attention whatever to the fact that, while the necessary *stimuli* for all the colours in the spectrum (and in the world) can be secured by appropriate mixtures of only *three* wave-lengths, the distinct, different, *sensations* that result are not three in number but five— yellow and white are just as good, just as unitary, light-sensations as are red and green and blue.[2] The things to be accounted for, then, in a theory of the visual sensations are, in the order of their phylogenetic development, a primitive achromatic sensation, the dull whites, and *four* chromatic sensations, first yellow and blue (the bees) and then red and green in addition (normal tetrachromatic vision) ; it may, therefore, be said that the Young-Helmholtz theory is at most three-fifths of a colour theory—it recognizes the existence of three

[1] It happens that his predecessor in the construction of a theory of the colour-sensations, Thomas Young, was also a man of the first distinction in half a dozen branches of learning.

[2] Black, as Helmholtz recognized perfectly, is a definite sensation, but it is a constant, permanent, background sensation which becomes evident and forms a dual blend with any of the colours—not with white only—when they are faint. It is a non-light-sensation, and it belongs to a totally different category from the light-sensations. Its function I have given a theory for (see *Dictionary of Philosophy and Psychology*, ii, Art. " Vision," p. 767, and *Psychological Review*, November, 1924). [See pp. 57 and 241 of this book.]

out of five of the actual sensations. But also it takes no account of why the chromata [1] are developed in this peculiar way in pairs : first *yellow* and blue (although yellow does not exist in this theory)—later red and green. (It is also in this order inverted that the colours are lost in the case of diseases of the eye—tobacco amblyopia, progressive atrophy of the optic nerve—and also restored if the disease is recovered from.) Still less has it occurred to the adherents of this theory to pay attention to the extraordinary fact (absolutely unique in the whole range of the sensations) that these very colours constitute " disappearing " colour-pairs [2]—that no human being has ever seen a red-green or a yellow-blue—though he would be very much surprised if he failed to see, on the other two sides of the colour-triangle, the blue-greens and the red-blues, or, in the taste sensations, *all six* of the possible blends, two and two—the bitter-sweets, the sweet-acids, etc. The theory is therefore in absolute contradiction to the first of the admirable " axioms " enunciated by Professor G. E. Müller—that in correlation with every distinct sensation some distinct physiological (cortical in the last instance) process must be assumed to exist. (*Ztsch. f. Psychol.*, X., 1–82.) To suppose (as v. Kries does) that for no assignable reason a three-fold process in the retina turns into a four-fold process in the cortex (or conversely, as Donders does) is to make admission of a fact, but does not provide a theory to account for it. Not everybody is interested in hypotheses (theories) ; some are content with a plain diet of fact. But it is well known that

[1] I have urged the introduction of this name, *chroma*, in the sense of *colour proper, getönte Farbe*, since 1913, in order to obviate the hopeless ambiguity that results from using " colour " in a double sense—now including and now excluding the achromatic sensations.

[2] The term " disappearing " colour pair is very necessary in order not to prejudice the mind of the reader, at first, as between the Hering conception (antagonistic chemical processes) and mine (that of *constituent* chemical processes). Still less is " cancellation " (Troland) a permissible term for this, unless one has definitely adopted the Hering theory.

successful theories of complicated occurrences in nature are not only intellectually satisfying but also most important as guides to further investigation.

Our ancestors thought that redness resides in the rose. They had, very naturally, no conception of the fact— now a commonplace of science (save for the physicists)— that there is no redness until specific light-frequencies have passed through the alchemy of the retina (and not always then—some persons, though they can see, are totally chroma-blind). That Helmholtz himself should have used the word " colour " in its primitive, objective, sense is singular in the extreme ; two successive sections of his book are called *Die einfachen Farben* and *Die zusammengesetzten Farben*, when what he is discussing is respectively homogeneous (or pure) and non-homogeneous (or mixed) light-rays. A blue-green sensation-blend may come from a homogeneous beam of light, and on the other hand a unitary yellow sensation may come from a mixture of " red " and " green " lights. While this use of the word " Farben " is a mere momentary inadvertence on the part of Helmholtz— he puts the matter in the third volume of this work (§ 26) in perfectly strict scientific terms—that is far from being the case with most of the physicists who write on colour at the present time, e.g. with Sir Oliver Lodge, Barton, Joly, Peddie, etc. This is all the more strange when it is remembered that Newton (no one, indeed, before him had made this discovery) says plainly : " The rays, to speak properly, are not coloured. In them is nothing else than a certain power or disposition to stir up a sensation of this or that colour . . . So colours in the object are nothing but a disposition to reflect this or that sort of rays more copiously than the rest."

Moreover, it is to be noted that in the original theory of Thomas Young it was the physiological difficulty of imagining a sufficient number of tuned retinal fibres for all the rays of light, in accordance with the view of Newton—" vibrations running along the aqueous pores

or crystalline pith of the capillamenta which pave or face the retina "—that led him to substitute a three-part mechanism, with an *overlapping* in various proportions for the intermediate blue-greens, etc.[1] Unquestionably, Thomas Young would never have called this hypothesis of his (a limited number-of-constituents-hypothesis) a *trichromatic* theory, nor (what is no improvement) a " triple nerve-excitation theory ".

It is for all these purely psychological reasons that the psychologists have never been able to regard the *colour theory* of Helmholtz as deserving of serious consideration. (The fact that Helmholtz gave no physiological explanation of what v. Kries[2] has lately furnished a much-needed name for, namely, the " accessory " visual phenomena, is of far less consequence ; the recent finding of Fröhlich, e.g. that contrast is simply an after-image of scattered light, would fit into any hypothesis regarding the fundamental process of the colour-sensations.) In fact, Professor Cattell has said of this theory (in the review already quoted from) that " if it were to be proposed at this time [1898] it would not have a single

[1] It would seem to be impossible for the physicists to realize that when once light has struck the retina, wave-lengths cease to exist—that their place is taken by *three* initial chemical products and *mixtures* of them. Thus no interest attaches to a pair of complementary *wave-lengths*. When red and blue-green, or green and blue-red, or blue and yellow (that is, red-green) mixed in the required proportions, make white, what we have is the fundamental Young-Helmholtz fact that white can be made out of the three physical constituents, red and blue and green. (Yellow does not need to be put in separately—yellow is a secondary chemical product that forms itself. See my theory, to be given presently.) A simple consideration of simple triangles (in the map of colour-sensations in terms of trilinear co-ordinates) will show that lines drawn through the whiteness-point will meet the spectral line in points such that their severally combined red and green and blue constituents will be in the correct proportion for making white. I have, therefore, to aid this process of thought, proposed the use of the term " transformer mechanism " (plainly adumbrated, as above, by Thomas Young) to accentuate the immediate change that takes place as soon as light performs its initial (photo-chemical) work upon the photo-æsthetic retina. There is everything in having a name when things are in danger of being overlooked.

[2] *Allgemeine Sinnesphysiologie*, passim.

adherent." William James said that Helmholtz is, in the science of colour, more eminent for his experimental work than for his theoretical contributions ; but it has been pointed out, on the other hand, that the *Physiologische Optik* was the work of his younger days.[1] In any case the physicists ought surely to take notice of the fact that the psychologists, who are experts in questions of *sensation*, find that the Helmholtz theory is wholly inadequate.

II. The Helmholtz-König Facts of Colour-Sensation

But however inadequate the Helmholtz theory may be for explaining the characters of the chromatic sensations —however certain it may be (1) that vision is tetrachromatic, (2) that it has undergone a remarkable and a perfectly well made out course of development, namely —(a) white, (b) yellow and blue in addition, which however revert to white, and (c) the addition again of red and green, which revert, when mixed, to yellow— nevertheless the result of the great work carried out in the Helmholtz laboratory by König and his assistants is plain matter of fact. It is indeed the most fundamental of all the facts regarding the colour-processes. However, it is not a fact regarding the *sensations* of colour, but only regarding the initial, photo-chemical process which starts up conditions resulting finally in sensation. Colour vision is not *trichromatic*, but it starts up (in the cones) with an initial " tri-receptor " photo-chemical process.

The distribution-curves of the (four) chromatic sensations which represent the theory of Hering are all purely the work of the imagination, and so are the first tentative curves of Helmholtz (still too frequently reproduced in the books). But the situation is very different when

[1] [A critic of mine (*Science Progress*) points out that Helmholtz revised the second edition of this work only shortly before his death. This is true, but, of course, he was making at this time only minor changes. He could hardly have undertaken to rewrite the whole book, what giving up his colour theory would have involved.]

it comes to the later curves, which represent what I may call the Helmholtz facts. These curves are drawn in accordance with the results of a vast number of observations in the game of " matching by mixtures "—the demonstration, by the eye, that all the colours of the spectrum can be matched by physical mixtures of red, green, and blue lights. When one-half of the field of view of the great Helmholtz instrument for mixing specific light frequencies, the *Farbenmischapparat*, is filled with a combination of two different lights and the other half with a homogeneous light, or a different light mixture, or white light, and if the proportions and the character of the several constituents are varied until the two half-fields are indistinguishable, we are said to have before us a colour-equation.[1] The results of these measurements are mapped in a *colour-triangle* (what the metallurgists call a triaxial diagram)—a very natural plan for representing (proportionally) by trilinear co-ordinates functions of three independent variables. The three distribution-curves picture the same facts by means of a different system of representation. But it was only after the incorporation into this work by König of the results of the equations made by the partially chroma-blind that it acquired its present immense significance.

This triangle should always be drawn with the yellow-white-blue line a fundamental (that is, a horizontal) line, as representing the fact that the yellow and blue system of sensations (that of the common form of partial colour-blindness, of the normal human mid-periphery, and of the bees) was the first to be developed.

When it came to deciding what wave-lengths to take for the independent variables in this work of matching by mixture, the choice was a difficult one for green

[1] The instrument provides also for the throwing of measured quantities of white light upon either field at pleasure. An improved model has been put on the market quite lately by its makers, Schmidt and Haensch, of Berlin. Other equivalent means of securing the same results are now in use in this country.

(the two ends of the spectrum were naturally chosen, as a first trial, for red and for blue). In the lack of any determining consideration for this choice, a green was taken somewhat at hazard, and tentative curves were determined. (König's names for these curves and for those which later replaced them, "*Elementaremp-findungen*" and "*Grundempfindungen*", are without present significance.) Just at this time it happened that it was possible to secure four individuals who were trained observers, and whose vision was dichromatic (two of each type). Would their curves show any coincidence with the curves of the normal eye? It turned out that while the *blue* curves of these defectives coincided with the blue curve of normal vision, the other two curves (both *yellow* in quality, it cannot be too often repeated) were markedly different. But would they perhaps have coincided if some *other* independent variables had been chosen? The question is easily put to the test: it is a simple matter of mathematics (merely a change in the vertices of the triangle of reference) to find out if there are independent variables, that is, unit quantities of lights of particular wave-lengths, such that the entire spectrum as seen by the three classes of individuals (the normal and the two types of defectives) can be built up out of like amounts of two or three of the several constituents—that is, are such that their curves do actually coincide. As a matter of fact König and Dieterici (König, *Gesammelte Abhandlungen*, p. 317) found that it was only necessary to make the following substitutions for the colours first chosen to disclose complete coincidence :—

$$R = \frac{R - 0{\cdot}15\,G + 0{\cdot}1\,V}{0{\cdot}95}$$

$$G = \frac{0{\cdot}25\,R + G}{1{\cdot}25}$$

$$B = V$$

The colours thus fixed upon are (1) a red less yellowish than that of the spectrum, (2) a green of about 505μμ, (3) a blue of about 470μμ. To repeat constantly that "these stimuli correspond quite closely with three of the fundamental physiological primaries of Hering" (*Colorimetry Report*, 1920–1) is to commit a sad error. The *Urfarben* of Hering are complementary colours, and therefore cannot be the same as the colours of the König curves. König and Hering both are perfectly explicit on this point (*Pflügers Arch.*, xli, 44, 1887, and xlvii, 425, 1890). The first set of König curves proves simply that three stimuli *are enough* to reproduce all the colours of the spectrum—they do not show that the actual constituents of normal vision may not be *more* in number. But the extraordinary circumstance that when vision is dichromatic the sets of two constituents (of two very different types) coincide respectively with one or the other pair of the three normal constituents, the blue and the red *or* the blue and the green, is a fact that can only be accounted for by admitting that we have here discovered the actual limited number of constituents of the wilderness of the colour-sensations. (It is this non-occurrence of either the "red" or the "green" *distribution* curve that has made it almost impossible for the physicist to admit the fact that in the case of undeveloped, second-stage, vision it is the more primitive yellow that the defective sees instead of *either* red or green.) In other words, the colour-systems of the two types of chroma-blindness are "reduction systems" (this admirable term is due to v. Kries.) [1] Another way of stating the fact here involved is this : in the colour-triangle all points on lines drawn through the vertices

[1] [But v. Kries and I do not mean exactly the same thing by this "reduction". I have decided now that a far better name for my purpose is "reversion systems". In both Type I and Type II of this atavistic condition there has been a failure to differentiate the more primitive yellow into red and green. The red and green which we see "revert", in these defectives, to the yellow which they were developed out of. I owe this good term to Professor Woodworth.]

R and G will represent colours which look alike to the defective concerned, and their quality will be that of the whitish yellow (or blue) point in which the line cuts the fundamental Y-W-B line of the triangle. The continued use of the term "confusion colours" shows great ignorance of all these well-established facts of colour-vision. To say that (*Colorimetry Report*, 1920–1, p. 553) "the results cannot be regarded as sufficiently final to justify their adoption in place of a maximally straight-forward [!] representation of the facts of colour mixture", and to reproduce König's crude, tentative, curves (loc. cit., p. 288), is to have missed this point altogether. The curves may be changed by future more exact methods, but the important thing is that they will both (normal and defective) be changed together, so that the *coincidence* will not be lost.

When it was decided to make the first edition of the *Physiologische Optik* instead of the second the basis of the third edition (1909–10), the editors automatically left out all of this very important work of König's in the determination of the distribution-curves. Many of the *theoretical* views of König were of such a nature as not to be confirmed by future results—as his belief that the cones have merely a dioptric function and that the photo-chemical process starts (for the chromata) in the epithelium cells. (It is plain that these large cells would have none of the minute space-specificity which is provided for in the cones.) But that is no reason for not recognizing the fact that his *experimental* work is fundamental in the highest degree. His great paper giving the complete account of this work did not appear until after the death of Helmholtz (1896; reproduced in *Abhandlungen*, pp. 214–321), but his final results had been very fully published, and they were expressly incorporated by Helmholtz himself in the *second* edition.[1]

[1] Up to page 640 this edition is the work of Helmholtz solely (as König expressly states in his preface); the account of the work of König is given in pages 357–70.

To have published an edition of Helmholtz with all this left out was very much like issuing the play of Shakespeare without the part of Hamlet. I therefore give on the opposite page the original diagram of König (loc. cit., p. 310), never before reproduced, as it happens, except schematically (Helmholtz) ; which exhibits the definitive coincidence between the normal distribution curves (König and Dieterici) and those of two each of the two common types of dichromatic vision (*yellow* and blue, in both cases, as sensations).

III. THE DEVELOPMENT THEORY OF THE COLOUR-SENSATIONS [1]

It can never be known beforehand what ones of a highly complicated (and apparently contradictory) collection of facts will be the ones to throw light upon the whole bewildering subject—to suggest a theory which will reconcile the facts in question and fuse them into one all-embracing conception. In 1891–2, when I had the good fortune to have successive semesters in the laboratories of G. E. Müller and König, and as a consequence to have the Helmholtz and the Hering points of view both very " warm " in my consciousness, I found the antagonistic states of mind produced by these two absolutely incompatible arrays of facts to be very irksome. It was (as I state in my first paper on the subject, *Mind*, N.S. ii, 1893) while I was engaged in writing an article to show that a certain theory by Donders was better than that of Helmholtz or of Hering, that it suddenly dawned upon me that a far better theory still was possible. The theory of Donders does nothing towards reconciling the views of Helmholtz and of Hering ; but (the converse of the position of v. Kries) it does at least recognize the fact that if vision is tetrachromatic in the retina, it must, to take account of the Helmholtz argument, become in some way " trichromatic " in the cortex. But this admission

[1] This has been variously called, by its adherents, the genetic theory, the evolution theory, and the development theory, as well as the Ladd-Franklin theory.

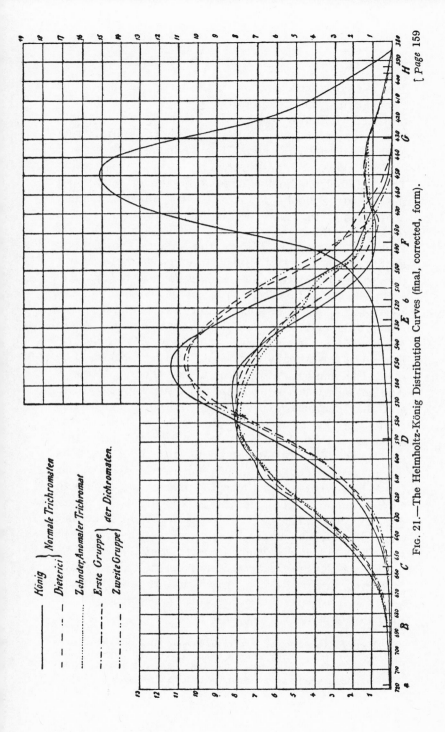

König } Normale Trichromaten
Dieterici }

Zehnder, Anomaler Trichromat

Erste Gruppe } der Dichromaten.
Zweite Gruppe }

Fig. 21.—The Helmholtz-König Distribution Curves (final, corrected, form).

[*Page* 159

does not constitute a *theory* of the fact. All theories of colour (with the exception of the one which I have proposed) fall into one or the other of two classes— they accept (and explain) *either* the facts of Hering *or* the facts of Helmholtz. Thus we have, as theories of " trichromatism " [1] and tetrachromatism, respectively : The Helmholtz School—Lodge, Joly, Barton, etc. ; and the Hering School—Donders, G. E. Müller, Fröhlich, Schjelderup, etc. Not one of these theorists does more than to shut his eyes to the facts which the rival theories explain. This applies also to the ardent exposition by Fröbes of the theory of Müller, although he comes nearer than is customary to understanding the adverse facts.

But in the light of the order of development of the colour-sense, the question became less insoluble. The remarkable fact of *the double structure and the double function* of the retina (rods and cones—Max Schültze, Parinaud) was already sufficiently well established to be made the foundation stone of a new theory of colour. And not only was it known that rod-vision is white vision, and that chromatic vision is cone-vision ; it was also plain that the chroma-pairs did not occur both at the same time, that the yellow-blue pair preceded the red-green pair. With this it became possible, by what Hegel might have called a " higher synthesis ", to reconcile the Young-Helmholtz tri-receptor process in a cone with tetrachromatism for sensation (Leonardo da Vinci, Brücke, Aubert, Hering), and to explain at the same time those singular phenomena, the reversion of the red-greens to yellow and of the yellow-blues to white.

The theory thus indicated may be described in the following terms. It is assumed that there is a light-sensitive substance in the rods which gives off, under the influence of light, a reaction-product which is the basis

[1] This word is a misnomer, if we take *chroma* in its actual significance. The vision of the totally chroma-blind is not monochromatic but achromatic. The initial three-fold photo-chemical process which actually takes place in a cone should be called a *tri-receptor* process.

of the primitive sensation of whiteness. In the cones, in the next higher stage of development of the colour-sense (the yellow and blue vision of the bees, that of partially chroma-blind individuals, and of our own mid-periphery), this same light-sensitive substance has become, by a simple molecular rearrangement, *more specific* in its response to light, and in such a way that the two ends of the spectrum act separately to produce nerve-excitant substances which, however, when they are produced both at once, unite chemically to form the " white " nerve-excitant out of which they were developed. In the third and final stage the " yellow " nerve-excitant has again undergone a development in the direction of greater specificity, and red and green vision are acquired. These reaction-products are, however, the constituents of the more primitive " yellow " nerve-excitant, and hence when they both occur at once— when red and green light fall together on the retina— they revert to the " yellow " nerve-excitant. If blue light is now added, the white sensation is again produced. Thus " yellow " and " white " are, in tetrachromatic vision, secondary products ; at the same time *they are the identical nerve-excitants* which produced the more primitive forms of vision. In other words (1) a light-sensitive " mother substance " in the rods which, on dissociation by light, gives off a cleavage-product, W, resulting (in the cortex) in the dull white sensations, becomes (2) capable of giving off two subsidiary cleavage-products, Y and B ; Y is split off by light of low frequency and B by light of high frequency ; Y is the nerve-excitant for the sensation of yellow, B for the sensation of blue. But suppose that, chemically $Y + B = W$; then if Y and B are both split off at the same time in the same cone they (being by hypothesis the chemical constituents of W) immediately unite to form W, and the *sensation* produced will be the primitive white. So in the third stage we shall have, in brief :—

$$R + G = Y, \qquad Y + B (= R + G + B) = W.$$

M

162 COLOUR AND COLOUR THEORIES

The accessory phenomena of colour are also given a perfectly simple and satisfactory explanation in this theory.

It is not necessary to discuss here the theory of Professor Hering; in addition to all its other difficulties it is absolutely incompatible with the Helmholtz fact of the tri-receptor process and consequently it has, naturally, never appealed to the physicists. There is no occasion for considering (as does Parsons) at great length all the minor merits and demerits of the Helmholtz and Hering theories. The situation is simply that Hering confutes Helmholtz and Helmholtz confutes Hering.

Before the time of Lavoisier, when chemistry was not yet in existence, the alchemists might by chance have discovered that on putting hydrogen and chlorine together in a test-tube, under certain conditions both of these substances disappear and hydrochloric acid takes their place. Being not yet chemists, they might have explained this experiment in this way: they might have said "Hydrogen and chlorine are a naturally antagonistic pair of elements—when they are put together in a test-tube they both vanish, and a hydrochloric acid which was there all the time takes their place". This would be analogous to the Hering explanation of the fundamental event in colour. But since chemistry *does* now exist, it would be a pity not to take advantage of its effectiveness for explaining disappearances and appearances.

The assumptions which I make (representing the psychological actualities) have been confirmed in a remarkable manner. (1) That the cones are *anatomically* more highly developed rods has now been put beyond question by Ramon y Cajal. It is natural, therefore, to think that the light-sensitive substance which they contain has also undergone development, and that, too, in the direction of greater specificity. (2) But following upon the discovery of Weigert (the photochlorides) that a specific light-sensitive substance need not show colour to the human eye, Hecht has proved that that in

the cones actually *is the same substance* as that in the rods, save that it has undergone a "molecular rearrangement"—the very phrase that I am in the habit of using to characterize the change in the colour-molecule made necessary by the *psychological* considerations (the same final whiteness-sensation in the cones as in the rods, though due to a three-part mechanism). (3) Moreover, nothing could be simpler, chemically, than this situation. In fact (as Dr. Acree has pointed out to me) there is a perfect analogy for it in a certain dye-stuff, a rosaniline carboxylate (no longer in practical use because it has been superseded by other less labile dyes). This is a substance such that (under proper conditions of light, heat, and moisture), (*a*) hydrogen, chlorine, and ethyl alcohol can either one of them be given off separately; but (*b*) when hydrogen and chlorine are given off together, they unite to form hydrochloric acid (analogue of the yellows); (*c*) when ethyl alcohol and *either* hydrogen or chlorine are given off they do not unite—they persist as mixtures (analogue of the blue-greens and the blue-reds); (*d*) when all three of these substances are given off at once they unite to form ethyl chloride (analogue of the three-part leucogenic nerve-excitant in the cones). In other words, the ethyl alcohol set free does not unite with either the hydrogen or the chlorine until after they have first united with each other, exactly as a "blue" constituent in the retina does not chemically unite with either a "red" or a "green" constituent *unless* they have first united with each other to make yellow. Nothing could be more perfectly analogous to what is required for the phenomena of colour vision.

In conclusion it must be kept in mind that no theory of colour-sensation is deserving of consideration which is not built upon, at once (1) the fact discovered by Thomas Young (and magnificently confirmed in the laboratory of Helmholtz)—that three light-stimuli are sufficient, as a physical cause, to start up the retinal photo-chemical processes; (2) the apparently

contradictory fact that nevertheless the *sensations* are *five* in number—yellow and white have been somehow added ; (3) the very illuminating fact that the *order of development* of the colour sense can be made to account fully for this anomaly and also for (4) the disappearance of the red-greens (and of the yellow-blues) and the appearance in their stead of yellow (and of white). Any proposed theory should be subjected to the test : Does it meet all of these " minimal requirements ? " (See *Journ. Opt. Soc. Amer.*, etc., vii, pp. 66–8.)

X

PRACTICAL LOGIC AND COLOUR THEORIES

ON A DISCUSSION OF THE LADD-FRANKLIN THEORY

THE psychologists, when they discuss reasoning at all (and some of them hardly give it passing mention), take the ground that the kind of reasoning that interests them is something very different from the cut and dried formulæ of the logician. The reason for this quarrel between two honourable branches of science is simply, of course, that the psychologist has the inveterate habit of including in his term reasoning the search for what I have called (a technical term) the " adequate " premises—which is half the battle, to be sure, when one is engaged in thinking out a solution to real difficulties. The pure logician, on the other hand, cares nothing for this aspect of the matter—he is concerned only with the validity of structures of premises. I propose to use the term *practical logic*, in a technical sense, for the psychologist's logic, and to call that of the logician theoretical logic, or pure logic. This simple device of giving two names to two different things ought to have the effect of modifying the contemptuous terms in which the psychologists sometimes discuss the logicians.

Why should not the scientist, whose constant occupation is practical reasoning, devote some time, now and then, to polishing up the tools of his trade ? Why should he not make a special study, when occasion offers, of the great quagmires of bad reasoning that, in various fields, lie behind him ? And it is exactly the psychologist who will have the best material for this study. It is safe to say that there has never been a subject of scientific research that has offered such a good field for studies of this kind as does the subject of colour-sensation. Both

the old theories and the new—both the current theories and the non-current—are rich in not only common errors of logic but far more, of course, in sins against the fundamental principles (axioms, as G. E. Müller calls them) of the neuro-psychic correlation. And as it is instances of bad grammar that we choose in order to teach the avoidance of errors of speech, so it is the mistaken theories of colour which have high pedagogical value in sharpening up the wits of the intending reasoner. As a matter of fact, moreover, it is some of the latest of the so-called theories which are quite the best pedagogically ; they will in general have been devised with knowledge of the most recent ideas in physics, physical chemistry and physiology—all indispensable to the knowledge of colour though not sufficient—and their errors in those plainest of methodological considerations which govern the making of theories in general and of psychological theories in particular will be found to be all the more curious and striking.

As a general principle, whoever notices some one of the innumerable effects of physical light that has not yet been made the basis of a colour theory immediately utilizes it as such, quite ignoring the basic anomaly of colour sensation—the existence of the " vanishing " colour pairs—the fact that of the six possible dual colour blends, the blue-greens, etc., there are two, the yellow-blues and the red-greens, which have never been experienced, and that in consequence (so different from what we have in taste) no tertiary blends and no quaternary blend have ever been sensed.

Theories which do not involve some hypothesis for the explanation of this curious circumstance are from the beginning negligible, and of this character are unfortunately most of the colour theories of which English physical science has lately been so prolific.[1] Another class

[1] In fact a table of the basic facts of colour (such as Professor Warren gives in his *Human Psychology*) should always be kept before one when he sits down to devise a theory of colour.

of negligible colour theories is that of the authors who fail to have noticed that while red and green are (like yellow and blue) a disappearing colour pair, they are not white-constitutive but yellow-constitutive ; this may be, from the point of view of logico-æsthetics, a misfortune, but it is, nevertheless, a fact, and there are many theories that are vitiated by ignoring it. The theory of Helmholtz falls, of course, into the first of these categories, that of Hering into the second. The latest of theories—that of Fröhlich, whose brilliant discovery of the oscillatory character of the nerve impulse in the optic nerve of the Cephalopod led one to expect much from an announced colour-sensation theory—suffers, at the beginning, from the defect that it adopts the erroneous view of Hering that red and green are complementary (white-constitutive) colours.

As, in making a study of the proposed new international auxiliary language (Hilfsprache) Ido, you will have a keen intellectual pleasure in seeing how apparently insuperable difficulties in the way of simplification have been overcome by the " Delegation " of clever language-logicians appointed by the International Congress of Philosophy of 1900, so in studying the mass of colour theories which have received, and are still receiving, solemn consideration at the hands of the critic, you will have a keen intellectual pleasure in noting what remarkable vagaries the mind of scientific man has now and then been capable of.

Before taking up a discussion of the logic of colour, I must remind my reader of the very essential reforms in colour terminology which I have been urgently recommending since 1913, and which the Optical Society of America seems now to be taking up. Half the battle, in taking in the ideas regarding colour which are necessitated by modern knowledge of colour—neither Helmholtz nor Hering knew the truth regarding, for instance, the development of the colour sense—consists in expressing those facts not in the primitive language of an earlier day but in precise, scientific terms.

Not only do I insist upon regularly using the terms chromatic and achromatic for the specific or toned (as the Germans say) colour-sensations, and for the non-specific, toneless ones, respectively—most writers, following Wundt, do this already ; but I also have boldly proposed the use of the shorter expressions chroma, achroma, in the corresponding senses.[1] It follows that the vision of the totally chroma-blind is not monochromatic but achromatic. The physicist should speak of homogeneous, not monochromatic, light rays, when they are (as they nearly always are) a dual colour blend, blue-green, etc. An exact monochromatic yellow may happen on the other hand to come from the mixture of a troop of very non-homogeneous lights.

From chroma and achroma follow at once, of course, chromaticity and achromaticity, which are far better words than saturation and non-saturation. Saturation with what ? A blue-green might be saturated with blueness or with greenness ; other things can be saturated with sweetness ; the word lacks the specific meanings that are conveyed by chromaticity and achromaticity. As, in the case of a series of blue-greens, we speak of the degree of blueness and of the degree of greenness, so here we express the degree of chroma and of achroma by the terms chromaticity and achromaticity. The free use of the term chroma will leave that terribly ambiguous word *colour* to be used in its inclusive sense. To the age-old question, then, " Are black and white colours ? " the answer is " Yes ".

It is hard to fully disabuse the mind of the idea that external objects are coloured. Colour arises only after specific light-rays have effected their alchemy of the retina (and not always then). Instead of red, yellow, etc., when one means the specific light-ray combinations, one should call them erythrogenic, xanthogenic, chlorogenic, cyanogenic and leucogenic. How could chemistry have

[1] The plural of *chroma* is of course *chromata*, save for such individuals as are in the habit of saying *scotomas* for *scotomata*.

ever reached its present stage of development if chemists had balked at hard names ?

The terms unitary colour and colour-blend explain themselves, and they are indispensable. A unitary red is the same thing as a red which is a psychological element, but that a given red is neither bluish nor greenish is the primary, direct deliverance of consciousness—that it is an *element* contains the addition of theory. Both terms are needed, but unitary comes first. Max Meyer uses the words *singular* colour and *dual* colour—also good and significant terms. But it is only of purely *chromatic* blends that we can say that they are dual only—a grey-green-blue is a quadruple *colour*-blend. To the age-old question, then, " How many different chromatic sensations are there in the rainbow (or in the world) ? " the answer is " Four ". The fatal confusion involved in the ineradicably wrong use (since Hering) of the terms luminosity and brightness I have discussed elsewhere. The lately proposed term " brilliance " merely makes matters worse.

The universe in which we find ourselves consists of three regions—the psychical, the intracorporeal, and the extracorporeal. Colour phenomena, like other phenomena of the conscious organism, include in the first place the physical, in the last place the psychical, and in the middle place the physiological. For the two " synapses " (if we may use this word in a metaphorical sense) which constitute the transition points between, respectively, these three regions, we need two names, and we shall also have need occasionally for a term expressing the final, non-direct connexion between the extracorporeal-physical and the psychical. I suggest, in the interest of precision, the use of the term psycho-physical parallelism for this latter sense (better still would be perhaps physico-psychic parallelism) in which " physical " is allowed to have the technical sense of extracorporeal physical.[1] For the sense in which psychophysical parallelism is

[1] Wundt explicitly uses the term in this sense.

usually used, and for which many writers have already substituted the better term psychophysiological parallelism, I propose to say, since it is, in fact, only the nerve processes (and chiefly the cortical nerve processes) that are concerned, the neuro-psychic correlation. I shall then have the word physico-physiological for the connexion between, e.g. the physical light-rays and the physiological (in the first place the retinal) processes which they excite. This restricted use of the term physical has perfectly good precedent ; we do not think of the "physicist" as being engaged in the study of physiology, as a whole—in spite of the fact that the dividing line between physics and some parts of physiology has become very narrow.

I am now able to point out that the psychophysical "parallelism" in conscious beings is a very different thing in the different sense regions. It holds, for instance, in the sense of taste ; for the different taste-*qualia* we have chemical substances which are capable of stimulating the different sense organs on the tongue. What could be simpler ? No "theory" of the taste-sense is required, or has ever been proposed. For the temperature sense the situation is the same—there are different sense organs for the different sensations, heat and cold. In sound also the physical stimulus—an ordered series of vibrations of different frequencies—runs parallel to an ordered series of tones of different pitch. There are no mixtures of these frequencies which give you a *vanishing* sensation—all possible mixtures are recognized as tonal blends.

But the philosophers quite forget the subject of colour when they virtually regard it as coming also under the head of a psychophysical parallelism (in the strict sense of the term). Note what becomes of the parallelism here. A single sensation, say, a grey-green-blue, can be excited by a thousand different combinations of electro-magnetic radiations—by a million, rather—and certain pairs of vibrations (what ought to give you, for instance, a blue-yellow) vanish, as such, and give you a whiteness instead.

It is as if, when you struck a *d* and a *g* on the piano together, you heard neither of these notes, but got a sensation of plain non-specific noise instead. This is what might be called a psychophysical perpendicularity, or topsy-turvyness, rather than a psychophysical parallelism. What to do ? It remains for the physiologist (but especially the student of photo-chemistry) to step in and to find out what can be done in the way of bridging this sad chasm. As a matter of fact, our knowledge of this whole situation is such, at the present time, that, by aid of the one simple hypothesis which forms the basis of my theory—that of a light-sensitive substance which undergoes development from a simpler form to a more complex form—we can make the whole situation fairly comprehensible. And the evolution of a chemical substance is not a far-fetched conception ; we have, in the very organs which contain this light-sensitive substance, an instance of structural evolution. That the cones are more highly developed rods was a constituent part of my theory from the beginning [1] : it has since been turned from hypothesis to fact by the work of Ramon y Cajal. It may be mentioned in passing that there is no occasion for speculating about the significance of *rod-shape* and *cone-shape* (as does Mr. Troland, at some length) for it has been made out by Pütter that the one *difference-character* between them that has been preserved throughout the animal kingdom (since these visual elements came in) is simply the character of the connexion with the second neuron—the rods have a knob-like ending, the cones have a dendritic ending. In 1907 [2] I said that these organs ought not to be called rods and cones (the cones are not even cone-shaped in the fovea), but that they should rather be named from their chief characteristics—knob-ended and finger-ended organs.

[1] Mr. Troland proposes to "supplement" my theory "by the assumption of an independent rod response for twilight vision". *The Enigma of Colour Vision*, p. 13, 1921.

[2] See Essay I in the present volume.

This prevision of mine has now (*v. Graefe's Handbuch der Augenheilkunde*) been confirmed by Professor Pütter. The greater specificity of connexion in the cones, of course, suggests a greater specificity in the character of the nerve-impulse, but one cannot say whether this has significance or not. There is another thing that should be mentioned here : the synapses between the bipolar cell and the third neuron occur in five perfectly distinct levels (Luciani) ; this naturally suggests a provision for the specific con-duction of the impulses which end in the five specific sense-*qualia*—the four chromata and the whiteness sensation. (Blackness—a non-light sensation—cannot be connected with anything conveyed up from the retina, on account of the fact that it is of one intensity only.)

When the physiologist has finally done his work (which, of course, he cannot do unless he keeps combined in his head the wisdom also of the physicist and of the psychologist), there remains the final transformation—that from cortical or possibly subcortical (Herrick) process to conscious experience, the neuro-psychic correlation. Here the correlation must be exact. It will not do to say with v. Kries (the most philosophical of the physiologists) " wir sind einem *gewissen* Parallelismus verpflichtet ". It is not necessary (as G. E. Müller has pointed out) that every cortical process that can have a conscious correlate should *always* have its conscious correlate. *Consciousness is a lambent flame*, and it does not always follow upon the appropriate stimulation. But in the other direction the axiom must always hold. No two final processes of a *different* kind can both give rise to the same grey-green-blue. The distinction cannot be topographical, for, just as in the retina, the *topographical* spread-out-ness has to be utilized for the place-coefficients of vision. But the peripheral rod-white-ness and the foveal cone-whiteness (since they are of the same quality) cannot be due to *different* final processes. v. Kries says that I do not explain why rod-whiteness and cone-whiteness look alike. But in this he overlooks one

of the main characteristics of my theory—not only do I explain this, but it is one of the principal things that my theory exists for the sake of explaining, as Hering has explicitly recognized.

The theories of Helmholtz and of Hering have been so fully discussed by the psychologists that their several inadequacies are now well known. Mr. Troland says (*Am. Jour. Physiol. Optics*, Am. Optical Co., pp. 8–9, 1913) : " The scientific value of the Helmholtz theory is at the present time almost negligible ; it explains only the most rudimentary of the phenomena of visual sensation ; and that of Hering, in its pseudo-chemical, physiological, and psychological aspects is guilty of all manner of offence against fact and reason." Bayliss makes short work of Hering : the disappearance of the two vanishing colour pairs cannot be accounted for by processes of assimilation and dissimilation, for there is nothing to prevent those processes from going on in one test-tube (or cone) at the same time. This is an argument that I have myself used against the Hering conception for a long time (" Professor Müller's Theory of the Light-Sense," *Psychol. Rev.*, vi, 1899). Parsons says that I am very severe on the theories of Helmholtz and Hering ; I can only say in reply, in the words of a clever medical article that I have just been reading, " If I could be more severe, I would be."

But, as I have already said, it is some of the most recent theories of colour that present the most instructive instances of sins against fundamental methodological principles. Of particular interest in this way are the colour theories of Mr. Troland. These theories are immensely interesting from the pedagogical point of view, as showing what vagaries the mind of a clever scientist is capable of when it goes a-colour-theorizing.

It is well known that Mr. Troland has a wonderfully fertile mind in the construction of theories. His original theory of nerve-conduction (that of 1913) will be found reproduced at length in *Physiological Reviews* of 192

But his present theory of nerve conduction is a very different one—in it he agrees with the views of Professor Lillie, but only as those views were developed up to 1911 (Lillie). This later theory (what Mr. Troland calls " our theory ") is very fully set forth in the *Psychological Review* of last year.

The earlier theory (of 1913) I find of very great interest from the "pedagogical" point of view. In this theory of 1913 (what he calls a " definite " chemical hypothesis) he follows the lines of Hering—there are assumed four distinct chemical processes to account for the four distinct chromatic sensations and a fifth to account for the sensation of white. (Black is, as in my theory—and in all theories except that of Hering—a sensation attached to a non-stimulated condition of the cortex.) But these processes are not antagonistic, nor reversible, as in the theories of Hering and G. E. Müller, respectively. This is, so far, an improvement over those theories ; but it still remains to account for the vanishing of the vanishing colour-pairs, red-green and yellow-blue. This mysterious phenomenon he explains in the following manner. The specific positive ions for yellow and blue, for instance, proceed safely through two synapses, and through one bi-polar cell, but when they reach the large ganglion cell of the inner stratum of the retina, the third neuron, a sudden exchange of partners takes place—a complicated molecule stands ready to yield up two specific negative ions to these two positive wanderers, and thus to prevent their proceeding farther. But their place is taken, obligingly, by the nucleus of this waiting molecule, which turns out to be a (double) *whiteness*-ion (and in the case of the red-greens a double yellowness-ion) ; in this way the white-sensation and the yellow-sensation take the place respectively of the missing yellow-blue and red-green.

I have tried to convince Mr. Troland (as he mentions in *The Enigma of Colour Vision*, pp. 28–30) that this conception is too much of the nature of a vicious *ad hoc* hypothesis—and even worse ; for, when once the four

specific chromatic nerve-impulses are safely started on
their way to the cortex, why should Nature, for no reason,
interpose a process for effecting their mutual extinction ?
Our blindness to the red-greens and the yellow-blues
is a loss, a defect (all blindness is a defect), and it can only
have occurred as an unavoidable insufficiency in the
method employed to make vision specific (as the heat-
sense has not yet been made specific—we cannot tell one
wave-length from another in heat). It is true that
Mr. Troland at first proposed the idea that this vanishing
of the colour-pairs might have sexual significance—that
yellow and blue were colours of approach and retreat
respectively, and that, in order to prevent the embarrass-
ment on the part of ardent youth and maid, of being
tempted to retreat and approach at the same time, they
were stricken with blindness (or their low-down ancestors
were) to the yellow-blues and to the red-greens. But
I understand that its author has at present given up this
part of his first theory. My contention that his hypothesis
is a purely *ad hoc* one Mr. Troland discusses, but he does
not assent to it and he still apparently defends this
colour theory.

In his second theory (*J. Opt. Soc. Am.*, 1917)
Mr. Troland has ceased to feel the necessity for having
yellow (or white) in his list of colours, and he adopts the
three resonance curves of Helmholtz, hitherto overlooked
by him. He actually says in this paper in plain black and
white : " To explain the facts of colour vision we have
only to assume the existence in the retinal receptors for
colour (the cones) of three substances of this sort, having
the maxima of their resonance curves in three repre-
sentative regions of the spectrum, and to suppose that the
relative intensities of these three excitations, for any given
wave-length, can be transmitted along the nerve to the
brain." This would seem to be merely a momentary
inadvertence on the part of Mr. Troland ; he knows as
well as do the psychologists that colour-sensation is
tetrachromatic—that yellow (and white as well) needs

to be accounted for in whatever purports to be a theory of colour-sensation. However, he repeats this statement in 1921. He says (*Enigma of Colour Vision*, p. 19) : It must be that " nerve-conduction must involve at least three independent variables, *and that three are sufficient* "— ignoring again the necessity of providing for yellow and for white. Fundamentally different as these two theories are, Mr. Troland usually refers to them as if he still believed in them both.

The third theory of Mr. Troland is indicated briefly in his paper of 1921 (*Am. J. Physiol. Optics*, p. 18). The habitat of this theory is now that " advanced " region, the cerebral cortex. The vanishing of the colour pairs becomes again, for him, antagonistic—namely a process of inhibition and excitation, and the " excess of nerve energy " that is thus set free produces " some " effect which is the basis of yellowness and of whiteness. However, I fear that even this hypothesis, vague as it is, is not perfectly satisfactory to Mr. Troland, for he says at the end of this same article that the facts of colour are still " in a fluid condition " in his mind.

But the principles of logic can be usefully studied not only in the composition of new theories, but also in the nature of the criticisms made upon theories that already exist.

Others have occasionally not fully understood what it is that my theory accomplishes, but no one has so completely misunderstood it as has Mr. Troland. The three important facts in colour (I cannot too often insist upon it) are (1) the development of the colour sense (with yellow and blue the middle stage, then red and green added), (2) complementation (but with yellow and blue *white*-constitutive, while red and green are *yellow*-constitutive), (3) the fact (Helmholtz, Young) that three initial *receptor-processes* are sufficient to start up the whole colour gamut—that yellow and white come in of themselves—that they are secondary products —that no *new* light-stimulus is required to produce them.

But what ones of the chromatogenic light rays are these three ? Strange to say, yellow (which plays such an important rôle in the *development* of the colours) is left out —all that are needed are red, and green, and blue ! This is indeed a mysterious situation, and the task of reducing to order and harmony such a contradictory collection of facts would appear to be (I am quoting from Mr. Troland) " a tremendous one "—" making more rigorous demands upon the intellect than the formulation of far more cosmic theories." But the problem of reducing these strange facts to harmony and order I have undertaken to solve,[1] and by the simplest of assumptions. I assume merely that there has been a *development* of a light-sensitive substance of this nature —that it has become, by a new segregation of its molecules, by the formation of new constituent radicals, more *specific* in its reactions to light ; but at the same time, since the molecules concerned are the same as before, certain of the decomposition products, when present together, unite chemically and form one of the previous nerve-excitant substances. This may of course not be the real state of things ; it is offered as hypothesis (not as " reality "), but it has perfect *vraisemblance*, and it affords a perfect explanation at once of complementation and of development. Until something better has been done, I hold that it invites consideration.

But it is exactly this fact—the explanation of complementation—that Mr. Troland has failed to notice in my theory. He says (" Enigma," 15, 2) : " They are supposed to generate an *entirely new type* of nerve excitation which ends in a *yellow* sensation." Not new at all— this is just the point—my theory explains why they produce the *old* nerve excitation—the very one that caused the sensation yellow in the more primitive forms of vision. That is to say, I explain (among other things)

[1] The other facts of vision, after these fundamental ones are disposed of, are of course more easily handled. [They are what v. Kries has called the " accessory " facts of colour-sensation—1924.]

why the *primitive* yellow is the *same sensation* as the yellow which (in tetrachromatic times) is made out of red and green, and also (what v. Kries too has overlooked) why the *primitive* white (in the rods) is the *same sensation* as the later white, that of the cones—in spite of the fact that the cones are such extremely different organs from the primitive rods. (Hering has expressed appreciation of this feature of my theory.) It seems to me that this is accomplishing a good deal in the way of explanation, and by the simplest of means. Unless defects in this hypothesis can be pointed out, I conclude that it ought to be regarded (as it is regarded by many) as an efficient hypothesis. Mr. Troland says that it is ingenious, and that the basic outlines are probably essential (that is indispensable) to any elucidation of the visual phenomena. But this is exactly what I have myself said regarding my theory from the first—that it is, at least, a " scaffolding " within which any final theory, when more detailed knowledge regarding the effects of light on the retina has been acquired, must be contained. Professor Burton Sanderson (presidential address, British Association, 1893) [1] after discussing the then recent facts regarding colour said that they could be best understood in terms of my theory, and added, quite correctly, that my schema is diagrammatic. At the same time I hold, with Mr. Troland, that it is indispensable.

Mr. Troland's attitude towards my theory [2] is, on the whole, rather complicated. These are the features of it which he appreciates :

1. He accepts my theory of the black sensation (but he has not noticed my theory of why we have a sensation of blackness nor my proof that the blackness sensation is of one intensity only—that the series of greys are

[1] *Nature*, 14th Sept., p. 469.

[2] Good diagrams of my schemata—better in fact than I have been using myself—will be found in Woodworth's *Psychology*, and in this book, Chart 5.

correlated with variations simply in the intensity of the white-constituent).

2. He yields to my insistence upon the fact that red and green lights, when mixed, are productive of yellow, not of white. (This is of course in complete contradiction to his Theories I and II—those of 1913 and 1917.) This view of mine has also been accepted by Westphal, by v. Kries, and others, and it has virtually been accepted by Titchener, when he, with great honesty, plainly says that the Hering green and red are not the exact green and red, but verdigris and crimson. There are two horns, one must note, to this dilemma. The real red and green lights, when mixed, do not make white but yellow. On the other hand, if you take a sufficiently bluish red and a sufficiently bluish green (" crimson " and " verdigris ") you will have complementary (or white-constitutive) colours, it is true, but you will be dealing with three (not two) unitary sensations, red, green, *and blue* (we have here the great Helmholtz fact), and you will need to assume for them, on the most elementary principle of methodology, not two but three photochemical processes. My theory, in fact, is the only one that both takes account of this fact and offers an explanation of it. The Helmholtz theory so called accepts indeed the fact, but (being, as Professor Cattell has pointed out, both pre-psychological and pre-evolutionary) it has not felt under compulsion to offer any explanation of it. This, as I have said, is an element of my theory which Mr. Troland explicitly appreciates ; it is in contradiction to his Theory I and it is unexplained in his Theory II, but he takes it over into his Theory III.

3. He recognizes the central feature of my theory, that it takes in both the sets of facts upon which the theories of Helmholtz and of Hering are founded (facts which are, respectively, subversive each of the other theory). He says, after " supplementing " my theory by the assumption of a primitive white process in the rods (which was of course a fundamental and essential

part of it from the beginning), " I think it is clear that the Ladd-Franklin theory is distinctly superior to the other two. This theory establishes contact on the one hand with the [four] psychologically primary colour qualities and on the other hand it takes cognizance of the three-colour-mixture laws upon which the Young-Helmholtz theory is based." (" Enigma of Colour Vision," *Am. Optical Company*, pp. 13–14.)

Mr. Troland's explicit objections to my colour theory are two in number :—

(1) He thinks that any theory of colour should deal exclusively with cortical processes—he says that retinal processes are probably " negligible " as throwing light upon these phenomena, and that the more " advanced " view is that the basis for the peculiarities of colour is to be found at some higher level. (It sounds a little like Christian Science, and New Thought, to say that some views on colours are more " advanced " than others. Topographically it is true that the cortex is more " advanced " than the retina.)

(2) His other objection is that in order for the partial dissociations to take place that my theory requires, there must have existed in the original whiteness molecule such aggregates of atoms as are those now to be broken off.

I take up the first objection first. In this tangled course of events from physical light to psychical light-sensation—from a " rectilinear " series (to use G. E. Müller's good term) of electro-magnetic vibrations to a poverty-stricken four chromatic sensations with their four (not six even, as there would naturally be) series of colour-blends, it is absurd to say that any *one* event is of " prime importance ". It is a total misconception of fundamental principles of methodology not to recognize that if we have a causal chain of events such that A conditions B, B conditions C, C conditions D, etc., each one of the intermediate events is, not only of prime, but of absolute importance. Who does not know that a chain is no stronger than its weakest link ?—though

there has not often been occasion, perhaps, to set it down as an axiom of scientific logic.

What Mr. Troland really means to say is that in his opinion the specificity of the visual chain of processes is more likely to reside in the cortical processes than in the retinal ones. But this is merely an opinion, and the fact that we know more about synapses than about photo-chemistry (if it is a fact) does nothing (though Mr. Troland seems to think it does) to support it. I agree with the opinion of Dr. Howell (just expressed to me in a personal communication) that the specific features of the visual chain of events are more likely to reside in the receptors, and in the receptor processes, than in any of the nerve-structures. When once the nerve impulse has started on its course it would seem to be practically the same thing in every sense region (save for the fact that the psychologist may demand of the physiologist provision for at least five different mechanisms of conduction in a single nerve fibre). In the debouching of nerve impulse upon that cortical structure, whatever it may be, which is correlated with the psychic experience of redness or greenness, there must indeed be something specific. There is no reason to think, however, that a " red " excitation and a " green " excitation can proceed uninjured to the cortex only there to be degraded into the basis for a more primitive yellow sensation.[1] It is far simpler to suppose that what I have called the " transformer mechanism " (by which for innumerable wave-length combinations are substituted *five* colours only) has its site in the retina. But Mr. Tro-land says (p. 15) that my theory would be more satis-factory if it were transferred to the cortex. I have no objection to carrying on, at need, a second theory in the cortex, but I confess that I still prefer, following Howell, the retina as my theory's principal habitat.

[1] In the Theory I of Mr. Troland they only reach a large ganglion, cell of the retina, there to be captured and to set free a waiting whiteness excitation. It may seem to some that this idea lacks " reality ", and *raison d'être*, though it is true that it has " definiteness ".

When it comes to the final link in the chain—what I have called the neuro-psychic correlation—we have indeed something which, as Mr. Troland says, is the most " interesting " stage of all. But it is a wilful ignoring of fundamental principles to suppose that light-sensation (or anything else) will ever do anything towards " explaining " it. What is an explanation ? It is a subsuming of facts, or of partial laws, under some more general law of which they constitute particular instances. But this connexion of final cortical process with conscious experience is unique—*sui generis*—there is no companion-piece to it in the universe elsewhere, and there is no more general situation under which it can be subsumed ; hence the effort to explain it will be futile. Its attendant conditions we may know more about but the real *why* of the situation is plainly undiscoverable.

Mr. Troland's second objection is not only trivial, it is also purely factitious. It is that if there are three groups of atoms in my final molecule which are separately cleavable by light, they must have existed in it from the beginning. This is not only a complete misunderstanding of my theory—it has also no foundation in fact. It is difficult to know where Mr. Troland got this idea that if certain substances are separated out from a given mother substance they *must* have existed already preformed in it. This fictitious rule does not hold even in the building of the complex nuclei of atoms out of the positive and negative electron groups of which they are composed. I have just come upon this statement by Professor Harkins, who is doing such important work in the evolution of the atom (*Phil. Mag.*, 42, 333) 1921) : " That groups which are not contained as such in more complex groups may nevertheless be separated out from them is one of the common experiences of workers in chemistry ; for example, anhydrous oxalic acid, with a formula

$$\text{H O C} - \text{C O H}$$
$$\quad\; \| \qquad \|$$
$$\quad\; \text{O} \qquad \text{O}$$

which does not contain the group HOH, nevertheless gives water when it is heated."

In the case required in my theory it is not a matter of a simple chemical reaction, but of the development of a chemical substance in the interest of greater specificity to light radiations ; it is an idea, therefore, which is still further removed from being questionable. In fact the belief that substances must be preformed, if they are to undergo cleavage is, my chemical advisors tell me, a conception that has not been current in chemistry since 1845.

But is my idea of the evolution of a colour molecule so out of the usual ? I admit that when I first proposed my theory this plan of paralleling (1) the known psychical development of sensation (non-specific whiteness into tetrachromatism) and (2) the known structural development of the visual elements (rods into cones) by an assumed development in the photochemical substance of the retina was somewhat venturesome, though even at that time it can hardly have seemed far-fetched. But the situation is completely changed now. Mr. Troland, who takes this view, but who at the same time explicitly accepts my idea that the added red and green sensations of normal central vision are not of the nature of a simple addition (as he took them to be in his Theory I) but that they constitute a real evolution out of a more primitive yellow sense, has probably not noticed that the idea of the *evolution of chemical substances* is at present very much to the fore. Aside from the new theory of Perrin—the radiation theory of chemical activity—I take it that there is nothing so exciting at present going on in the scientific world as the making out of the evolution of the atom by Soddy, Rutherford, Bohr, and Harkins. I find myself, in fact, in the best of company in my conception of a chemical evolution, and I consider that Mr. Troland is a little old-fashioned in opposing it.

But I have, as it happens, a very beautiful companion-

piece to my own conception—of such fundamental importance, in fact, as to give me all the analogy that I can ask for. Chlorophyll and hæmoglobin (perhaps the two most important substances in nature, Bayliss says), are both constructed out of practically the same constituents—both are compounds (with other substances present also, namely magnesium in chlorophyll and iron in hæmoglobin) of three dimethyl ethyl pyrrols. Willstätter (in a personal communication to Bayliss) uses these very striking words—he says that he does not regard the similarity in constitution between chlorophyll and hæmoglobin as being of any great significance. (By this he means that it is nothing extraordinarily unusual.) I quote from Bayliss : " The mother substances were probably at hand, and compounds with the properties of the two pigments, respectively, being required (if one may use the expression) these pyrrol derivatives were made use of."

With this analogy, so very much to the point, I confidently rest my case, as far as a chemical evolution is concerned.

I cannot then too strongly urge upon the scientist the study of practical logic as it is exhibited in the good, but more especially in the bad, theories of colour. The subject of light-sensation is a difficult one in the sense that there is no parallel in any other domain of the senses to throw light upon it, and also that the facts, which are numerous, are, indeed, when not woven together into some consistent structure, complicated and confusing in the extreme. These complicated facts have given rise to many attempted solutions, most of them, however, of a negligible degree of *vraisemblance* and wholly lacking in conformity to the simplest methodological principles. It is probable, in fact, that no subject of human endeavour has ever been the source of more vagaries and misconceptions—not even the squaring of the circle or the trisection of the angle—than will be

found in the existing theories of colour-sensation, sixty or seventy in number according to Frank Allen.

I do not however agree with Mr. Troland when he says that the task of comprehending colour is a " tremendous " one, and that it makes, perhaps, " more rigorous demands upon the intellect than does the formulation of far more cosmic theories." If, indeed, one envisages the phenomena of colour from the point of view of the way in which the colour sense has actually been developed in the animal kingdom, and if one also bears in mind that instead of a spacious cochlea Nature had only a very minute space—an infinitesimally small cone, in the fovea—in which to set up a whole new mechanism for specificity, it will be found, I believe, that the phenomena of colour are by no means so much more mysterious than other events which psycho-physiology has to deal with. Certainly when it comes to the nature of nerve conduction, and of the final neuro-psychic correlations, there is no reason to think that the domain of colour differs fundamentally from any other of the sense domains. And in the light of the known course of development of the colour sense, the facts of peripheral vision and of the illuminating progression of stages of colour-blindness cease to offer difficulties.

A more explicit discussion of the logical principles that should govern the making of theories of colour will be found in my paper " The Theory of Colour Theories ".[1] The science of methodology has of course a totally new problem presented to it when it reaches this subject. In other sense-regions variations in stimulation produce variations in consciousness, but that is far from being the case in colour. In general, a point on the colour area can be got by countless different combinations of wave-lengths. Such a sensational point is, however, uniquely expressed in terms of the three variable quantities which have been substituted, in the retina,

[1] *Comptes rendus du VI^e Congrès international de Psychologie*, Genève, 1909, 698–705. This book, p. 114.

for the octave of frequencies of the visible energy-radiations. This constitutes what I have called a "transformer mechanism"; if one fastens his mind upon the colour-triangle (the map of the possible colour-sensations) and forgets the visible spectrum, comprehension of the phenomena of colour will be greatly facilitated.[1] There is, it is true, an immense amount of work to be done (and being done) in making out, quantitatively, the details of each stage of the colour-sensation processes, but nothing is gained by over-emphasis upon the fundamental difficulties of the subject.

[1] Where, as I have said, in other sense regions we have a very good psychophysical *parallelism*, in colour we have what might rather be called a psychophysical perpendicularity, or topsy-turveyness. *Psychol. Rev.*, xxiii, 242–5, 1916. This book, p. 171.

PART II

SHORTER CONTRIBUTIONS AND REVIEWS

I

LIGHT-SENSATION (A NEW THEORY)[1]

THE reasons which make it impossible for most people to accept either the Hering or the Young-Helmholtz theory of light-sensation are familiar to every one. The following are the most important of them :—

The Young-Helmholtz theory requires us to believe : (*a*) something which is strongly contradicted by consciousness—viz. that the *sensation* white is nothing but an even mixture of red-green-blue *sensations* ; (*b*) something which has a strong antecedent improbability against it— viz. that under certain definite circumstances (e.g. for very excentric parts of the retina and for the totally colour-blind) all three colour-sensations are produced in exactly their original integrity, but yet that they are never produced in any other than that *even* mixture which gives us the sensation of white ; (*c*) something which is quantitatively quite impossible—viz. that after-images, which are frequently very brilliant, are due to nothing but what is left over in the self-light of the retina after part of it has been exhausted by fatigue, although we have otherwise every reason to think that the whole of the self-light is excessively faint.

The theory of Hering avoids all of these difficulties of the Young-Helmholtz theory, but at the cost of introducing others which are equally disagreeable : it sins against the first principles of the physiologist by requiring us to think that the process of building up highly organized animal tissue is useful in giving us knowledge of the external world instead of supposing that it takes place (as in every other instance known to us)

[1] Part of *Abstract* of paper distributed at the Congress of Experimental Psychology, London, August 2, 1892.

189

simply for the sake of its future useful tearing down ;
it necessarily brings with it a quite hopeless confusion
between our ideas of the *brightness* and the *relative
whiteness* of a given sensation (as is proved by the fact
that it enables Hering to re-discover, under the name of
the specific brightness of the different colours, a
phenomenon which has long been perfectly well known
as the Purkinje phenomenon) ; the theory is contradicted
by the following fact (now for the first time announced)—
the white made out of red and green is *not the same thing*
as the white made out of blue and yellow ; for if (being
mixed on the colour-disc) these two whites are made
equally bright at an ordinary intensity, they will be
found to be of very different brightness when the illumina-
tion is made very faint.[1]

[1] [This observation, announced by Ebbinghaus two years later,
is referred to in Parsons' *Colour Vision* as " by Ebbinghaus and Ladd-
Franklin ". Ebbinghaus gave a paper at this Congress (a very long one,
introducing a colour theory which he was afterwards obliged to give
up), but neither in the abstract distributed at the time nor in that
printed later in the Proceedings did he make mention of this very
significant phenomenon.]

II

COLOUR-BLINDNESS AND WILLIAM POLE

IT has long been matter of common knowledge among
psychologists that the colour-sensations which persist,
in the ordinary cases of partial colour-blindness, are
blue and *yellow*.[1] This was a requisite consequence
of Hering's theory and was predicted by him ; it was
proved by the first case of monocular colour-blindness
which was observed—that of v. Hippel in 1880—and
this proof has been abundantly confirmed by the cases
which have been discovered since. But the theory of
Young and Helmholtz apparently required that, when
two colour-sensations only persisted, if one was blue
the other must be either red or green. Now, the physicists
(and most physiologists as well) too hastily took the
Young-Helmholtz view as expressing fact and not theory,
and they continued to infer (although Helmholtz himself
had recognized the true state of the case) from the
circumstance that the partially colour-blind had two
sensations only, that these sensations were, in the ordinary
cases, blue and *red*, or blue and *green* ; and in accordance
with this deduction they classified most cases of colour-
blindness as red-blindness or green-blindness (without
expressly stating that, in their view, in both cases,
blindness to yellow was involved as well). There was
absolutely no reason *except the theory* for affirming that
the warm colour of the defective person was either red
or green ; all that was known was that it occupied that
portion of the spectrum which, for the normal person,
is occupied by red, yellow, *and* green. Nevertheless,
it is stated in twenty textbooks that the sensations
of the colour-blind furnish exceedingly strong, if not
convincing, evidence of the truth of the Young-Helmholtz

[1] [This showed rather too much politeness to the psychologists—
they are still very far from *all* knowing this very evident fact.]

theory. Moreover, the belief that the warm colour is either red or green has become so ingrained that the cases by which it has been shown beyond question that it is in fact yellow have often failed to produce any effect. Abney and Festing, in the *Philosophical Transactions*, say that the examination of colour-blind persons is of prime importance for testing any theory of colour vision, and, nevertheless, they are content, like so many others, to *infer* the sensations of the colour-blind from a theory which they have already adopted.

But as early as 1856 there was one man who, himself colour-blind, had convinced himself that his own sensations were blue and yellow, and he should have convinced all the world as well if the world had been open to reason—if it had not been preoccupied with a theory. This man was William Pole, F.R.S., professor of civil engineering in University College. His papers on the subject were published in the *Philosophical Transactions* ; his argument is exceedingly ingenious and it is little to the credit of the reasoning public that it did not make headway. Had it appeared a few years earlier than it did, it is probable that the Young-Helmholtz combination would never have been formed.

The history of opinion regarding colour-blindness presents, therefore, this series of occurrences :

1. A deduction from a theory was taken for a fact.

2. That supposed fact was taken as confirming the theory.

3. The same supposed fact was held so strongly that the highly ingenious reasoning by which Professor William Pole showed it to be erroneous failed to awaken attention.

4. Moreover, the cases of monocular colour-blindness, by which it is absolutely contradicted, are without effect upon it, with many people, even at the present day.[1]

[1] Even Parsons (*Colour Vision*, 1924, p. 191) is not yet able to make up his mind on this question. And the vagaries of Edridge-Green on this subject, in the *Encyclopaedia Britannica*, 12th ed., vol. 30, are wonderful in the extreme. It is a singular thing that his English public do not read Parsons on his views, in *Colour Vision* and also in *Brit. Journ. Ophthal.*, IV, 322, 359, 403 ; 1920.

III

THE EXTENDED PURKINJE PHENOMENON
(FOR WHITE LIGHTS)

BY the Purkinje phenomenon is usually meant the curious fact that blues and especially greens look abnormally bright when the illumination is diminished, and that yellows and especially reds look abnormally dull. The name commends itself as being also a proper designation for the still more curious fact that when a red and a blue-green are combined so as to give a colourless mixture, and also blue and yellow, these two mixtures, if made equally bright for an ordinary illumination, differ very much from each other, and also from an undecomposed colourless light, when the illumination is faint. This is in spite of the fact that, as far as the undiscriminating human eye can make out, they are all three identically the same thing. Tschermak, in a recent paper,[1] does not make use of this term, but it is evidently the right name for the fact, and its use will facilitate the report of Tschermak's observations. It is the Purkinje phenomenon only in so far as it deals with these colourless mixtures that is the subject of the present paper. The fact itself is evidently in direct contradiction with Newton's law of colour mixtures. That law states that if there are two pairs of indistinguishable light-mixtures, the double mixtures formed by uniting them two and two will also be indistinguishable ; as a particular case, one particular pair of light-mixtures may be the same as the other pair, and hence the law covers as well the supposed constant equivalence of two light-mixtures (and in particular of two colourless light-mixtures)

[1] " Ueber die Bedeuting der Lichtstärke und des Zustandes des Sehorgans für farblose optische Gleichungen," *Pflüg. Archiv.*, lxx, 297–329.

under all variations of objective intensity of illumination. The difficulty which besets the search for truth by experimental means, even in well-appointed laboratories, is well illustrated in the historical sketch with which Tschermak begins his paper. Newton's law was tested experimentally and proved to be valid by Maxwell and by Aubert by means of the colour-wheel. As Hering pointed out, this is very inadequate *proof*, so far as colourless mixtures are concerned, because greys made out of different coloured papers are very likely to be, in the end, physically exactly alike. [This objection does not hold for a *disproof* of the law ; for it is evident, even in the absence of a spectroscopic examination, that a *difference* in sensation-effect could only be due to a difference in light-ray composition.] v. Kries and Brauneck (1885) tested the law by spectral lights (colourless equations being included) and declared it to be valid. At the same time Hering published the results of his own investigation of the question, both by papers and by a good colour-mixing apparatus, and declared the " complete constancy " of colourless equations under changing illumination.

The next year, in his paper *Ueber Newton's Gesetz der Farbenmischung*, he reaffirmed this result in the strongest terms, and declared that any exception to Newton's law (whether due to different intensities of the lights or to changed conditions of the retina) would be quite inconsistent with our knowledge of the structure of the universe, and was *überhaupt* wholly unthinkable. If changes should afterwards present themselves at higher intensities than he had been able to try (he does not mention any exceptions for low intensities, which were of course easily attainable), it would be easier to suppose that secondary changes had been caused in the tissues of the eye by the strong light than to give up the validity of Newton's law. Hering also maintained with equal conviction, as the result of his experiments, that the equations were not affected by the local condition of

the retina, by fatigue, by increase or diminution of excitability, by simultaneous or successive contrast, or in fact by anything whatever that could affect the temporary excitability of the eye. And v. Kries, in two papers in *Du Bois' Archiv* in 1878 and 1882, had also announced that equations of all kinds persisted, no matter what the condition of the eye. The first authors who affirmed the dependence of colourless equations upon the intensity of the light for the trichromatic eye were Ladd-Franklin and [a year later] Ebbinghaus.[1] Hering,

[1] My own experiment was made for the express purpose of testing the Hering theory—that is, for deciding the question whether two opposite colours were antagonistic or complementary. If the colour-processes had destroyed each other, in a colourless mixture, and left behind only the accompanying white-process, then that ought not to be changed on the two sides of the equation (on the two zones of the colour wheel), being a chemical process of exactly the same nature in both. But if the two pairs of colour-processes contributed as such (either in whole or in part) to the colourless result, then, since they were brought about by different light-ray combinations, then, there was no reason to suppose that they would be equally affected by every possible change of circumstance ; and, in fact, König's recent measurements of the Purkinje phenomenon for colours made it probable that they would be unequally affected by changes of intensity. That turned out to be the case. The argument was conclusive against the Hering theory, until after König's discovery that the renewal of the powers of the eye in a dull light is due to the renewal of the rod-pigment. If the eye adds to itself an entirely new function in a faint light—a new organ, so to speak—a new absorption medium and that not of an " orthochromatic " kind, then, of course, any irregularity of sensation is accounted for ; and in this case the irregularity becomes immediately a regularity, for the light absorbed by the visual purple is of exactly the light-ray composition to account for the brightness-character of the new sensation. All this has been so self-evident, in the light of recent discussion of rod-function and rod-pigment, as not to stand in need of explicit statement.

Professor Ebbinghaus has never explained how it happened that he published his " discovery " of the extension of the Purkinje phenomenon to colourless light without any reference to my previous announcement of the same fact. He could not easily have been unaware of it, for his experiments were carried out in the same laboratory as mine—Professor König's—and he listened to my paper read before the Psychological Congress at London (1892), of which a printed abstract was also distributed. [Professor Ebbinghaus was, not unnaturally, very angry with me when my note on this subject came out in *Nature* (xlviii, 517, 1893), and for fifteen years we were not on speaking terms ; finally,

in his paper of the same year, attributed the reported departures from Newton's law, both for colours and for greys, to certain sources of error, and in particular to the varying proportional absorption of the yellow pigment of the retina for varying intensities, and he reaffirmed most explicitly the independence of colour-equations, whether seen centrally or peripherally, of, first, the intensity of the light, and, second, the condition of the retina. It is at this point that Tschermak quite destroys the dramatic character of his tale by leaving out the part played in it by Hamlet. It was König who definitely effected the connexion between the changed relative brightness of the different portions of the spectrum and the changed condition of the retina, by showing the quantitative coincidence between the former and the visual purple absorption. Hering had been, it is true, for some time insisting upon the importance of attending to the state of adaptation of the eye in all experiments with light, and he made a particular study of the Purkinje phenomenon, in the limited sense of the term ; but the *experimentum crucis*, by which it was connected with the visual purple, and hence with the rods, and hence with the white-producing portion of the visual apparatus (and by which, therefore, the fact was robbed of its force as an argument against any theory of antagonistic colours), was carried out by Professor König. Tschermak has taken up his present investigation at the instance of Professor Hering, and has carried it out in his laboratory. His purpose was to show that the departures from Newton's law are not due to anything in the nature of the *change of intensity* in itself, but that they are due to a change in the adaptation condition of the retina, which is in turn caused by the change in intensity of the illumination—in other words, that the

however, through the kind offices of Professor Deussen, at the end of the International Congress of Psychology at Heidelberg (1908), we became reconciled. Parsons always refers to this as the work of Ebbinghaus and Ladd-Franklin, in spite of the fact that my announcement of the fact came out a year before that of Ebbinghaus.]

change of intensity is not the immediate, but the mediate, cause of the phenomenon in question. He does this by showing in detail that the departure does not occur when the colour match is looked at in a faint light, but with the eye unadapted to that light, and that it does occur when the eye is in a state of darkness-adaptation even though the illumination is not faint. But I feel sure that there is no one except Tschermak among those at all interested in the subject who has had the least idea that anything else than this was the case. Whatever may be the modes of expression which König and v. Kries sometimes make use of, it cannot for a moment be supposed that they have attributed the above-named departures to anything else than the state of adaptation of the rods of the retina. As far as they yield to the temptation to use the fact against the theory of Hering, they are certainly quite without any ground to stand upon. Nevertheless, this paper of Tschermak is of much importance as containing the first admission that has issued from Hering's laboratory, as far as I have noticed, of the fact of the instability of colourless mixed light equations, which was announced by myself in 1892 and by Ebbinghaus in 1893.

IV

CONES ARE HIGHLY DEVELOPED RODS

DR. GREEF gives an interesting summary of the most recent additions made by Ramon y Cajal[1] to our knowledge of the structure of the retina ; the subject, up to the stage of its development here described, has been made most accessible to the non-specialist reader in *Die Retina der Wirbelthiere* (Wiesbaden, 1894) by Dr. Greef, who has also made contributions of his own to the work of the Spanish author. The most interesting points now made out (which may be added, for the English reader, to the excellent account in the *System of Diseases of the Eye*, by Norris and Oliver) are the following :—

Most important of all, it can now be affirmed, without doubt, that the cones are, quite simply, rods in a higher stage of development. This fact is very much to the favour of those theories of the light sense which regard the colour function of the cones as a developed form of the rod function, the latter affording no means of discriminating between lights of different periodicity. That the cones are intrusted with the conveyance of some more complicated form of excitation (whatever the nature of the excitation may be) is indicated by the fact that the knob-like basilar ending of the rods is replaced in them by numerous fine arborizations. If our subjectively acquired belief regarding the different functions of the rods and cones had happened to be the reverse of what it is (if we had been induced to attribute the colour sense to the rods and the undiscriminated light

[1] " S. Ramon y Cajal's Neuere Beiträge zur Histologie der Retina," R. Greef. *Ztsch. f. Psych. u. Physiol. der Sinnesorgane*, vol. **xvi**, 1898, pp. 161–87.

sense to the cones), knowledge on this subject would now be at a standing-still point of contradiction ; as it is, it can go on its way rejoicing in one more of those mutual confirmations of reasoning processes proceeding by different routes which are, in general, the source of the confidence we feel in our interpretation of the phenomena of the natural world. Even the latest writers on the histogenesis of the retina have had little to say on the early stages of the infra-limitant portion of the rods and cones. *It has only now been made out, by the Golgi method, and especially by means of the double impregnation and the rolling-up of the retina, that the rods and cones pass through a period (in the new-born cat, for instance) when they exhibit no difference in structure (so far as structure is preserved in these methods) and can only be distinguished from each other by the circumstance that the nucleus of one is surrounded by a somewhat thicker layer of protoplasm than that of the others, and so stains darker. (This is a stage in which the end members are wholly undeveloped, and so can give no means of orientation.) The question of their embryonal identity—a question which Cajal himself was formerly obliged to give up—he has now, therefore, been able to solve in the affirmative sense.*

Other points which may be noticed in this summary of results are these : There have been many reasons for regarding the rods and cones as differentiated epithelial cells, and not as nerve cells or as neuroglia cells—the epithelioid appearance of their outer members, their position as limiting cells in the interior of the primitive optic cup, etc. That they are, in fact, such is now established by the circumstance that in their development they pass through, like nerve cells, a monopolar phase, but that, unlike the neuroblasts of His, the cellulipetal process is first developed, and not the cellulifugal. If Ramon y Cajal is right, we have a criterion by which to distinguish between the three classes of cells which are capable of conducting nervous currents : (1) cells in which the cellulipetal process is formed first

(rods and cones, taste-cells, etc.) ; (2) those which begin
their development with the sending out of a cellulifugal
process (the great majority of the multipolar cells of the
nervous centres) ; (3) cells which seem to form both
processes at the same time (bipolar cells of the retina,
of Corti's organ, etc.). The difference between the bipolar
cells intended for the rods and those intended for the
cones is much greater in mammals the fourth day after
birth than it is later, which confirms Cajal's discovery
that these cells are distinctly different.—Recent studies
of the retina of the sparrow (in which this organ has
reached an extremely high development) disclose a new
form of cell (later detected also in the retinæ of reptiles
and of some mammals) which resembles both in shape
and in position the amacrine cells, but which differs from
them in having an immensely long (sometimes a milli-
meter long) axis-cylinder process. Their function seems
to be to act as association-fibres between distant amacrine
cells. They are extremely numerous and it is very
probable that the ramifications of the centrifugal nervous
fibres are spread out around these cells. They may be
called the amacrine-association cells.—The retinæ of
birds offer the best field for the study of the centrifugal
fibres ; for the finch, sparrow, etc., the Golgi method
is best ; for the thicker retina of the dove, that of Ehrlich.
Cajal is now thoroughly convinced that these fibres all
terminate in close contiguity with amacrine cells, and
that the function of the latter is to form an important
member in a conducting chain between the brain and the
junction of the bipolar with the ganglion cells.—Among
the regular cells of the ganglion layer are certain others
which are now made out to be true amacrine cells, but
not in their proper place—dislocated amacrine cells.
R. y Cajal has before laid down the rule that for the
recognition of the nature of a nervous cell one should
not attend so much to the position of the cell-body,
for that may vary greatly, but rather to the position
and the relations of the protoplasmic processes and the

axis-cylinder. By means of this principle Lénhossek has been able to discover the bipolar cells of Cephalopods, although they are on top of, instead of beneath the feet of, the rods and cones, and also their amacrine cells, although the bodies of these cells are quite out of their natural position.

V

AN ILL-CONSIDERED COLOUR THEORY

THAT the making of colour-theories goes on apace is a most healthy sign of intellectual activity—a sign that there is a widespread feeling of the utter inadequacy of the theories of Helmholtz and of Hering. These are both theories which served a useful purpose in their day, as a means of holding together the vastly complicated facts of colour vision, but they are both wholly inadequate to represent our present knowledge of the subject. The theory of Ebbinghaus met certain logical requirements which must be made of any theory in a very satisfactory fashion, but it was unfortunately wholly in discord with facts discovered immediately after it was brought out, and it has now been withdrawn by its author.[1] It is much to be regretted that Professor von Oppolzer has not been any more successful in meeting the conditions of a satisfactory theory.

The theory of colour here laid down[2] may be characterized as, in the first place, a " return to Goethe ". The author considers that Newton did not sufficiently emphasize the subjective character of colour—and this in spite of the fact that Newton states in the clearest terms that colour as an experienced sensation is something entirely disparate from the cause of colour—a given wave-length or combination of wave-lengths—in the

[1] In a very interesting investigation of Fechner's colours which has lately appeared in the *Journal of Psychology*, the results obtained are regarded as confirming the theory of Ebbinghaus, exactly as if that theory were still in existence. But surely an author must be conceded the right to withdraw his own theory when the occasion demands it!

[2] " Grundzüge einer Farbentheorie," Professor Dr. Egon Ritter von Oppolzer, *Ztsch. f. Psychol. u. Physiol. der Sinnesorgane*, xxix (3), 182–203.

external world. The purely metaphysical (or non-scientific) standpoint from which the problem of colour is approached in the paper before us may be inferred at once from the disquisition which meets us already on the second page on the subject of total colour-blindness. What the sensations of the achromatic really are, we are told, it is possible to infer, after frequent conversations with them, by means of the fact that colour-sensations for normal individuals are accompanied by certain feelings, certain æsthetic effects, which we discover to be wanting in these defectives. Even after we have made out that the spectrum looks alike to the totally colour-blind throughout its whole extent, how can we tell that it does not look to them all red or all green or all blue (as the Helmholtz theory would require us to believe) ? " Durch die Art, wie er seine Empfindungen beschreibt, was nur durch Angabe von aesthetischen Wirkungen möglich ist, erhalten wir die Gewissheit, dass er alles so sieht, wie wir, wenn wir Kreide, Schnee, Tageslichte ansehen." This is very wonderful ! Is our author really so acute that he can tell, when his patient sits in front of, say pink and white ice-cream, whether the æsthetic feelings which he describes are those appertaining to the sensation pink or to the sensation white ? If so, his powers of psychological insight are something marvellous, and he ought to be able to revolutionize our whole science, to lay its foundations broad and deep as they have never been laid before, if he will but bend himself to the task. And would the same principle, may we ask, enable us to pick out also the sensations which remain intact in the case of the partially colour-blind ? We can easily make out from what they tell us that their sensations are of two kinds only, as the entire spectrum moves before their eyes. But what two ? Are there four sorts of æsthetic feelings attached to the four colours, so accurately characterizable that we can infer from our conversation with the patient that red and yellow and green all give him the sensation of

yellow alone ? If the thing can be so easily made out
as this, our ancestors were very foolish to believe as they
did for several generations (misled by the theory of
Young and Helmholtz) that when the cherries and the
cherry-tree leaves looked alike to these defectives, they
saw them sometimes both green and sometimes both red
(and that yellow was a colour-sensation of so little
importance that it was not necessary to mention whether
they saw it at all or not). A simple examination into
these æsthetic feelings, according to our author, would
have settled this question correctly many years ago—
in fact, upon the first detection of colour-blindness.
What a pity that this idea did not occur to Dalton,
who concerned himself much about the character of his
colour-sensations ! Even William Pole, who showed
wonderful acuteness in this subject, overlooked this
method. The fact that the question has been wholly
set at rest by the occurrence of individuals who are
achromatic and dichromatic in one eye only seems not
to have attracted the notice of Professor v. Oppolzer.

To return to the contributions of Goethe to colour
theory—he has shown himself to be, according to our
author, a wonderfully fine observer in all questions which
concern " die innere Anschauung ", as appears at once
from this passage of his among others : " Die Farbe
sei ein elementares Naturphänomen für den Sinn des
Auges, das sich, wie die übrigen alle, durch Trennung
und Gegensatz, durch Mischung und Vereinigung, durch
Erhöhung und Neutralization, durch Mittheilung und
Vertheilung und so weiter manifestirt, und unter diesen
allgemeinen Naturformeln am besten angeschaut und
begriffen werden kann." This passage our author him-
self characterizes as "allerdings höchst dunkel", but he
takes it as proving " zur Genüge " that Goethe regarded
colour as a purely psychological phenomenon, " das auf
innerer Gegensätzlichkeit beruht." No one can have
glanced at Newton's writings without seeing that he too
regarded colour as a psychological phenomenon ; to say

that it rests upon an "innere Gegensätzlichkeit" is a statement that would not be contradicted by saying that it rests upon an inner harmony, for both are statements that are totally devoid of meaning. But it is especially upon Goethe's view that colour is accompanied by specific effects "die sich unmittelbar an das Sittliche anschliessen", and that while certain colours "stimmen regsam, lebhaft, strebend, andere ruhig" (why not four distinguishable temperamental qualities as there are four colours?), "voll und ganz rein wirkt nur die Weisserregung." "Hence" (to give at last the details of the author's theory) the sensation conveyed by any single rod or cone is purely white, and a colour-sensation is mediated by a combination of any two or of any three rods or cones. (Apparently it makes no difference whether a group of three is composed of rods and cones mixed up together or not.) But these retinal elements are not affected directly by light—that first reaches the cells of the pigment epithelium, passing through the thin plates of the retinal elements on its way. Here it effects a chemical change in the contents of these cells, and also in the pigment crystals which penetrate into the space between the rods and cones, and the products of this change act in turn upon the nerve ends within the visual elements. The idea that colour can result from a fusion of colourless sensation-elements the author says has been suggested to him by the phenomenon which we call tone-*colour* in sound—surely a very wild piece of analogizing!

It is singular how many ineptitudes a single theory of colour is capable of containing; the one here reported on has them on every page. Space in this Journal would be ill used in setting them all out, but it may be of some interest as a study in the working of a human mind, to indicate a few of them:

(*a*) When we get a tone-colour by the fusing of a fundamental tone with its overtones, the things fused together are tones which already differ in quality (namely

in pitch) ; but the three elementary sensations whose
fusion is here to produce colour are all alike—namely
white. Three pieces of molasses candy fused together
do not produce the taste of thoroughwort, nor of anything
whatever other than molasses candy. No application
of Fechner's law, nor of the formula

$$H = \sqrt{x^2 + y^2 + z^2},$$

will make anything but nonsense out of an idea like this.

(b) That it takes the working together of three visual
elements (three cones, two cones and a rod, two rods and
a cone, or three rods) to produce the least extended
sensation of colour contradicts well-known facts—the
fineness of vision in the fovea corresponds very closely
with the fineness of structure of the retina, as has been
well confirmed lately, among others, by Schoute. Minute
points of light do not give different sensations, as they
fall upon one or another visual element in the rod-less
region of the retina ; hence there can be no difference in
the functions of the several cones.[1]

(c) More than this, it is fundamentally wrong to assume
as essential to any visual sensation-quality the union
of three contiguous visual elements. The spread-out-
ness of the visual elements in the retina is the physio-
logical correlative to the subjective feeling of extension ;
it cannot be at the same time the substratum for visual
quality. In the ear, indeed, the successive efficient
elements of structure are devoted to differences of quality,
but that is not the case in the eye—there objective
spatial extent gives us subjective spatial feeling.

(d) While there is no difference in the sensation pro-
duced by each of the three members of a group of visual
elements, there is supposed to be a difference in their
receptivity—the thickness of the plates in the end
members is supposed to be so regulated as to make
them pervious now to blue rays only, now to red and now
to green. But this is just as it should not be—this is an

[1] [Isaacson, in the laboratory of König.]

arrangement for giving lying messages from the real world. Take the case of a small surface of a non-saturated purple ; if it falls upon a happily chosen group of three visual elements, it will look as it should do— as if constituted of red and blue, and a small portion of green. But if it changes its position a bit, it may hit a different group of three—say two red and one blue producing element ; then it would look wholly saturated, and far more red than blue. And a wrong group of three it would fall upon much more frequently than a right one. No correct and unvarying representation of nature could be obtained upon this scheme. This is, of course, an objection which applies to any three-fibre theory of colour, but a three-fibre theory was long since given up by Helmholtz—hard as it seems to be for the knowledge of this fact to become widely distributed.

(e) A more fundamental difficulty still remains. When three fibres of a proper group are all equally affected, the sensation produced is white (including grey). A saturated blue means that a certain one of the three is strongly affected and the other two vary slightly. But when we come to the case of that same one being affected to the total exclusion of the other two, then we have again absolutely colourless sensation. But is not this pure nonsense ? Was there ever a case of a theory which had been more thoroughly non-thought-out than this ?

(f) The beautifully fine structure of the retina in the fovea permits an exceedingly fine discrimination of parts in the visual field. But if a ray of light must go through the layer of cones and enter the pigment cells of the epithelium in order to produce there a chemical effect which has then to be reflected back into the cones, this fineness of structure would be thrown away ; it is impossible that such a chemical effect should be reflected back into the single cone from which it came, and hence we should get only an enlarged and blurred image instead of a sharp one of any small point of light.

(g) As a fitting wind-up, we may mention that the author is guilty of a very singular lapse in a matter of elementary geometry—he thinks that if one cylinder is n times as long as another, it has a surface which is n^2 times as great. This is so curious a phenomenon that it is worth while to chronicle our author's very words. Speaking of the rods he says : *Ihre im Vergleich zu den benachbarten Zapfen mindestens um das Dreifache grössere Länge des Aussengliedes vergrössert natürlich die Oberfläche auf das Neunfache.* This is not so "*natürlich*" as Professor v. Oppolzer supposes, and such lapses are not calculated to inspire confidence in his long mathematical lucubrations. It is sad to see that the present paper is only a first instalment of what is apparently to be a work of considerable length. It is a pity to waste precious pages of the *Zeitschrift* on such worthless matter, but it seems that even the acute responsible editor of that journal must sometimes nod.[1]

[1] [Prof. Nagel apologized later for having published this amusing specimen of a colour theory.]

CHANGE IN RELATIVE BRIGHTNESS OF WHITES OF DIFFERENT PHYSICAL CONSTITUTION AS SEEN IN PHOTOPIC AND IN SCOTOPIC VISION

DISPROOF OF THE HERING THEORY OF COLOUR

I AM very much surprised to see that Professor Ebbinghaus, in the last number of the *Zeitschrift für Psychologie,* announces as new a discovery which has a critical bearing upon Hering's theory of colour vision— the fact, namely that two greys composed the one of blue and yellow, and the other of red and green, and made equally bright at one illumination (by admixture of black with whichever of them turns out to be the brighter), do not continue to be equally bright at a different illumination. If two complementary colours were purely antagonistic—that is if the colour-processes simply destroyed each other, as processes of assimilation and dissimilation are supposed to do, and if the resulting white was solely due to the residual white which accompanies every colour, and gives it its brightness, then the relative brightness of two greys composed out of different parts of the spectrum could not change with change of illumination. The fact that they do change is therefore completely subversive of the theory of Hering, or of any other theory in which the complementary colour-processes are of a nature to annihilate each other. This consequence of the fact, as well as the fact itself, I stated at the Congress of Psychologists in London in August, 1892, and it was printed in the abstract of my paper, which was distributed at the time, and also in the *Proceedings* of the Congress.

Professor Ebbinghaus' discovery is apparently independent of mine, for he supposes that the phenomenon

cannot be exhibited upon the colour-wheel. This is not the case ; with fittingly chosen papers [one cannot tell beforehand what the spectrum of a coloured paper is], it is perfectly evident upon the colour-wheel. The same paper circles which I used to demonstrate it in Professor König's laboratory in Berlin are, at the request of Professor Jastrow, now on exhibition at the World's Fair at Chicago. While Professor Ebbinghaus' discovery of the fact is therefore doubtless independent of mine, I allow myself to point out that mine is prior to his in point of time.

VII

THE UNIQUENESS OF THE BLACKNESS-SENSATION [1]

A^N ingenious effort is made to put the blackness-sensation into the same category with those visual sensations which are the response to the action of light on the retina. Without entering into the merits of the several hypotheses of this kind, I feel it proper to remark that the purpose for which they are set up is not one which the nature of the phenomena calls for. I do not regard it as a defect, but as a merit, of my theory of blackness that it does not explain that sensation " in terms of processes of the same general nature as those assumed to explain the other visual sensations ", since the sensation of blackness is the psychic correlate of a very different physical situation, namely that of no stimulus whatever—a situation which does not vary in intensity.

But the crucial difficulty that arises when one tries to put the blackness-sensation into the same category with the other visual sensations is that a black-white, a black-blue, etc. (unlike a green-blue, a red-blue, etc.), cannot be made to change its intensity without at the same time changing its quality. The only way you can make a blue-black, for example, brighter is by making it at the same time *bluer*, while a blue-green can have the blue and the green *both* increased in (subjective) intensity *pari passu*. The simplest way in which to understand this is to suppose that the " black " physiological situation, exactly like the " black " physical situation, is something that cannot change in intensity. This total unlikeness of the whitish greens and the blackish greens, for example, was first

[1] *Am. J. Physiol. Optics*, 6, 1925, 453.

pointed out, very acutely, by Professor G. E. Müller. Hering meets this difficulty by supposing (1) that the " black " process changes, and (2) that it does not change *independently* of the light-sensation process : that (unlike all the other dual sensation-blends, the green-yellows, etc.), it is " tied to " it, in a definite way. In Hering's view, the " black " process diminishes exactly as the " white " process increases. This is a possible way to meet the difficulty (to use Mr. Troland's happy phrase) " academically " ; but it is more in accordance with simple methodological principles *not* to introduce an assumption which has to be immediately countered by a second assumption. It is simpler to avoid, in the first instance, this jumping into a bramble bush.

It happens that my theory of blackness has just been discussed more fully by Dr. Neifeld in the *Psychological Review* for 1924, and by Mr. Michaels in the same *Review* for 1925 (pp. 241 and 255 of this book).

VIII

PUTTING PHYSIOLOGY, PHYSICS, AND PSYCHOLOGY TOGETHER

THE reason that *comprehension* of the vast mass of facts already well known regarding the chromatic sensations has made practically no progress since the days of Helmholtz is that these *facts* are somewhat equally distributed among three different sciences, and that consequently there is no one who is able (or, at least, willing) to hold them all in hand at once. (1) Important work by Hecht has been appearing in the last six volumes of the *Journal of General Physiology*, which makes it quite certain that the initial retinal process is a photo-chemical one, and that the light-sensitive substance concerned in the primitive white of the rods is the same substance (as shown by its subjective-intensity-distribution) as that in the cones. (But Hecht here over-looks the fact that the circumstance that the *sensation* is the same, that of whiteness—the basis of my colour theory—is already an irrefragable proof of this identity.) (2) Most important of all of these contributions is the fact that König determined (1892) the actual constituents of the tri-receptor retinal photo-chemical processes by means of establishing (after proper change of the independent variables) perfect coincidence between normal tetrachromatic vision and that of both of the two types of atavistic dichromatic vision. This is a fact, however, that, by a marvellous chain of accidents, has been overlooked by the physicists themselves. I have endeavoured to restore it to its proper significance in the Appendix which the Optical Society has permitted me to write to the English translation of Helmholtz. (3) The contribution of Psychology to this subject is (*a*) the laying

213

down (1888) by G. E. Müller of the fundamental principles
that must govern the formation of any theory concerning
the neuro-psychic correlations, and (*b*) the work done
by Hering during his fifty years of magnificent activity
(aided by a large body of students both at Prag and at
Leipzig) in showing successfully that the so-called theory
of Helmholtz is no theory at all. His own theory, however,
exists only by denying the great Helmholtz *fact* that the
initial photo-chemical process is a tri-receptor process
(I am much pleased to see that Howell, in the 9th edition
of his *Physiology*, just out, has adopted all my
terminology). In neglecting Hering's *theory*, however,
the physicist has unfortunately overlooked the *fact*
which made it a necessity—the fact that both *yellow*
and *white* are simple unitary *sensations*, no matter what
their *physical* basis. In conclusion I permit myself to
quote from a letter just received from M. Piéron of the
Collège de France : " Il est certain que votre théorie
concile le mieux les faits si complexes relatifs au
fonctionnement lumineux et chromatique."

IX

THE REDDISH BLUE ARCS AND THE REDDISH BLUE GLOW OF THE RETINA : SEEING YOUR OWN NERVE CURRENTS

A SIMPLE band of bright red light thrown upon a screen in a dark room gives rise to a very curious phenomenon—discovered in the first instance by Purkinje.[1] What you see on the screen is not only the red band but also, projecting out from it on both sides, big slightly reddish blue arcs. They are not of the colour of the visual purple, which is a slightly bluish red. If one considers the shape and the angular size of these arcs, it is perfectly plain that what one sees, as an entoptic phenomenon, is certain fibres of the optic nerve which lie on the surface of the retina and which proceed to their exit point, the papilla.

But why are they visible ? The explanation that has been given of this phenomenon hitherto, by Gertz and by others, is that the nerve current by which one sees the red band gives rise to a secondary current in adjoining nerve fibres. Such a current as this, however, would not be provided with the right " place coefficients "—it would not enable one to see the stimulated fibres in the place where they lie. Let me put this hypothetical question : Suppose that one could lay open an optic nerve fibre all the way from the retina to the occipital lobe of the cortex, and suppose that one were to pinch it in half a dozen different places. The pinching of this

[1] This rare work of Purkinje—so rare that Gertz reproduces what Purkinje says about this phenomenon, because so few of his readers will be able to see his book—has now been reproduced in Czecho-Slovakia. Purkinje, Johann Evangelista, *Opera Omnia*. Praze : C. Calve, 1919.

nerve fibre would give one a light sensation (either chromatic or achromatic), but *where* would that sensation be seen to be ?—not, certainly, in the half dozen different places in which the nerve fibre is pinched. The sensations would one and all seem to be in that direction in the external world which is in one-to-one correspondence with the rod or cone in the retina from which the fibre which is pinched has come. We have the same situation when the man who has had his leg amputated at the knee has a nerve fibre pinched—he feels a sensation of tickling (or something), but he feels it not in his knee but in the ball, or the toe, of his foot.[1] It is, therefore, plain that in the case of the Blue Arcs of the Retina no possible nerve current evoked in adjoining fibres by the fibre which is conveying the red-light excitation would enable you to " see " those fibres—the actual place-coefficients attached to a sensation produced in this way would be entirely wrong.

There is another insuperable difficulty in resorting to any sort of a nerve-fibre stimulation as the cause of the reddish blue arcs. An after image of these blue arcs can be obtained ; one gets a sensation which meets the requirements of the after image both in achromatic intensity and in chroma—it is of a slightly greenish yellow. But an after image does not occur after a stimulation of the visual mechanism by an electric current. This one would have been inclined instinctively to take as self-evident ; but it has now been proved beyond question by the work of Lasareff, in which he finally demonstrates that nerve action is not subject to exhaustion.[2]

[1] To express this situation the psychologist has need of a new term. It is absurd to apply the phrase " local sign " to the case of the knee and the foot. " Sign " is a wrong term anyway, for there is every reason to think that we have here to do with an actual element of consciousness and not at all with a *sign* simply. I propose " place-coefficients " as the proper term for this form of *attachment* to the pure sensation. See also Katz, David : " Die Illusionen der Amputirten," *Beiheft zur Zts. f. angewandte Psychologie*, Leipzig, Barth, 1921.
[2] Lasareff, *Comptes rendus de l'Académie des Sciences*, 1925.

That nerve fibre when stimulated gives off some sort of an emanation which enables it to take its own photograph has now been proved by Nodon [1]; and it is perfectly easy to suppose that this " emanation " may be of the nature of visible light or, at least, of a nature to produce visible light by means of fluorescence, which is known to occur in the retina.

Various details of this phenomenon—the blue glow, which has been entirely overlooked by most observers, the absence of the effect in the case of individuals who have myelinated fibres in this region of the retina, and other considerations—make it very certain that its real cause is actual light emitted by the excited nerve fibres. It would follow that all nerves when excited shine by their own light—a light which is invisible, of course, when the nerves are not non-myelinated. One has not discovered this before, because, although one devotes much time to studying the excited nerve fibre, one does not do it in an absolutely dark room.[2]

[1] Nodon, Alfred : Ibid., 1923–6.
[2] See new *Comptes rendus des séances de l'Académie des Sciences*, 1927, 20th Sept., p. 584, and *Science*, 1927, 66, 239–241 ; 1925, 67, 162.

APPENDIX A

EINE NEUE THEORIE DER LICHTEMPFINDUNGEN
(*A New Theory of the Light-Sensations*) [1]

B IS jetzt weiss man gar nichts über das, was in der
Netzhaut vorgeht, wenn das objektive Licht in
Nervenerregung umgewandelt wird—man weiss sogar
nicht, ob dieser Prozess physikalischer, chemischer [2]
[oder elektrischer] Natur ist. Alle Theorien darüber
sind notwendigerweise rein hypothetisch ; man kann
sie nur als heuristisch wertvoll ansehen. Jede derartige
Theorie braucht, um existenzberechtigt zu sein, nur
einen solchen Prozess anzunehmen, welcher die
Erscheinungen naturgemäss und einfach erklärt, ohne
mit unseren anderen wohlbegründeten physiologischen
Anschauungen in Widerspruch zu kommen. Die Aufgabe
jeder Lichtempfindungstheorie besteht nämlich allein
darin, einen Netzhautprozess anzunehmen, welcher ein
mögliches Verbindungsglied zwischen den zwei Bereichen
des physikalisch Feststehenden und des psychisch unmit-
telbar Empfundenen ist.

[1] The original article, of which Essay No. II in Part I of this volume
is an abstract. An expansion also appeared in *Mind*, N.S., vol. iii,
1892. See page 66.

[2] [Evidence has now accumulated to the effect that the process
is really a photo-chemical one, as in fact is already assumed in the
theory which follows. Indeed it is with nothing but a chemical process
(and the resulting chemical reactions) as a basis that the magic dis-
appearances and reappearances which constitute the essential facts
of colour vision can be accounted for. Hence the success of this theory
in explaining *both classes* of the facts of colour (see p. 225) may be taken
as constituting, already at this time, pragmatic demonstration that the
action of light on the retina is in fact of a photo-chemical nature.
The details of this chemical process have now been made out much better
by Hecht (see *Journal of General Physiology*, 1927, vol. x, 781–811, for
his latest paper with references. It is supposed that what takes place
is a *coupled* photo-chemical reaction—two products of the decomposi-
tion by light of a light-sensitive substance act as catalysers to change
some inert substance into an active form which then excites the nerve.]

Es ist unmöglich, jemanden für eine neue Theorie der Lichtempfindungen zu interessieren, der nicht von der Unzulänglichkeit der bisherigen Theorien überzeugt ist.

Jede Theorie der Lichtempfindungen muss die fehlenden Brücken zwischen folgenden zwei Reihen paralleler Thatsachen, die für sie von kritischer Bedeutung sind, herstellen :

Physikalischer Vorgang.		Psychischer Vorgang.
1. Licht einer bestimmten Wellenlänge wirkt auf die Netzhaut.	Ein bestimmter Farbenton wird empfunden.
2. Eine Mischung von Licht zweier verschiedener Wellenlängen wirkt auf die Netzhaut.	In den meisten Fällen entsteht eine gemischte Empfindung, d. h. eine solche, in welcher [man verschiedene Bestandteile wahrnehmen kann ; sie stimmt jedoch auch, abgesehen von der Weisslichkeit, im Farbenton mit der durch eine zwischenliegende Wellenlänge verursachten Empfindung überein.
3. Gewisse Wellenlängenpaare (welche physikalisch nicht besonders ausgezeichnet sind) wirken auf die Netzhaut.	Es ensteht eine Empfindung, die wir die ,, Grau- (Weiss-) Empfindung '' nennen— welche (a) stets dieselbe ist, und (b) keine Spur einer gemischten Empfindung darbietet.
4. Der Einfall des Lichtes in das Auge unterliegt folgenden Einschränkungen : (a) Das affizierte Stück der Netzhaut ist sehr klein. (b) Es ist weit von der Fovea entfernt. (c) Das objektive Licht ist sehr schwach. (d) Es ist sehr stark. (e) Das betreffende Auge ist ,, total farbenblind,'' eine krankhafte oder atavistische Anomalie.)	Unter diesen fünf Umständen entsteht ohne Ausnahme ebenfalls die Grau-Empfindung.
5. (a) Dasselbe farbige Licht hat lange Zeit auf dieselbe Stelle der Netzhaut eingewirkt.	Das Bild erblafst, wird weiss und nimmt, falls das objektive Licht schwächer gemacht wird, sogar die komplementäre Farbe an, obwohl dasselbe farbige Licht noch weiter einwirkt.[2]
(b) Wenn man dann die Augen schliefst.[1]	so tritt die Komplementärfarbe deutlich hervor.

[1] [Oder eine graue Fläche ansieht.]

[2] [This last is an observation first made by the writer.]

Jede Theorie der Lichtempfindungen muss in die oben leergelassene Mittelspalte einen fingierten Netzhautprozess einführen, welcher eine natürliche Verbindung oder ein Zwischenstadium zwischen den beiden Seiten bildet. Den Anforderungen 1. und 2. wird durch die Young-Helmholtzsche Theorie genügt ; ebenso auch dem ersten Teil von 3., d. h. der Thatsache, dafs die Mischung aller jener Farbenpaare g l e i c h aussieht. Die Tatsache aber, dafs man ihre Bestandteile nicht wahrnehmen kann (unser Bewufstsein macht sogar keine andere Aussage mit gröfserer Bestimmtheit, als die, dafs die Weissempfindung n i c h t eine Mischung der Rot-, Grün- und Blau e m p f i n d u n g e n ist) wird gänzlich ignoriert—d. h. sie wird in das dunkle Gebiet der Urteilstäuschungen verlegt. Für den Psychologen ist also jedenfalls nie ein Grund vorhanden gewessen, diese Theorie anzunehmen, aufser demjenigen, dafs niemand eine bessere aufgestellt hatte.— Die unter 4. erwähnten Thatsachen kann man auf Grund dieser Theorie nur dadurch erklären, dafs zwar alle drei Farbenempfindungen unter jenen Umständen wirklich hervorgerufen werden, dafs dieses aber—was auch die objektive Beschaffenheit des Lichtes sein mag—durch eine ungemeine Boshaftigkeit der Natur stets im gleichen Grade geschieht. Solch eine Erklärung lässt natürlich viel zu wünschen übrig.—Was die negativen Nachbilder betrifft, so hat Hering durch eine grofse Anzahl höchst geschickter Versuche die Unmöglichkeit bewiesen, sie durch das nach der Ermüdung noch vorhandene Eigenlicht der Netzhaut zu erklären, wie dieses die Young-Helmholtz'sche Theorie tut. Es ist also unumgänglich eine andere hinreichendere Ursache für die negativen Nachbilder anzunehmen.[1]

Den l o g i s c h e n Forderungen einer Theorie der Lichtempfindungen ist von Hering in vorzüglicher Weise

[1] Dass Hering dasselbe für Kontrasterscheinungen geleistet hat, erwähne ich hier nicht ; bis jetzt lassen sich diese Erscheinungen mit keiner Theorie in Zusammenhang bringen. Herings sogenannte Erklärung ist bloss eine Übersetzung der Tatsachen in die Sprache seiner Theorie.

genügt worden. Aber, ohne auf seine Anschauungen über
die Helligkeit näher einzugehen, weise ich doch auf die
unüberwindliche Schwierigkeit hin, welche für seine
Theorie darin liegt, dafs er den Assimilierungs- und
Dissimilierungsprozessen Funktionen zuschreibt, die mit
den grundlegenden Überzeugungen des Physiologen nicht
in Einklang stehen.

Abgesehen von Herings Theorie, gibt es keine allgemein
bekannte Theorie, welche einen irgendwie gelungenen
Versuch gemacht hat, den oben aufgestellten Forderungen
zu entsprechen. Die folgende Hypothese stelle ich nicht
als die endgültige Hypothese der Lichtempfindungen auf,
sondern vielmehr als eine symbolische Darstellung einer
Hypothese von der Form, wie sie unseren logischen
Forderungen einigermafsen genügen kann.[1]

Die Hauptpunkte meiner Theorie bestehen in der
Annahme folgender Eigenschaften der in der Netzhaut
vorkommenden photochemischen Substanzen :

 1. Der Verbindungsprozess zwischen den physikalischen
und psychischen Vorgängen bei der Lichtempfindung
vollzieht sich (wenigstens zum Teil) als Dissoziation zweier
Arten von Molekülen, die wir als ,, Graumoleküle '' und
,, Farbenmoleküle '' bezeichnen wollen.[2] In den unent-

[1] [This theory is now to be taken, of course, in a much more literal
sense.]

[2] [" Grey " is a word of double meaning. We may intend by it
either (a) a dull white or (b) a black-white. Titchener has very acutely
said, " What a dull white would look like if we could ever see it by
itself we shall never know—the black sensation always jumps in when
a white (or any other colour) becomes of low intensity." I prefer now,
when speaking of colour theory, to say a dull white (or simply white)
and to pay no attention to the presence of the black. Not to do this
is to ignore the fact that black is a constituent of a dull red, a dull
yellow, etc., exactly as much as it is of a dull white, or grey. Black
is a background sensation, and it is connected with *all* the colours in
exactly the same way: it forms a " blend " with all of them, and a
" fusion " (or disappearance) with none of them. It is doubtless to
the artist that we owe, in the first instance, that close association
" black and white " ; the artist has no occasion to accentuate the
fact that " blacks " occur just as frequently in his chromatic pictures

wickelten Formen des Gesichtssinnes, wie sie in der Netzhaut der total Farbenblinden, in der Netzhaut-Peripherie der Farbentüchtigen und höchst wahrscheinlich in den Augen vieler niedriger Tiere vorkommen, sind nur Graumoleküle vorhanden. Sie bestehen aus einer äusseren Schicht, deren Atome viele verschiedene Schwingungsperioden haben, und einem inneren festen Kern. Die photochemische Zersetzung des Graumoleküls besteht in dem Losreissen dieser äusseren Atomschicht, welche nun zu einem Erreger der Nervenendigungen wird und die unmittelbare Ursache der Grau-(Weiss-) Empfindung ist. Diese Zersetzung wird hervorgerufen durch alle Ätherschwingungen des überhaupt sichtbaren Lichtes, jedoch am stärksten durch den mittleren Teil des Spektrums ; man kann vielleicht annehmen, dafs die Anzahl der Moleküle, die durch Licht von den verschiedenen Wellenlängen zersetzt werden, proportional ist den entsprechenden Ordinaten der Kurve der Intensitätsverteilung im Spektrum der total Farbenblinden.

Die Farbenmoleküle sind aus den Graumolekülen durch Differenzierung in der Weise entstanden, dafs die Atome der Aufsenschicht sich nach drei Richtungen verschieden gruppierten. Diese drei Atomgruppen unterscheiden sich durch die mittleren Schwingungsperioden der in ihnen befindlichen Atome, und diese drei mittleren Schwingungsperioden stimmen nun mit denen gewisser drei tatsächlich vorkommenden Atherbewegungen überein. [One speaks now of electrons rather than of atoms.] Durch solches Licht werden die entsprechenden Atomgruppen, und nur diese (oder fast nur diese), losgetrennt ; und die so entstandenen drei Zersetzungsprodukte rufen nun die drei Grundempfindungen hervor. Die Fähigkeit der Lichtbewegungen, eine solche Atomgruppe loszutrennen,

as in his achromatic ones. But whatever its origin, there is no question that Hering's association of black with white (even aside from his curious idea that black and white are " antagonistic " colours—that we never *see* a black and a white together) is one more of the various misfortunes which the subject of colour has been subjected to.]

hängt von der Genauigkeit der oben erwähnten Überein-
stimmung ab. Fällt Licht einer nicht übereinstimmenden
Schwingungsperiode auf die Netzhaut, so werden zweierlei
Atomgruppen, aber jede in geringer Anzahl, losgerissen,
rufen zwei Grundempfindungen hervor und erzeugen so
die (für das Bewusstsein auch gemischten) Empfindungen
der zwischenliegenden Farbentöne.

Um die Beschaffenheit der Farbenmoleküle ein wenig zu
versinnlichen, habe ich sie durch umstehende Figur
schematisch dargestellt, in welcher die verschieden
grosse Ausdehnung nach den drei Richtungen im Raum
die verschiedenen Schwingungsperioden der betreffenden
Atomgruppen symbolisch andeuten soll.[1]

FIG. 22.

Hat sich die Differenzierung in der äusseren Schicht der
Farbenmoleküle nur nach zwei Richtungen vollzogen, so
haben wir dichromatische Farbensysteme—die Welt
sieht Gelb und Blau aus.

2. Wenn eine Mischung von Licht zweier verschiedenen
Wellenlängen auf die Netzhaut fällt so bewirkt jeder
Bestandteil die ihm eigentümliche Zersetzung, und man
empfindet im allgemeinen, genau wie in dem einen eben

[1] Ich lege den grössten Teil der Masse des Moleküls in das rote
Gruppenpaar um der Tatsache Ausdruck zu geben, dass das rote Licht
des Spektrums, obwohl es wenig weisses Licht enthält, dennoch einen
hohen Grad von Helligkeit besitzt.

beschriebenen Fall, auch eine Mischung der Grundempfindungen. Die rot-blauen Empfindungen unterscheiden sich von allen anderen Mischempfindungen dadurch, dafs sie n u r durch solche Mischungen entstehen.

3. Es wird jedoch Mischungen von objektivem Lichte geben, welche die Eigenschaft haben, die dreierlei Atomgruppen in gleicher Menge loszutrennen Hierdurch aber entsteht eine nervenerregende Substanz, welche genau dieselbe Beschaffenheit hat, wie die äufsere Schicht der Graumoleküle ; sie bringt also auch dieselbe Empfindung hervor. Die Erreger der Rot-, Grün- und Blauempfindungen sind ja zusammengenommen gleich den chemischen Bestandteilen der äufseren Schichten der Graumoleküle. Sie haben jedoch nie getrennt existiert, bis die differenzierten Farbenmoleküle ihr selbständiges Losreissen ermöglichten. Dass also Lichtmischungen von komplementären Wellenlängen gleiche Empfindungen hervorrufen, wird auf Grund meiner Theorie (wie jeder Dreifarben-Theorie) dadurch erklärt, dass in jedem solchen Falle dieselben Netzhautprozesse vorhanden sind ; dass aber gerade diese (und keine anderen) Mischungen von Netzhautprozessen keine Spur von einer Mischempfindung wahrnehmen lassen, ist eine Folge davon, dass in diesen Fällen die Erreger der Farbenempfindungen genau in solchen Mengen entstehen, dass sie diejenige chemische Substanz erzeugen, welche die Grauempfindung verursacht.

4. Das ausschliessliche Entstehen der Grauempfindung unter den übrigen Umständen lässt sich in folgender Weise erklären. In der Netzhaut der total Farbenblinden und in den exzentrischen Teilen der Netzhaut der Farbentüchtigen sind nur die unentwickelten Graumoleküle vorhanden.—Ist das objektive Licht schwach oder auf einen sehr kleinen Teil des Gesichtsfeldes beschränkt, so werden nur die Graumoleküle in genügender Menge dissoziiert, um eine Empfindung hervorzurufen. Wenn auch einige Farben-Moleküle zersetzt werden sollten, so ist doch selbstverständlich das Vorhandensein einer Erregung überhaupt viel leichter wahrzunehmen als die

spezifische Natur dieser Erregung. Nur bei Rot ist dies
nicht der Fall. Das rote Licht löst in sehr geringem Grade
den Grauprozefs aus, und sein spezifischer Bestandteil
in der von ihm verursachten Gesamtempfindung ist
bedeutend.—Bei sehr intensiver Beleuchtung empfindet
man wieder Weiss, da die Farbenmoleküle, die schon bei
mittleren Intensitäten leicht zersetzt werden, früher
als die Graumoleküle verbraucht sind.—Die drei letzten
,, Erklärungen '' sind nur Übertragungen der Tatsachen
in die Sprache meiner Theorie und bilden keinen wesent-
lichen Teil derselben.

5. Die negativen Nachbilder aber e r f o r d e r n zu einer
Erklärung im vollen Sinne des Wortes die Aufstellung
einer Theorie von der Art der meinigen. Die partiell
dissoziierten Moleküle nämlich, deren losgerissener Teil
schon eine Farbenempfindung verursacht hat, sind
unfähig in diesem beschädigten Zustand fortzu-
bestehen, und das allmähliche Freiwerden der übrigen
Teile des Moleculs hat das Entstehen derjenigen
Empfindung, welche die schon empfundene Farbe
zum Weiss hätte ergänzen können, zur notwendigen
Folge. Um dies durch ein Beispiel deutlicher zu machen,
nehme man an, dass rotes Licht eine Zeit lang auf die
Netzhaut wirkt ; dann haben viele Moleküle ihre die
Rotempfindung hervorbringenden Atomgruppen verloren ;
als solche unvollständig zersetzte Moleküle bestehen sie
einige Zeit, doch ist ihr Zustand jetzt höchst labil. Durch
das allmähliche Auseinanderfallen ihrer blau- und
grünwirkenden Atomgruppen bekommen wir die
Erscheinung, dafs die Rotempfindung sich allmählich
in eine Weissempfindung umwandelt und sogar, wenn
das objektive Licht herabgesetzt wird—noch mehr aber,
wenn man die Augen schliefst, [oder eine graue Fläche
ansieht]—in eine Blaugrünempfindung übergeht. Die
Komplementärfarbe des Nachbildes wird also durch den
allmählichen Verbrauch verstümmelter Moleküle hervor-
gebracht, welche nun nutzlos geworden sind, deren
Fähigkeit aber, in diesem halbzerrissenen Zustand

wenigstens eine Zeit lang fortzubestehen, eben die Ursache davon ist, dafs wir überhaupt die verschiedenen Teile des Spektrums verschieden empfinden.[1]

Dies sind die Erklärungen, die meine Theorie für die oben angegebenen kritischen Tatsachen der Lichtempfindung liefert. In zweifacher Hinsicht übertrifft sie aber noch die übrigen bisher aufgestellten Theorien.

(a) Die Netzhautelemente bestehen aus Stäbchen und Zapfen, die zwar verschieden aussehen, denen wir aber bis jetzt keine verschiedene Funktion haben anweisen können. Die Schwierigkeit, dies zu tun, liegt darin, dafs die Zapfen, da sie in der Fovea allein vorhanden sind, ausreichen müssen, um alle Lichtempfindungen hervorzurufen, dass aber die Stäbchen auch eine wichtige Rolle spielen müssen, da sie eine sehr ähnliche Struktur haben wie die Zapfen, und diese Zapfen in der Netzhautperipherie fast gänzlich fehlen. Wenn man aber annimmt, dafs die Zapfen Farbenmoleküle von der beschriebenen Art enthalten und also Grauempfindungen sowie Farbenempfindungen hervorbringen, dafs aber in den Stäbchen nur Graumoleküle vorhanden sind, also hier nur Grauempfindungen entstehen, so wird die Anordnung der Elemente der Netzhaut ganz verständlich. Sehr interessante Versuche von Eugen Fick[2] erlauben uns, folgende Beziehungen zwischen Netzhautstruktur und eben wahrnehmbaren Erregungen festzustellen :

In der Fovea :	In den anliegenden Netzhautzonen :	In der weiter entfernten Peripherie :
Nur Zapfen ; maximalen ,, Farbensinn '' und nicht-maximalen ,, Grausinn ''.	Allmählich zunehmende Anzahl von Stäbchen und abnehmende Anzahl von Zapfen ; zunehmenden ,, Grausinn '' und abnehmenden ,, Farbensinn ''.	Fast ausschliefslich Stäbchen ; fast gar keinen ,,Farbensinn''.

[1] [The later presentations of the fundamental assumptions of this genetic theory of the colour-sensations are in some respects to be preferred to this.]

[2] Eugen Fick, "Studien über Licht- und Farbenempfindung," *Pflügers Archiv*, Bd. xliv, S. 441, 1888.

Ein besseres Beispiel von St. Mills ,, Method of con-
comitant Variation '' wäre schwer zu finden.[1] Die
Netzhaut eines total Farbenblinden ist bis jetzt nie
untersucht worden. Sollte es sich ergeben, dass eine
solche Netzhaut nur Stäbchen und keine Zapfen enthielte,
so wäre dies eine glänzende Bestätigung meiner
Vermutung ; wenn nicht, so könnte man doch annehmen,
dass hier auch in den Zapfen keine Farbenmoleküle,
sondern Graumoleküle vorhanden sind. Der atavistische
Zustand bezöge sich also nicht auf die Form der
Netzhautelemente, sondern auf die in letzteren
enthaltenen Moleküle.—Es ist noch zu erwähnen, dass,
wenn diese Verteilung der Netzhautprozesse richtig ist,
die Beschaffenheit des Auges in dieser Hinsicht eine
genaue Wiederholung derjenigen des Gehörsorganes
ist ; auch im Ohre haben wir vermutlich einen phylo-
genetisch sehr alten, [in seinem Bau] sehr einfachen
Bestandteil des Organs und neben ihm einen hochent-
wickelten Apparat zum Zerlegen der affizierenden
Schwingungen.

(b) Licht von Schwingungsperioden die zwischen
denen der Grundempfindungen liegen zersetzen, wie ich
schon bemerkt habe, eine verhältnismäfsig geringe Zahl
von Farbenmolekülen ; dieses könnte zur Erklärung
der sonst nicht erklärten Tatsache benutzt werden, dafs
die Mischungen von Rot und Grün und von Grün und
Blau weniger gesättigt aussehen, als die Grundem-
pfindungen.[2]

[1] [The fact that, as here pointed out, this '' double structure and
double function of the retina '' (the name I gave it later, see p. 57)
is sufficient to elucidate so many of the until then mysterious characters
of colour vision gives strong additional proof to the discovery already
made (independently of each other) by Max Schultze and Parinaud.
It should be called (if a personal name is necessary) the Schultze-
Parinaud-Franklin fact (not theory). The name which it sometimes
goes by—the v. Kries duplicity theory—is a triple misnomer. v. Kries
has discussed the subject at much length but when looked at in the
light of the development of the colour sense (see above) its actuality
could never have been doubted.]

[2] Helmholtz, *Handbuch der physiol. Optik*, S. 332, 2 Aufl.

Aufser Herings Theorie sind zwei andere (die aber wenig Aufmerksamkeit erregt haben) veröffentlicht worden, die dasselbe erreichen wollen, wie die vorliegende Theorie. Es sind dies diejenigen von Donders [1] und von Göller.[2] Letztere ist eine physikalische Theorie. Die von Donders ist eine chemische und der vorliegenden sehr ähnlich ; in ihr ist aber die Voraussetzung von vier Grundfarben (neben der Weissempfindung) ein wesentlicher Bestandteil. Um den psychischen Tatsachen völlig zu genügen, scheint es zwar nötig zu sein, vier Grundfarben anzunehmen, denn Gelb sieht nicht wie eine Mischfarbe aus ;—doch giebt es einige Tatsachen, die sich bis jetzt nur mit einer Dreifarbentheorie vereinigen lassen. Dieses sind : 1. die Trennung der dichromatischen Farbensysteme in zwei bestimmte Gruppen (Rot- und Grünblindheit).[3] 2. dafs es, wie A. König und C. Dieterici bewiesen haben, Farbentöne giebt, durch deren Wegfall aus dem normalen Farbensysteme sich die Farbenverwechselungen der Rotblinden und der Grünblinden erklären lassen.[4]

Die zwei letzterwähnten Tatsachen sind aber sehr wichtig ; darum scheint es nicht zweifelhaft zu sein, dafs in dem jetzigen Zustand unserer Kenntnisse eine Dreifarbentheorie—unter sonst gleichen Umständen— einer Vierfarbentheorie vorzuziehen ist.[5]

[1] Donders, " Noch einmal die Farbensysteme," *Gräfes Archiv für Ophthalmologie*, Bd. 30 (1), 1884.

[2] Göller, " Die Analyse der Lichtwellen durch das Auge," *Du Bois-Reymonds Archiv*, 1889.

[3] A. König, " Über den Helligkeitswert der Spektralfarben bei verschiedener absoluter Intensität ; in : *Beiträge zur Psychologie und Physiologie der Sinnesorgane* (*Helmholtz-Festchrift*). Hamburg und Leipzig, 1891, S. 370.

[4] A. König und C. Dieterici, *Sitzungsberichte der Berl. Akad*, vom 29 Juli, 1886.

[5] [This was a mistake. The development theory is just as much a four-colour theory as it is a three-colour theory—that is to say, it is tetrachromatic (it admits and accounts for *four chromatic* sensations at the same time that it accepts the Helmholtz *fact* (not theory) that no more than a tri-receptor process is required to start up the whole process—if red, green, and blue lights are *put into* your colour-mixing

Ich erlaube mir, die Punkte zu rekapitulieren, worin meine Theorie sich von den jetzt herrschenden unterscheidet. Sie nimmt—wie die Young-Helmholtzsche Theorie—drei Grund-(farben-)empfindungen an ; die Weifsempfindung aber erklärt sie nicht als eine Mischung von Farbenempfindungen, sondern als durch einen selbständigen Prozefs verursacht, der jedoch auch entsteht, sobald die farbigen Prozesse in gleicher Menge vorhanden sind. Von der Heringschen Theorie ist sie dadurch verschieden, 1. dafs die Grundfarbenprozesse physiologisch begreifbar sind, 2. dafs sie sich zum Weissprozess zusammensetzen, anstatt sich einander aufzuheben und diesen dann übrig zu lassen, und 3. dafs sie (wofür ich in dieser vorläufigen Mitteilung die nähere Begründung leider unterlassen mufs) nicht unsere sämtlichen Helligkeitsbegriffe in Verwirrung bringt, wie es durch die Heringsche Theorie geschieht.

Berlin, den 18. Juli 1892.

apparatus, then not only red, green, and blue will be taken out, but yellow and white as well. These last are secondary products—they make themselves. *Why* they do, the actual development of the colour sense furnishes the explanation of. The simple chemical reactions that must take place are these :

$$R + G = Y$$
$$Y + B = R + G + B = W.]$$

APPENDIX B

I

DR. TROLAND'S DISCUSSION OF COLOUR THEORY (NEIFELD)

IN recent papers entitled "The Enigma of Colour Vision",[1] Troland discusses various hypotheses of nerve conduction which would account for the facts of luminosity, chroma, and chromaticity in colour vision. He is fertile in suggesting possibilities. I shall briefly summarize the suggestions that are scattered throughout the paper, and I shall add a word or two of criticism.

He thinks that the theories which assume retinal activity to be the basis for differentiation of colour-sensations are too simple, and he finds reason to believe that colour discrimination is a function of the cortex. Accordingly, he builds up the conception of a complex group of related cerebral processes. It is correct, of course, to say that there must be *some* character in the final cortical process which corresponds to every character in sensation ; but it is by no means true that this may not have been insured by characters already given to the visual process by what takes place in the retina. For instance, if the change from one hundred sixty discriminable colour tones in the spectrum to three or four or five different retinal processes and discriminable mixtures of them has once taken place in the photochemical process of the retina, it does not need to be accounted for again in the corresponding process of the cortex. Once done is done once for all.

But Troland, having as he thinks successfully shifted

[1] *American Journal of Physiological Optics*, vol. i, p. 317, 1920 ; vol. ii, p. 23, 1921.

the function of colour discrimination to the cortex, immediately and cheerfully relinquishes what he has fought so hard to gain, and raises the question as to the nature of the variation in nerve conduction which results in characteristic chromatic vision. If we must seek for an explanation of chromatic vision in the manner " in which the several components of the visual process are represented in the nerve conduction at various neural levels ", what is simpler than to assume that such distinctions are fixed at the very beginning of the process of nerve conduction (or rather already in the initial photochemical retinal process), and are simply preserved at the transference of nerve stimulation at each synapse from one to the next following of the six or seven stages of which the entire course (physical light to sensation) consists ? There will be no occasion for any fresh specificity of processes in the cortex ; but, moreover, no fresh specificity (it is such things as the yellow-looking of what are *physically* the red-greens that one has here in mind) can be produced, *en plein air*, in the cortex— none, at least, that could, by any chance, be a true representative of any character of the external light-world.

There must be (so far as possible—this is the aim) a one-to-one correspondence between physical light-frequencies and final sensation and hence final cortical processes. To get this, there must be (so far as possible) the same specificity in not only the initial photochemical process but also in (1) each successive neuron and (2) synapse and (3) final cell body. No specificity which is not preserved in a given stage can ever form itself again in a later stage, hence every specificity which occurs in the final correlated cortical event must have its exact representative in each distinct, different event in a preceding stage. This may be added to the axioms of G. E. Müller. What is lacking in the final sensation (and hence also in the final cortical event) may be occurrent anywhere down below and may, by some untoward character in some synapse or neuron, be lost on the way up. In a chain of

connected events, A, B, C, connected so that each, in all its details, is caused by (though it may be very different from in its character—as different, for example, as the chemical substance which is a nerve excitant is different from the nerve impulse which it originates) its immediate precursor, anything may be lost but nothing (that is, nothing in the way of a fresh, true, representant of external nature) can be added on. The relation at each level of change may be, in the terms of the mathematician, a one-to-one change, or a many-to-one, but it cannot be a one-to-many.

The " all or none " principle for the response of nerve tissue indicates that the impulse which passes along a nerve fibre is incapable of quantitative variation. Gradations in activity are explained by the number of nerve fibres in a particular nerve that are simultaneously in action. Troland believes that he has proved the same principle to hold for the optic nerve fibres ; but since in the case of sight the number of fibres simultaneously in action is reserved to determine our recognition of the area of the retina which is stimulated, he suggests that the transmission of variations in intensity of stimulation (or luminosity) must be explained " by means of the conception of nerve impulse frequency, a weak impulse sending fewer impulses per second along the optic nerve fibres than a stronger impulse ".[1]

Since the "all or none " principle rules out the possibility of more than one type of variation in a single nerve current, and since it was assumed that luminosity depends upon the frequency of impulses, it would seem as if there were nothing left upon which colour tone and " saturation " (chromaticity) could depend. In contra-distinction to Ives, Exner, and others who have proved that luminosity is an aspect of the chromatic valence of a stimulation, Troland asserts that the colour tone and " saturation " enter in only a minor way into the laws which govern luminosity. He thinks that the

[1] Loc. cit., vol. i, p. 335, 1920.

luminosity may merely be a proportional "accompaniment" of the chromatic value of a sensation, and not an integral attribute. But if the luminosity is a proportional accompaniment of the chromatic value of a sensation, it would seem as if it would have to be an integral attribute, because a change in the proportion of luminosity would mean, since the proportion is a fixed proportion, for any particular colour, a shift in the colour value. "The amount of luminosity accompanying a single chromatic unit of any spectral hue would depend upon the position of this hue relative to the visibility curve, and upon the inherent saturation of the hue." [1] This amounts to saying that luminosity depends upon luminosity.

The function of complementation, Troland believes, is to restore or to preserve primitive achromatic vision when no significant deviations in energy distribution from that of sunlight exist among the given visual stimuli. [2] But why read a purposive idea into a situation, when it is simpler to conceive it as a reversion (made inevitable by the nature of the development of the colour sense) to a more primitive type of response ?

Troland then discusses a number of possible types of functioning on the part of the retinal cones on the assumption that the cones are, in fact, differentiated into three kinds. [3] One suggestion is that chromatic value is determined by the central mechanism of counteraction between the several cone systems. This central mechanism selectively weights the frequency of the respective currents for purposes of neutralization under the conditions of solar energy or luminosity distribution. And in addition, the three species of conducting nerve fibres might differ functionally as well as in their connexions. The individual impulses might have different characteristic amplitudes,

[1] Loc. cit., vol. ii, p. 29, 1921.

[2] Loc. cit., vol. ii, p. 33.

[3] For conveying the red green and blue sensations. Loc. cit., vol. ii, p. 37.

although obeying individually the "all or none" principle.

Still another suggestion is that phase or phase differences might be involved in the neural propagation of the visual qualities.[1] " The central mechanism might consist of a species of neuron forming synapses concomitantly with the required number of optic nerve fibres, combining their frequencies when they were out of phase to form a new characteristic frequency or impulse pattern." Achromatic sensations would depend on the exact synchronism of adjacent impulses, while chromatic vision would depend on characteristic deviations from this condition. However, there is just as much reason to suppose that the conditions Troland assumes might be reversed ; the exact synchronism of characteristic adjacent impulses might result in chromatic vision, while achromatic sensations would depend on deviations from these conditions.

At any rate, with the weight of competent opinion inclined to favour the sensitivity of all cones to all colours, it seems idle to speculate on differences in conduction in different systems of cones.[2]

Turning to a consideration of single foveal cones as capable of exercising all the functions of trichromatic vision (tetrachromatic vision is what he means, following upon an initial tri-receptor process in the retina), Troland still thinks that changes in phase relative to some standard might be involved. " Phase could either be advanced or retarded ; these two counter-effective variations, together with frequency, might provide the three variables

[1] Loc. cit., vol. ii, p. 40.

[2] Distinction of cones cannot be correlated with distinction of colour, because it is needed for distinction of spatial points. It has now been shown, however, by two different investigators, Ellis (*Am. Jour. Physiol.*, 1927) and Judd (not yet published), that the Blue Arcs do vary in brightness (at low intensities) and consequently that the all-or-none law does not (at least is this instance) hold for nerves of sensation. The situation is therefore completely changed ; it will doubtless be necessary now to reconsider the proof of the all-or-none law for motor nerves. C. L.-F.

required." [1] It is not clear to me how advanced and
retarded phase contribute two counter-effective variations.
If $A - B$ represents the difference in phase of two nerve
currents, and A is considered as advanced in phase over
B; then it follows that B is retarded in phase compared
to A. Now unless $A - B$ and $B - A$, although algebraically
representing the same quantity, are qualitatively con-
sidered different by Troland, this arrangement results
in one and not in two counter-effectives.

Still another possibility he points out lies in the idea
of impulse patterns and group frequencies. " The
individual nerve pulses could conceivably be spaced in
different characteristic ways to represent the various
colours, luminosity still depending upon the total number
of pulses arriving per unit of time. A stream of rapid
impulses could be broken up by gaps of different sorts,
these gaps only being detected by the central colour
receiving apparatus, which may be too lethargic (of too
long a refractory period) to pick up the faster series which
control luminosity perception." [2] This telegraphic
transmission theory of chromatic impressions would
explain " complementation " by the accidental neutraliza-
tion of one such variation by another. Troland over-
looks the fact that such " accidental neutralizations "
would not explain the definite, predictable, processes of
complementation. "Accidental" is hardly the word
to describe the conditions under which " complementa-
tion " occurs. On the other hand, I see no reason why
some " telegraphic " conception of chroma transmission
may not be made use of without including Troland's
idea of complementation.

Troland thinks that the extreme sensitiveness of the
retina throws doubt on the simple chemical theories of
its operation.[3] The retina is sensitive to stimuli so
slight, he says, as to be inappreciable in any except
the most highly sensitive physico-chemical system.

[1] Loc. cit., vol. ii, p. 43. [2] Loc. cit., vol. ii, p. 43.
[3] Loc. cit., vol. ii, p. 45.

There is, however, no reason to suppose that the retina is not just such a highly sensitive physico-chemical system. It is the common fault of the physiologist to trust too much to the argument from analogy in inferring from conditions in other parts of the body to conditions in the visual system. The optical system is so complicated and so highly evolved that all analogies between it and other systems break down.

II

After all, however, interesting as are the various hypotheses of nerve conduction that Troland discusses, they are only of transitory value. All of the possibilities are in his mind " in a very fluid condition ",[1] and he has by this time very probably discarded them all, and replaced them by others just as fanciful. What makes his paper of more permanent interest is his treatment of the Ladd-Franklin theory of colour vision. Nowhere else in any of his writings does he criticize that theory, and it is to be assumed that he considers this paper as complete a treatment of that theory as he can give. How far short we feel he fails of grasping the true reach and sweep of the Ladd-Franklin theory will be indicated below.

It is often possible to arrange an order-of-merit ranking for a series of facts, the possession of a trait or traits by different individuals, the amount of intelligence, wealth, athletic prowess of a given group, the effectiveness of various educational systems, police departments, social organizations, and so forth ; but the attempt to arrange in a hierarchy of importance a linked series of phenomena, the absence of any of which breaks down the series, seems to be attempting the impossible. Yet this is what Dr. Troland tries to do in his paper.

After dismissing the claims for consideration of the Helmholtz and the Hering theories of colour vision as

[1] Loc. cit., vol. ii, p. 47.

inadequate to explain all the facts, he is gratified to note the increasing popularity of the Ladd-Franklin theory and thinks " that its basic outlines are probably essential to any satisfactory elucidation of the visual process ". However, this theory " postulates the existence in the retina of conditions of sensation of the sort required for the processes in the cerebral cortex which directly underlie the visual consciousness, but which are not required and probably do not exist in the case of the retina ".[1]

The reason seems to be that while " sophisticated views make the retinal process the chief determinant of visual perception " and " a still more advanced conception would look upon the visual projection areas of the cerebral cortex as of prime importance," yet " an even deeper analysis indicates that the cerebral processes which immediately determine the character of the visual consciousness probably lie in the so-called association areas of the cortex ".

It is hard to see why any one link in the entire visuo-neural chain of events should be any more important than any other, and why a theory that stresses the function of the visual association areas of the cortex should be any " more advanced " or indicate a " deeper analysis " than one that postulates distinct photo-chemical changes in the rods and cones of the retina when stimulated by light.

Certain it is that any peculiarity of the continuous process involved would be, naturally, retained ; but no new one can suddenly spring up in the cortex or any-where else which is not absolutely caused by its immediate precursor. If the non-unitariness of a red-green has once disappeared in favour of a unitary yellow (indistinguishable from the yellow given by a certain physically unitary wave-length) it cannot later be recovered from. Troland seems like one who asks the old question, " Which comes first, the hen or the egg ? " and

[1] Loc. cit., vol. i, p. 330.

then elaborately sets out to prove the primacy of the hen.

In following out this line of reasoning he argues that the evolutionary relationships of the Ladd-Franklin visual molecule must be detached from the molecule and be applied to the developmental connexions of the several component processes which are involved in the " colour functions of the cerebrum ". Mrs. Ladd-Franklin, I am sure, would make no objection to having the general schema of her light-sensitive molecule applied to the interrelations of brain processes rather than to those of the chemical constituents of such a substance in the retina, providing such an application served the useful purpose of more clearly accounting for the facts of colour vision. I doubt whether she would agree that Troland's suggestion does make the facts any clearer. A loss of a red-green sense, for instance, if it has once been accounted for in the retina, does not need to be separately accounted for in the cortex. Once lost is lost for ever, and a second mechanism of loss in the cortex is not required.

It is to be noted that Troland acknowledges the essential nature of the Ladd-Franklin explanation, but that his objection is to the chemical action of the molecule. If we resort to analogy, it is clear that a theory based on chemical action has more grounds for belief than one based on hypothetical interrelations of unknown cortical processes. Furthermore, Dr. Ladd-Franklin is now able to point to a chemical compound—rosanilin carboxylate [1] —which possesses the very properties she assumes her retinal molecule to have. It cannot be said, therefore, that from the chemical point of view they " lack reality " ; from the psychological point of view, as Dr. Troland has himself shown, they are actually " essential " to an understanding of the enigmatical facts of colour.

If it seems necessary, as Troland thinks, to educe a function for complementation aside from a reversion to the more generic response of yellow for the red-greens

[1] *American Encyclopedia of Ophthalmology*, vol. iv, p. 2504.

and of white for the yellow-blues, it devolves upon him to explain what is the inherent nature of this function such that neither the red-blues, the blue-greens, the red-yellows, nor the yellow-greens form antagonistic pairs of colours. *A priori* there seems to be no essential reason why nature should single out two of the six possible combinations of colour pairs formed from the four unitary colours to handle them differently from the rest. For the evolutionary theory advocated by Mrs. Ladd-Franklin this difficulty does not exist.

As to the Ladd-Franklin explanation of normal achromatic vision, colour-blindness, twilight vision, after-images, contrast, and the other facts of colour vision, Troland has nothing to say.

II

THE LADD-FRANKLIN THEORY OF THE BLACK-SENSATION (NEIFELD)

IT is worthy of note that in half the extensive literature dealing with colour vision the subject of black has been barely mentioned. It is not so remarkable that such is the case. In only one theory, that of Herzing, is black made an essential part of the theory. In all other theories the explanation of black, the non-light sensation, stands or falls independently of the explanation of the chromatic and the achromatic light-sensations. Consequently, in these, very little mention is made of black. In the Hering literature, black is naturally very much discussed —mostly, it must be admitted, in a very inconsequential way.

It has sometimes been objected to the Ladd-Franklin theory that it fails to account satisfactorily for the sensation black. Fröbes in his admirable *Lehrbuch der experimentellen Psychologie* gives a good account of that theory, but follows Warren in believing " that the chief difficulty of the theory is to account for the sensation of black ". It is desirable, therefore, at this time to call attention to the views of Dr. Ladd-Franklin on this subject—views that she has definitely expressed at various times,

Black is the psychic correlate of the absorption, by objects, of all the visible light-ray frequencies. On account of the faint grey sensations (the " self-light of the retina ") caused perhaps by endogenous retinal processes—or more probably, by the pressure of the fluids within the eyeball on the optic nerve fibres which run over the surface of the retina—an absolute black can be obtained only after exhaustion by pre-exposure to a strong light, or by

contrast (the exposure of adjoining regions of the retina to a strong light).

That black is a sensation follows from the most elementary introspection. As a psychic entity black is just as real as any of the other visual elements. To speak of black as the negation of all sensation, as does James Ward, is naïvely to assume a relation of identity between cause and effect—a pure fallacy. In the other sense-regions it is true that the absence of a stimulus results in producing no effect, but while this may be a sufficient it is not an indispensable correlation.[1]

Like all other sensations, black is our response to a " definite situation ", but, paradoxically enough, and unlike all other cases, the definite situation is in the case of black the complete absence of stimulation. In other words, when we look at a black object there is no light reflected back to the eye by that object, there is no activity set up in the rods and cones, and there is no message relayed to the brain by the optic nerve. It follows that the sensation of black is a definite sensation attached to a cortical situation of inactivity or rest.

Since black is thus the result of zero stimulation, it follows again that there is only one intensity of blackness. There can be but one degree of zero. Sensations of grey, i.e. black-white blends, are made up of this constant amount of the sensation of blackness and a variable amount of the sensation of whiteness. Change of intensity of illumination of a grey surface changes not only the intensity but also the quality of the sensation : the

[1] All the visual sensations which are caused in the first instance by *light* can also be caused by internal conditions, as (a) by toxins (hashish, santonin, etc.), (b) by pressure (exerted in six different ways), (c) by an electric current running through the head, (d) and finally there is a permanent visual sensation when there is no stimulus whatever—see the case (which is not unique) of the man who had had both eyeballs enucleated six years before (during the War) and who nevertheless saw a continued entire field of (a slightly-purplish) *black*. In all these cases there is no after image—hence it is very probable that the self-light of the retina is also a case of pressure. C. L.-F.

resulting grey becomes not only brighter but also whiter.[1] In a colour blend, on the other hand, increased illumination changes the brightness but not (except sometimes very slightly) the chromatic *quality*. [That is to say, if you have a blue-green of a given proportion of the blue to the green you can change the subjective *intensity* of the dual colour blend by giving it an illumination of a higher objective intensity, but you will not by this means change the *proportion* of the blueness to the greenness.]

The followers of Hering make black and white one of the three (" antagonistic ") disappearing colour pairs. It has often enough been pointed out in the literature that this coupling of black and white destroys the very

FIG. 23.—Diagrammatic sketch to illustrate the range of greys. Black is of one intensity only, white is variable.

symmetry of the theory that it is aimed to produce. Complementation in the case of the other disappearing colour pairs (the blue-yellows which unite to produce white and the red-greens which unite to produce yellow) produces a sensation which partakes of the nature of neither of the two members of the antagonistic pair. In the achromatic pair equilibrium results in an analysable dual blend of the two original components of the " antagonistic " pair. To make this plan at all workable, G. E. Müller found it necessary, in the interest of the Hering theory, to introduce the assumption of a " constant

[1] The higher illumination is the cause of an increased whiteness without having any effect on the constituent blackness : the black is consequently *proportionally* less than before.

neutral grey " sensation, due to two cortical processes which are assumed to produce, constantly, invariable and equal amounts of " black " and of " white ". Hering's system thus becomes tautologous. He assumes the existence of black and white, and also of a " mean grey " which is itself a blend of black and white. But an additional assumption still is necessary, and a very improbable

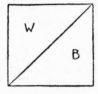

Fig. 24.

one, namely, that exactly in proportion as the white increases in intensity, the black decreases in intensity. All this explaining and counter-explaining is obviated by the simple assumption (recognition of fact rather) of the Ladd-Franklin theory that the blackness-sensation has for its physical correlate a zero stimulus, and that it is,

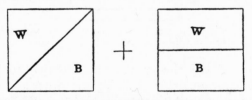

Fig. 25.—Diagrammatic sketch to illustrate the range of greys in the Hering theory. Every grey consists of a constant even black-white due to cortical processes to which is added a variable black as well as a variable white due to retinal processes.

consistently with this, a background sensation of one " intensity " (or amount) only.

But the Ladd-Franklin colour theory involves also an explanation of *why we have* a sensation of blackness. The fact that black is correlated with a non-stimulated condition of the retina can be almost paralleled by the case of silence in hearing. Silence is not yet a definite sensation, but if consciousness found it necessary to

attach a definite sensation to a situation of zero sound such a sensation would undoubtedly develop. We are perhaps on the way to it. We have already the phrase " a silence that can be felt " ; that is, sensed. If our entire auditory field were filled with sounds, and if we had already developed definite " place-coefficients " [1] for sound, then in those places where sound was absent we might well have developed a " silence sensation " to take the place of nothingness. There is no occasion for this in the case of sound, however, because our ability to localize sources of sound is very poorly developed. But in the case of vision it is different. We live every moment of our lives in a visual field. We are aware of every point of this field which is giving us a light-sensation. Breaks in the field due to the absence of stimulating light, such as would occur if we had no black-ness-sensation, would be decidedly unpleasant. What would otherwise be " cosmic holes " (as Dr. Ladd-Franklin has called them) in our space-field have been avoided by the fact that they are filled up with a definite non-light-sensation, that of blackness. In other words when a portion of space would intrude itself into con-sciousness only because it aroused awareness of its vacant place, when, that is to say, the cortical area in question is at rest, then the convenient sensation of black arises.

A more primitive eye than the human would perfectly well, of course, be able to distinguish between light and the absence of light even if there were no sensation of black. An organism possessing such an eye might give the proper responses to luminescent objects without being interested in having the whole visual field filled in. In other words it follows from this that it is by no means certain that the blackness-sensation arose with the beginning of vision.[2]

[1] Place-coefficients is Dr. Ladd-Franklin's term to take the place of the unhappily chosen " local signs ".

[2] [Fishes, for instance, may see bright flashes of approaching food or danger without having any consciousness of a wide intervening field of blackness.]

The Ladd-Franklin theory, then, is far from being unable to account for all the phenomena connected with the sensation of blackness, and at the same time it permits a reasonable explanation of the puzzling question why we have any sensation of blackness at all. As black forms in sensation a simple dual colour-blend with white, and with all the other colours in exactly the same way, so this theory represents it as due to an independent physiological situation, and thus avoids the curious compensating vagaries which the Hering view necessitates.[1]

SUMMARY

In the theories of colour vision, the sensation of black is usually independently accounted for. In the Hering theory alone does it form an integral part of the general explanation ; but the Hering view is full of inconsistencies and logical impossibilities. The only satisfactory explanation is the Ladd-Franklin view. Black is a positive sensation of constant intensity. It is the psychical correlate of a cortical condition of inactivity in correspondence to a non-stimulated retinal area. Black-white blends are the results of combinations of varying amounts of white with the one constant amount of black. Black developed as a result of nature's attempt to fill in the entire visual field in order to avoid the inconvenience of " cosmic holes ". It is not necessarily contemporaneous in development with white.

[1] See p. 9 of this book.

III

THE COLOUR-SENSATION THEORY OF DR. SCHANZ [1] (NEIFELD)

IN the issue of *Zeitschrift für Physik* for October, 1922, the late Dr. Fritz Schanz pointed out that scientists cannot agree on either the Helmholtz or the Hering theory of colour vision, and that a new theory is, therefore, required.

Nowhere in this paper did Schanz show that he was aware of a theory that by a higher synthesis takes cognizance of both the Helmholtz and the Hering sets of facts, and that most satisfactorily explains the complicated phenomena of colour vision. The Ladd-Franklin theory evidently did not exist for him.

Schanz proposed a theory based on photo-electric phenomena. Recent researches have thrown light on the nature and action of physical light, and on its absorption by matter on which it falls. The action of light on inorganic and organic substances, particularly albumen, has been extensively investigated. It has been shown, for example, that the albumen of the lens of the eye is probably changed by the action of light so that in time it loses its easily soluble nature, and the consequent hardening results in loss of the power of accommodation with age, that is, in change to far-sightedness—and is also the most common cause of old-age cataract.

Other researches showed that such changes were caused only by the short wave-lengths absorbed by the albumen. Other albumens were tested with similar results, and since protoplasm consists essentially of

[1] A translation of an article on a " New Theory of Vision " by the late Dr. Schanz appeared in the *American Journal of Physiological Optics*, vol. iv, p. 284, 1923. The original of this article appeared in the *Zeitschrift für Sinnesphysiologie*.

albumen, light must affect living substance in the same way. In nature, however, the long wave-lengths also have a photo-biologic effect, but the substances acted upon are always bound up in such case with the presence of sensitizers, which are pigments intimately associated with the albumens.

Tests have been devised which show that the Hallwachs phenomenon—the emission of electrons by illuminated matter—also occurs in organic substances, and in a more intense form. Since light can only work where it is absorbed, the same or similar phenomena must be at the basis of vision. The cones, at least, Schanz thinks, can no longer be regarded as the visual sensitive elements, because they cannot absorb the visible wave-lengths. These are absorbed, according to him, by the pigment of the pigment epithelium of the retina, and we must assume that electrons are caused to be emitted by the light so absorbed just as in the case of numerous pigments which have been investigated by him and by others. The rods and cones simply act as a sort of wire netting to intercept the electrons after they have been emitted. Different wave-lengths give rise to electrons of a characteristic velocity. Where the electrons enter the rods and cones they give rise to a current that proceeds through the optic nerve to the cortex.

This " action stream ", it is assumed, is identical with the electric current that arises in the testing of photo-electric emissions, and the currents must therefore be supposed to have similar properties. Brossa and Kolhrausch have shown that the current of the optic nerve arising from stimulation by homogeneous light-rays is characteristic for different wave-lengths.

Vision can, therefore, be explained on the basis of non-vitalistic and well-known physical phenomena. This theory suffices as well, Schanz claimed, for the explanation of all the attendant physiological and clinical phenomena. Take, for example, the case of the albino. A survey of the literature shows that without

exception pigment is present in the pigment layer of all
albinoes, even when the rest of the eye and the rest of
the organism is entirely free from pigment. There is,
however, another very evident function which would
account for the presence of such pigment. This I shall
discuss later on.

Now how, Schanz asked, is chromatic colour vision
explained by this theory ? In the first place, different
wave-lengths are associated with different velocities of
the electrons, and so the pure spectral colours arise.
But nature presents many colour mixtures which are
psychologically indistinguishable from the sensations
given by some intermediate homogeneous light-
frequencies. When such light-ray mixtures are exposed
to the eye, electrons of different velocities are emitted
simultaneously by the pigment layer. It is a matter of
fact that these light-ray mixtures awaken the same
impression in the cortex as the electrons of a single
velocity. To explain this phenomenon Schanz assumed
that the electrons in their passage to the cortex mutually
influence each other. The faster ones accelerate the
slow ones, and the slower ones retard the faster ones,
and somewhere along the path a mean velocity is attained.
If they reach the cortex after attaining a mean velocity,
the colour-sensation will arise which is characteristic
of the electrons which have travelled the entire path with
a velocity which the mixture of electrons first attained
at the end of the path. In both cases, electrons of the
same velocity reach the cortex and awaken there the
same cerebral activity.

White as a sensation arises when the electrons simul-
taneously travelling to the cortex *cannot* attain a mean
velocity before reaching there. The sensation aroused
will be white when the electrons show a maximal difference
in velocity. A smaller difference in velocities produces
a chromatic sensation. The closer together the colours
lie to each other in the spectrum, the smaller are the
differences in the velocities of the electrons, and the

quicker they will reach a mean velocity in their path
to the cortex and the more saturated the resulting colour-
sensation will be.

Schanz also explained the Purkinje phenomenon by
this theory. The electrons emitted from the pigment
layer by red have a slower velocity or, what is the same
thing, a lesser energy than the electrons emitted by blue
light. In the dim light the first cannot act any more,
while the latter still can. Schanz evidently forgot,
however, that the Purkinje phenomenon is now absolutely
explained by the character of the visual purple. It has
been thoroughly established by Garten that in an inter-
mediate stage the rod-pigment becomes yellow. Its
complement is blue, and, therefore, in dim light blue
becomes too bright. The fact that the blue end of the
spectrum becomes not only brighter but also whiter
firmly establishes the fact that the Purkinje phenomenon
is a rod phenomenon.

Dr. Ladd-Franklin has called attention to "the
extended Purkinje phenomenon" in which two "whites"
which were absolute matches for the light-adapted eye
appeared as of different brightness for the dark-adapted
eye. This was due to the fact that the brighter "white"
for scotopic vision had more green in the mixture.
Now the visual purple is purple because it is absorbing
green light and reflecting red and blue light. Green
light is, therefore, the effective light, and hence it is
most intense in scotopic vision. This results in a shift
in the relative brightness of different parts of the spectrum
and moves the maximum brightness from the yellow
region in photopic vision to the green in scotopic vision.

The author ends the paper with the statement that his
theory takes into account the new data on light, and that
it also bases the theory of colour vision on known physical
laws without resource to the vitalistic hypotheses of
Helmholtz and Hering.

As pointed out at the beginning of this review, Schanz
ignored entirely the existence of the Ladd-Franklin

theory. This may be a case of the ostrich hiding his head in the sand to shut off the view of what he would not see. At any rate, it discloses far from a scientific attitude to deliberately pass over in silence a theory that leading psychologists are more and more coming to recognize as the most comprehensive explanation yet offered of the facts of colour vision.

To begin with, any theory, as this one, which stresses the part played by the pigment epithelium as the initial stage in the intra-corporeal visual process fails to take account of the extraordinarily accurate " spatial co-efficients " to the quale of colour which are carried by the rods and the cones. A single pigment cell is large enough to cover up the entire fovea, and if we assume with Schanz that it is the pigment cells which are first affected by light, we lose the possibility of each one of the cones having a point-to-point correspondence with light from different directions. The pigment cells are provided with a sufficient function in the fact that they constitute a source of nutrition for the highly developed retina, and in that they are an absolutely necessary means for the absorption of light which would otherwise be reflected, and re-reflected. In high light these cells send down black crystals between the rods and cones which act as insulators to isolate them so that no light can be reflected. If light were reflected from cone to cone, it would impair their function as determiners of place-coefficients.

The distinction that Schanz drew between vitalistic and non-vitalistic hypotheses is somewhat hard to follow, and it is equally hard to see why a non-vitalistic hypothesis should be any more desirable than a vitalistic hypothesis. Moreover, it would seem that any theory that attempted to explain the how and the why of any sensation must *ipso facto* be a vitalistic hypothesis. Theories of colour vision are of two sorts. They either include a new theory of nerve conduction, or they do not. Schanz's theory includes a new theory of nerve conduction. He says he

avoids a vitalistic hypothesis, but nerve impulse is
necessarily vitalistic. He seems to think that he has
reduced his theory to established physical laws because
he has identified nerve conduction with an electric
current, and that the fact that it is an electric current
is sufficient. We know now, however (Forbes and others),
that the electric current is not enough. An electric
current is an accompanying phenomenon of nerve con-
duction, but the mere presence of an electrical
current does not mean that there necessarily goes with
it a complete nerve impulse.

Schanz attempted to meet a difficulty that Janet H.
Clark, in an independent paper on " A Photo-Electric
Theory of Vision " [1] published, curiously enough, in exactly
the same month as the paper I am discussing, entirely
overlooks. To explain why light-ray mixtures give
rise to a sensation indistinguishable from that excited
by the corresponding spectral colour, he assumes that
electrons of different velocities mutually influence each
other so that they attain a mean velocity before reaching
the cortex, and that this velocity is the same as that
of the electrons of the corresponding spectral colour.
There appears to be no particular reason why this should
be so. If you grant the assumption that electrons
rush along the nerve paths to the brain, it requires a
considerable stretch of the imagination to assume that
the mutual interference of velocities would follow any
such regular laws as the theory requires ; and that any
three definite velocities would secure the ascendancy
required to account for the fact that the correlate to
colour-sensation in the retina is a triceptor process, so
that combinations of red, green, and blue are sufficient
to give you all of the one hundred and sixty discriminable
colours of the spectrum, and also (in combination with
black and white) the whole one or two million dis-
criminable colours of nature.

Why would not the mutual interaction of thousands

[1] *Journal of Optical Society of America*, 1922.

of different velocities give a chance result each time rather than the definite, predictable, mean velocity here required ? Or again, why not assume that the electrons of different velocity travel side by side without mutual interference like trains running on parallel tracks ? If it is true that the path of an electric current approaches the surface of the conducting medium with increase in the velocity of the current so that at a sufficiently high rate of velocity the current passes entirely along the outside rather than the inside of the conductor, then the last conception would give a truer picture than Schanz's supposition.

The explanation of a sensation of white—the simultaneous arrival at the cortex of electrons with a maximal difference in velocity—is totally inadequate. The assumptions made would result not in a definite, different, sensation, and certainly not in the reconstitution of that primitive sensation, whiteness, which is the colour of the whole spectrum to the lower animals and also to us when light of any wave-length is responded to by the rods only. Nothing, in fact, but the Ladd-Franklin view, that an even red-green-blue combination must revert to a primitive white, will explain complementation. Utilization of our present knowledge of the actual development of the colour sense is essential to a comprehension of the true nature of colour : as Mr. Troland has pointed out, with much acuteness, the Ladd-Franklin theory in its basic outlines is " probably essential to any satisfactory elucidation of the visual process ".

Although some attempt is made to explain colour complementation, nothing is mentioned about the yellow-constitutive colours, red and green. Neither are we shown what kind of velocity-interference phenomena would explain negative after-images (residual images) or contrast effects.

Schanz dismissed the hypothesis that assumes the presence of light sensitive substances in the cones, because these have not yet been isolated. Further-

more, he follows Hess in lightly brushing aside all differences between the action of rods and cones. It is a general principle of physiology that functions vary with differences in structure, and the relatively simple anatomical structure of the synapses of the rods as compared with the synapses of the cones would lead us to expect a more complicated mode of reacting for the cones, or a more specific sensitivity to the same order of stimuli. Schanz, however, found it convenient to reject the view, in reality well established, of the striking differences between rods and cones both in structure and in function, and he assumed that they act alike in intercepting and transmitting electrons. Furthermore, his conception is pre-evolutionary in character, and sacrifices the light that a genetic theory sheds on the evolution of the colour sense.

It may well be that in time a new hypothesis will be evolved that will explain the facts of colour vision even more satisfactorily than the Ladd-Franklin theory does at present, but it will not be the theory advanced by Schanz.

IV

BLACK : A NON-LIGHT SENSATION (MICHAELS)

THE sensation of black is a subject which has received very *stiefmütterlich* treatment at the hands of the psychologists—in fact they have (with the exception of Hering) very seldom treated it at all. That they have been very negligent of the duty of devoting some intelligent consideration to this subject is proved by the fashion in which they have permitted the vagaries of the Hering theory to be believed in for so many years. It would seem that a moment's attention to the simple facts of sensation would make it impossible for any conscientious person to think for a moment that there is anything " antagonistic " in the relation of black to white, or to any of the other colours (to any of the chromata). Black forms a simple dual colour blend with white (we use the term colour as including white and black—the two achromatic colours), and also with all the chromata—yellow and blue, red and green.

But the nature of the sensation of blackness is really very simple ; we propose to set it forth here, as it is treated (but perhaps too briefly) in the Ladd-Franklin theory of the colour-sensations.

Black (1) is a colour, (2) is a non-light-sensation attached in the cortex to zero stimulation, (3) has only one degree of intensity. A consideration of these points ought to pave the way for a better understanding of the problem.[1]

There are six elementary colours : White, Yellow and Blue, Red and Green, and Black.[2] Four of these

[1] Neifeld, M. R. : " Ladd-Franklin Theory of Black Sensation," *Psychol. Rev.*, 1924, 31, 6, p 241.

[2] The names of the elementary colours are always capitalized in these papers.

colours are chromatic ; the other two, White and Black, are achromatic. Of five of these elementary colours, namely the four chromatic sensations and White, it can be said that they give rise to an intensity series. *Black has only one degree of intensity.*

Black is a non-light-sensation attached to zero stimulation. Many agree to this, but in their eagerness to explain the occurrence of this black-sensation they depart widely from fact. For instance, Titchener says : " Black, indeed, is wholly a contrast sensation ; it has no physical stimulus ; and you see deep black only in strong illumination." [1] This is simply wrong. You see an absolute black just as well if it is an after-image of white as you do if it is a contrast-image to an adjoining white.

In strong illumination a black object reflects a good deal of white light, with the result that we get *not* a deeper black but a less deep one. Zero stimulation with something added no longer gives us Black but Black plus another factor—in this case a light-sensation, namely, White. When black is not an absolute black, but a blend of black and white, it is commonly but unnecessarily called grey. But illumination is not essential to our getting Black. We can get a perfect Black under two different conditions :

(1) By means of contrast (exhaustion of the light-sensitive substance) produced by a surrounding White field.

(2) By means of the " after-image " (exhaustion) produced by pre-exposure of the retina to a bright light.

The reason that the presence of an adjacent or of a preceding white is necessary in order to produce an absolute black is that the persistent self-light of the retina must be extinguished by means of exhaustion.— A non-light sensation is exactly what the term implies, zero stimulation. As soon as we introduce a new medium

[1] Titchener, E. B., *Beginners' Psychology*, p. 61.

of stimulation we are not in a position to say that the sensation we get " has no physical stimulus " : illumination introduces a light-sensation stimulus by its reflection from the black and gives a black-white or grey.

" Black is as much a sensation as white or any of the colour hues ; yet it is not due to stimulation of light waves at all ", says Warren.[1] No one can object to this statement, and it covers the ground very accurately. But in order to devise a correlate for Black, the following is added, " though to get absolute black-sensation some nearby region must be stimulated by light." [2] Warren forgets here, however, that previous exposure to a bright light is just as good a means of securing an absolute blackness as is a surrounding white.

All the intricate assumptions made about black in an effort to make the Hering theory work become unnecessary as soon as it is assumed (what is the simple fact in the case) that :—

(1) Blackness is due to zero stimulation.

(2) There is no possibility of varying the amount of Black. You can only change the *relative* amount in a black-white blend, and that by increasing the amount of *white*.

We cannot speak of different intensities of Black. The constituent, a light-sensation (white), which combines with it to form grey, cannot act at the same time to give it degrees of intensity. The peculiar nature of the B-W series is that it is at once a quality series (like the blue-greens) and an intensity series (the white constituent increases in intensity as the illumination is made stronger and stronger). It was to explain this that G. E. Müller introduced the wholly unnecessary conception of a " cortical grey ".

Warren, quoted by Fröbes and others, says that the Ladd-Franklin theory gives an explanation of all the

[1] Warren, H. C., *Elements of Human Psychology*, p. 82.
[2] Ibid.

phenomena of sight except the sensation black. As matter of fact, the theory not only explains that sensation, but it also makes it plain *why we have*, in vision, a sensation (Black) attached to zero stimulation—what occurs, of course, in no other sense region. I quote the passage : [1]

> " Black may well be the sensation attached to the resting-stage of the cortical visual process. A state of non-excitation from the external world does not, in the case of the other senses, need to enter consciousness; but in the visual sense the spatial attribute is of extreme consequence, and if we were unconscious of objects which send to us no light there would be *lacunæ* in the retinal optical field which would be most disturbing. This state actually occurs in the case of localized lesions in the cortical visual field ; the ophthalmologists distinguish between a *negative* and a *positive* scotoma—in the latter (disease of the retina or optic fibres), a black spot is seen in place of a portion of the external field ; in the former, nothing is seen. This fact alone goes far to prove that black is purely a cortical excitation which enters consciousness as a *mark* of the absence of retinal excitation." [2]

As we mentioned above, Black is a sensation of zero stimulation, and therefore cannot be a light-sensation. —*it is a non-light-sensation.* Since there can be only one value for zero, we get only *one degree* of *subjective intensity* for Black, and the series of greys is a result of the change in the subjective intensity of the White constituent. The proof for this is not difficult. Take a blue-green with a certain proportion of blueness and greenness, and it is possible to see it in different degrees of intensity. But when we try to give a grey greater

[1] I put this now a little differently. I say : Black is a permanent cortical *background* sensation, which comes into evidence when the light-sensations are absent or of low intensity. C. L.-F.

[2] Ladd-Franklin, C., " Vision," *Dictionary of Philosophy and Psychology*, p. 767, 1902 ; page 9 of this book.

illumination we change not only the brightness but the
quality by introducing more White—it becomes a whiter
black-white.[1] For example, place a black piece of velvet
in a black box with an aperture at one end. By enlarging
or narrowing the slit we get different intensities which
will be not those of Black (a non-light-sensation) but
Black plus White (a light-sensation). The result is a
black-white or grey ; zero stimulation is no longer
present by itself. From this we see that there is only one
degree of intensity possible for Black and that any
apparent change that occurs in it is simply a change in
the White constituent. Black, then, *is a sensation
attached to zero stimulation* and of *only one degree of
intensity*.

[1] Id., " Tetrachromatic Vision and the Genetic Theory of Colour,"
Amer. J. Physiol. Optics, 1923, iv, 403, 415.

LATER DISCUSSION OF THE LADD-FRANKLIN THEORY OF COLOUR (ISRAELI)

IN the nineteenth century for the first time a serious attempt was made to devise some reasonable theory by which to hold together—to unite into one all-embracing conception—the physical, physiological, and psychological facts of the colour-sensations. Of the four-score and more different schemes that resulted, there remain, for worthwhile discussion at the present time, only the famous theories of Young and Helmholtz, of Hering, and of Ladd-Franklin. All the remaining theories fall into the lines of either the Young-Helmholtz or the Hering theory, they assume as the elements out of which the many discriminable colours are built up either *three* chromatic sensations (as the facts of colour-mixing demand) or else *four* chromatic sensations, together with white (as is demanded by the facts of sensation). It is only the Ladd-Franklin theory which assumes at once a tri-receptor initial photo-chemical process with a subsequent reversion to five nerve-excitants (in accordance with what is demanded by the plain facts of the development of the colour-sense). It will be sufficient consequently if we discuss what claims to acceptance these three rival theories offer at the present time.[1]

While the Ladd-Franklin theory has patent marks of superiority over the other two—the facts which they

[1] [The Germans have the unfortunate fashion, too often followed in English, of saying colour-sensations *and* light-sensation, meaning by the latter term the sensation of *whiteness*. The implication in this that " light " is always *white*—that there is no such thing as *red light*, *blue light*, etc., is of course wholly erroneous. We should say that *light*-sensations are of two kinds, chromatic and achromatic, or that they consist in ehromata (pl. of chroma) and achromata (pl. of achroma).]

explain, more or less, *severally*, it explains all at once by means of one happy conception based upon neglected fact—it has nevertheless not been at once as widely accepted as it deserves to be. It is evident, however, that that situation is now coming to an end. Typical ways of treating the subject are represented in two recent books—the *Psychology* of Woodworth and the *Physics* of Crew : in one the theories of Helmholtz and of Hering are given the briefest possible mention, in the other they are not mentioned at all. It may be worth while, however, in view of the fact that during the past few years there has been considerable discussion of the subject, to go over the matter again. This paper will make a brief survey of this discussion, and will present some of the important arguments advanced for and against the theory.

<div align="center">I</div>

THE LADD-FRANKLIN CRITERIA OF A COLOUR THEORY

A good plan to adopt for considering the three colour-theories mentioned above would be to refer to the " minimal requirements " which, according to Ladd-Franklin, ought to be met by any colour theory. Her four suggested criteria are : " (1) the fact discovered by Thomas Young (and magnificently confirmed in the laboratory of Helmholtz)—that *three* light-stimuli are sufficient, as a physical cause, to start up all the retinal photo-chemical processes ; (2) the apparently contradictory fact that nevertheless the *sensations* are *five* in number—yellow and white have been somehow added ; (3) the very illuminating fact that the *order of development* of the colour sense can be made to account fully for this anomaly and also for (4) the complete non-occurrence of the red-greens and of the yellow-blues." [1] (We adopt the very important name that v. Kries has suggested for after-images, contrast, and other phenomena of that

[1] *Jour. Opt. Soc. Am.*, 6, 822, 1922.

kind—he proposed to call them " accessory phenomena ".)
These four requirements then will now serve as a guide
for a treatment of the Ladd-Franklin theory and its
criticisms of the older Young-Helmholtz and Hering
theories.

The Criteria Applied.—1. " The fact discovered by
Thomas Young (and definitively proved by the work
of König and Helmholtz)—that three light-stimuli are
sufficient, as a physical cause, to start up all the retinal
photo-chemical processes." Leonardo da Vinci held
that the primary colours are red, yellow, blue, green,
white, and black. Newton sought to connect the
spectrum (which he was the first to discover) with the
musical scale. It is related on p. 92 of the *Opticks*
how Newton and his assistant divided up the spectrum
mathematically into something analogous to a musical
scale. Houston points out that he was doubtless
influenced by Kepler's work, the *Harmonices Mundi*
and by the *Harmonies* of Ptolemy. The doctrine of the
" Music of the Spheres " was at that time peculiarly
attractive ; it inspired Kepler to " discover the third
law of planetary motion, and upon this law Newton
built his theory of gravitation." [1] But it was reserved
for the distinguished physicist, Thomas Young, at the
beginning of the last century, to discover (what Newton
came very near to discovering) the *fact* that three specific
light-rays are sufficient, when mixed, to produce matches
for all the colours of the rainbow. Helmholtz later did
a large amount of experimental work on these same lines.
This work is what is known as colour-mixing ; a better
name for it, however, is (Ladd-Franklin) " matching
by mixture "—for the reason that no attention is paid,
in this game, to the *colour* produced by the mixing.
When one mixes blue and green one gets the dual colour-
blends, the blue-greens, which is simple, but when one
mixes red and green one gets no reddish greens nor
greenish reds—nothing but *yellowish* greens or *yellowish*

[1] R. A. Houston, *Light and Colour*, 1923.

reds—what demands explanation. Colour-mixing is a very inadequate account of the facts of colour. The simple " matching by mixture " the Young-Helmholtz theory takes account of—but as no explanation is given of the extraordinary *results* that may attend upon this mixing, it would be better if we were to speak of the Thomas Young *facts* of colour rather than of the Thomas Young *theory* of colour. As is well known, the Hering theory makes no attempt to explain these facts, and indeed is entirely contradictory to them.

2. The " apparently contradictory fact that nevertheless the sensations are five in number—yellow and white have been somehow added ". It is on account of its failure to even recognize this fact that Ladd-Franklin has called the Young-Helmholtz theory only at best three-fifths of a colour-theory. For a hundred years physicists have been psychically colour-blind to yellow and to white. White is not, as it should be by that theory, a reddish-greenish-blue ; it is a distinct, unique and unitary colour-sensation. Furthermore, white can be produced not only by the mixture of red, green, and blue lights in the proper proportions, but also by mixing yellow and blue lights. Again, there are many circumstances (the totally colour-blind, our own periphery of the retina, a faint light and the lower animals) where it is not produced out of anything, but is the only colour exhibited by the whole spectrum. Nevertheless, the three distribution curves, red, green, and blue, made out by König in the laboratory of Helmholtz and confirmed by his four cases of yellow-and-blue vision, remain far and away the most important work yet done in colour.

It was for the purpose of making good this sad defect of the Helmholtz theory (the omission of yellow and white) that the Hering theory was devised. The present criterion then is met by the Hering and the Ladd-Franklin theories but not by that of Young and Helmholtz.

3. The " very illuminating fact that the *order of*

development of the colour sense can be made to account fully for the disappearance of the red-greens (and of the yellow-blues) and the appearance in their stead of yellow (and of white) ".

Yellow, although a primary and unitary colour-*sensation*, is due to a secondary photo-chemical product resulting from the combination of the red and green cleavable portions of the colour-molecule. White may be produced by a combination of this secondary photo-chemical product with blue, or by a union of the red-green-and-blue cleavable portions of the colour-molecule— but since it is the case that red and green unite first and their product then unites with blue, it may be said that on this view (as Professor Titchener has pointed out) white (the composed, non-primitive white) is *always* made out of *yellow* and blue. Colour vision in man is in an advanced stage. Originally—in the carboniferous times—light impinging on the retina of the living organisms gave a sensation of white only. At what time in this course of development the sensation of black entered there is, of course, no means of knowing. Long ages after this the light sensitive substance became more specific ; the colour molecule became constituted of two cleavable portions, yellow and blue. In the final development of colour vision the yellow cleavable portion split again into two portions, those which give us the red and the green sensations. This view of the development of the colour sense had its basis, of course, in the discovery made by Max Schultze in 1881, and again by Parinaud in 1886— that of the double function of the visual elements (the rods and the cones) which parallels exactly their double structure ; the rods are organs for whiteness only, the chromatic sensations are the work of the cones. With this fortunate conception as a ground-work, it was possible to combine into one connected whole :—

(*a*) The very complicated facts of partial colour-blindness, with its deuteranopic and protanopic yellow-and-blue vision and its complete series of intermediate

stages, the protanomalous and the deuteranomalous systems.

(*b*) Total colour-blindness, with its (very common) total foveal blindness and with the (connected) " normal night blindness of the fovea ".

(*c*) The defects of colour vision in the periphery of the normal eye.

(*d*) The colour sense of animals ; and many other of the enigmatic characters of colour vision.

All these things are beautifully accounted for in the genetic tetrachromatic colour theory originated by Ladd-Franklin. It is an interesting fact that the nineteenth century, which applied the evolutionary view-point to the organic world (Darwin, Wallace, and Spencer), should have also arrived at a developmental explanation of the phenomena of colour.

4. The last criterion of a colour theory is concerned with the facts that red and green lights, when mixed in proper proportions, constitute a disappearing pair (that a new and totally different colour-sensation arises, that of yellow), and that yellow and blue lights also constitute a disappearing colour-pair, giving white. The Hering theory conceives the colour-sensations as being primarily six : red and green ; yellow and blue ; black and white, forming three antagonistic pairs ; the first two pairs giving white when their constituents are mixed. This explains, after a fashion, the disappearance of the disappearing colour-pairs, and we should have been obliged to be content with this explanation (it is far better than no explanation at all—Helmholtz) if no more all-embracing theory had been offered. But there remain wholly unnecessary errors involved in making red and green *white constitutive* (they are yellow-constitutive), and in making black and white antagonistic (they form the series of the white-blacks, or greys). The Hering theory, however, is utterly " antagonistic " to the Young-Helmholtz *fact*, the initial *tri-receptor* process in the

retina—it fails completely to meet the first requirement of this list. But just as much the Young-Helmholtz theory fails to meet *any but* the first requirement ; for it there exists the series of the red-greens as such—there is no such thing as yellow. No more does it account for the fact that yellow and blue make white—for the normal eye as well as for those who have yellow and blue vision only.

All told, it is seen that the Young-Helmholtz and the Hering theories fail to meet the " minimal requirements " for a colour theory.

The rest of this paper will centre around some of the most recent literature on the Ladd-Franklin theory. The question of black as a sensation will be dealt with ; Troland's discussion of the Ladd-Franklin theory will be summarized ; and finally the criteria for a colour theory advanced by Hartridge, and applied by him to the one under consideration here, will be set forth.

II

Is Black a Sensation ?

For Ladd-Franklin years ago black was " a mark of the resting-stage in the cortical portion of the total light-process ".[1] And she has recently restated her theory of black ; thus it is " as Helmholtz recognized perfectly, a definite sensation, but it is a constant, permanent, background sensation which becomes evident and forms a dual blend with any of the colours (not with white only) when they are faint. It is a non-light-sensation and it belongs in a different category from the light-sensations ".[2] Michaels has briefly presented Dr. Ladd-Franklin's views on black as a colour—a " non-light-sensation attached to zero stimulation, and of only one degree of intensity ".[3] Neifield also has an article on the Ladd-Franklin theory of the black sensation. He points out

[1] *Dictionary of Philosophy and Psychology*, ii, 767, 1902.
[2] Helmholtz, *Phys. Optics* (Eng. Trans.), p. 456.
[3] *Psych. Rev.*, 1925, xxxii, 248. See p. 255 .

that in only one instance (that of Hering) is black made an essential part of any theory. He shows that black and white are far from constituting, as maintained by Hering, a disappearing colour-pair, but that they form, in fact, a simple dual colour-blend. The *reason we see* black is because breaks " in the field due to the absence of stimulating light, such as would occur if we had no blackness-sensation, would be decidedly unpleasant. What would otherwise be ' cosmic holes ' in our spatial field, as Dr. Ladd-Franklin has called them, have been obviated by the fact that they are filled up with a definite non-light-sensation, that of blackness ".[1]

In 1920 James Ward asserted that black is not a sensation at all, reversing his position of 1905 ; he says : " I have to confess that I was long among the number of those who championed the specific and positive character of black as a sensation. Mr. McDougall, who also now dissents, has made a like admission ".[2] Professor Titchener engaged in a brilliant discussion of this subject with James Ward in the columns of the *British Journal of Psychology*—but without effect. When the collected papers of the latter came out (*Psychological Essays*), there was no reference whatever in it to this work of Titchener.

As an example of the Hering position on the nature of black as a sensation, the articles of F. L. Dimmick of 1920 and 1925 [3] may be cited. He maintains that there are two series of greys which join each other at an angle of 180 degrees, and that in one of them no white is perceptible, in the other no black. It is hardly necessary, however, to discuss this view at any length.

A brief examination of recent discussion of the nature of black as a colour-sensation shows, then, that Ladd-Franklin shares Helmholtz's view of blackness as a definite sensation, a background sensation, and a non-

[1] *Psy. Rev.*, xxxi, 1925, 501.

[2] James Ward : *Psychological Principles*, 1920, p. 122.

[3] *Psy. Rev.*, 1925, xxxii, 336.

light-sensation. It also points to the fallacy of the Hering theory of *three* antagonistic colour-pairs. She maintains, further, that it is a sensation of one degree of intensity only.

III

TROLAND AND THE LADD-FRANKLIN THEORY

[Most of this chapter of Mr. Israeli's paper will be omitted, because the subject has been fully discussed elsewhere, see pp. 231–240.]

Is the photo-chemical process assumed by the Ladd-Franklin colour theory a mythical one, impossible in terms of present photo-chemical or chemical principles to understand ? The answer to this is that there is a dyestuff, a rosaniline carboxylate, which affords a perfect parallel to the light-sensitive molecules assumed by her. This dyestuff resembles the hypothetical colour-molecule in that there are " three cleavage products, say A, B, C such that A and B, and A and C, form mixtures, but when B and C have once formed a chemical compound, then that compound unites with A and forms the chemical compound ABC—in this case an ethyl chloride ".[1] This exactly parallels the case, in colour, of blue, green, and red. We have the whole series of the distinct blue-greens, and of the distinct blue-reds, but when we look for the red-greens, they are not to be found—yellow has been formed in their place, and that, when chemically united with " blue " gives white. . . . However, in a review of the translation of Helmholtz's *Treatise on Physiological Optics*, Professor Troland discusses the chapter in that book on " The Nature of the Colour-Sensations " by Ladd-Franklin (written especially for this English translation, see p. 148 of this book), and he says : " Finally, she expounds anew her well-known developmental theory of colour vision as a resolution of the combined difficulties of the Helmholtz and Hering

[1] Neifeld, *A. Jr. Phys. Opt.*, 412, 1923.

views. The exposition is clear, concise, and convincing."
He also calls attention to the fact that "a chemical
substance, a rosaniline carboxylate, has been noted which
has decomposition reactions accurately paralleling those
of the completely differentiated molecules postulated by
the developmental theory ".[1]

IV

THE HARTRIDGE CRITERIA AND THE LADD-FRANKLIN THEORY OF COLOUR

Like Troland, Hartridge readily admits the pre-
eminence of the theory as far as colour theories of the
present day go, but for him the theory is too simple.

Hartridge advances three criteria of a colour theory :
(1) the ability of the theory to fit in with all the known
facts of colour vision ; (2) its novelty ; (3) its utility.

He applies these criteria to the Ladd-Franklin theory.

1. What about the ability of this theory to fit in with
all the known facts of colour vision ? Hartridge finds that
it certainly passes the test of the " double function and
double structure of the retina " (what Titchener has,
quite sufficiently, called " dual vision ").[2] As for the facts
of simultaneous and successive contrast—what v. Kries
has now called (a very useful term) the " accessory facts "
of colour vision—Hartridge is of the belief that these are
to be correlated with cortical processes, and so do not
necessarily need to be explained by a theory which deals
with retinal processes only. This is a curious position to
take, for whatever calls itself a " colour theory " ought
surely to explain all the elementary facts of colour vision.
Moreover, it has now been definitely proved that these
phenomena *are* of retinal origin. Excitation of the visual
apparatus is now known to be of two very different kinds ;
two excitations, due to different kinds of stimulus, may

[1] *Science*, 11th July, 1926.
[2] [There is no occasion for the name " v. Kries duplicity *theory* ".]

look, as sensations, exactly alike, and yet may differ to an extraordinary degree—(1) one may be followed by a negative after-image, and (2) the other not. Stimulation *by light* is always followed by a negative after-image (a residual image), but there are two other kinds of stimulation : (*a*) direct pressure on the optic nerve, and (*b*) the action of the electric current. A table of what happens follows :—

	II	I
(*a*)	By pressure, of *six* different kinds ("Visible Radiation from Excited Nerve Fibre", *Science*, 9th September, 1927, 239–41).	By physical light.
(*b*)	By the electric current—here the results are very different, depending on the different application points of the electrodes.	
	All of these *entail* the absence of the residual image.	This *entails* the presence of the residual image.

The reason for this is plain. Pressure is a regular means of excitation of any nerve whatever ; when it is exerted upon the optic nerve fibres that line the surface of the retina (and in all other cases), it acts as it acts everywhere else, and there is no negative ("complement") effect. It is only when the highly specific light-sensitive substance in the end members of the cones is acted upon (and that can be done only by means of light) that there is any possibility of producing the highly specific negative after-image (residual image). All this, then, takes place in the retina (and more specifically in the end-members of the *cones*, in the case of the *chromatic* after-images).

Nothing could be more satisfactory than the Ladd-Franklin explanation of the residual image (negative after-image). As regards contrast, it has been proved by Fröhlich that that is simply the negative after-image of diffused light in the eye-ball, and the explanation of that is, of course, the same as the explanation of the negative after-image.[1]

[1] But see also the theory of contrast given by Mildred Focht in the *Psychological Review*, 1928, 35, 87–91. C. L.-F.

2. The work of Ferree and Rand on peripheral colour vision shows that red stimuli are recognized as such at a greater distance from the centre than are green. But according to the theories of both Hering and Ladd-Franklin (for different reasons) red and green should fade out together. According to the Ladd-Franklin theory they represent a differentiation (a specification) in that photo-chemical product which more primitively produces yellow.

In reply to this, Dr. Ladd-Franklin points out (*a*) that the extreme periphery of the retina is largely made up of rods, that rod-vision, which is white in quality, has its maximum intensity in the mid-frequency region of the spectrum (the green), and that therefore the green furnished by the cones would be, in this place, quite " drowned out " by the superabundant amount of white light mixed up with it. This would not happen in the case of red—rod vision is very minute in quantity in the red. Hence green would necessarily become invisible, in the periphery, much sooner than red.

(*b*) But in any case on the Ladd-Franklin theory, and on that of Hering, it is not *Red* and *Green* that must disappear together, but the stable (invariable) colours ; these are a bluish-red and a bluish-green (Ole Bull, Hess, Hegg).[1] Rand and Ferree seem to have paid no attention to this feature of the fact that since red and green come in together, they ought also to go out together. *Why* the zonally invariable colours are at the intersection-points respectively of the normal *green and blue*, and *red and blue*, distribution curves of König-Helmholtz is perfectly evident to anyone who takes the trouble to study (in the light of the work of König and Dieterich) the nature of red and green defect.

(*c*) But again it is, of course, not when they are of *equal*

[1] They are, of course, colours of the utmost importance, but there was no reason whatever (except accidental mischance) for Hering's taking them for the fundamental, elementary, colours—his so-called *Urfarben*.

energy that these colours ought to disappear together, but when they are of *equal colour-quenching power*. (This very necessary term is due to Helmholtz.) When we make an even yellow by mixing red and green, we are very far from taking a red and a green of *equal energy*. The most fundamental fact of colour vision is that the reaction of the light-sensitive substance in the retina to light-rays of different frequency is *specific*. It is very singular that this fact should have been overlooked by Rand and Ferree—especially when the work of Hegg, and now that of Engelking and Eckstein, is accessible to them (see *Psych. Rev.*, vol. iii, and *Kln. Mbl. f. Augenhk.*, 1921).

(*d*) The colours which have been put on the market by Hegg, of Berne, have been carefully prepared to meet all of these requirements, but they also have the character of being of the same degree of brightness when they both become colourless (achromatic). They owe this character to the fact that, as colours, they are of such relative brightness and saturation that it takes exactly semi-circles of them on the colour disk to make a pure white. Small squares of *r* and *g* (the invariable red and green) turn into one uniform grey rectangle when they lose, together, their chromatic constituent. These colours of Hegg do actually disappear together all over the retina, and at all degrees of illumination. This set contained also small tubes of oil paint, with which to replace the colours if they became faded. But these tin sheets and paints were expensive. The colours required—" invariable and periphery-equal "—have now been put on the market by Engelking and Eckstein, at a much less price.

2. Is the theory new ? Ladd-Franklin says this (in her first paper on the subject of colour—*Mind*, N.S., ii, 1893) : " It was while I was engaged in writing an article to show that a certain theory by Donders was better than that of Helmholtz or of Hering, that it suddenly dawned upon me that a far better theory still was possible." The theory of Donders contains the idea of partial dissociation, but it is a singular fact that he does not go on to show that

this conception leads at once to an explanation of that great " enigma " of colour—why the red-greens and the yellow-blues (unlike the four other possible dual colour blends) have absolutely disappeared. Donders, therefore, does nothing whatever to unite the Helmholtz *facts* with the Hering *facts* and to make them into one reasonable and consistent whole. He is, on the other hand, compelled to say, simply, that there is a four-fold process in the retina and a three-fold process in the cortex—as v. Kries also reaches the stage of affirming that *there is* a three-fold process in the retina and " somehow " a four-fold process in the cortex [1]—without offering any explanation of this curious tergiversation on the part of Nature. Whoever has any comprehension of the Ladd-Franklin theory, with its *initial*, three-fold process in the *light-sensitive substance* of the retina—immediately followed (still in the light-sensitive substance of the retina) by a chemical reaction between red and green which constitutes a *reversion* to the more primitive yellow, and again by the *reversion* of whatever yellow and blue may be present to the more primitive white, will see at once how very far the Donders conception is from meeting the requirements of an adequate colour theory. [2]

3. Has the theory been useful ? Hartridge says that the Young-Helmholtz theory explains the facts of colour-matching and of complementary colours as well as that of Ladd-Franklin, and that in the case of colour-blindness neither of the theories explains anything. But this is to show a total lack of comprehension of the Ladd-Franklin theory; nothing could be more definite than the explanation which it gives of all the facts of colour-defect. Red-green blindness, as well as total chromatic blindness, is plainly an atavistic throw-back. Hartridge asks if the Ladd-Franklin theory has led to as much research

[1] And now also G. E. Müller. C. L.-F.
[2] Donders is to be credited, however, with having first introduced into the subject the idea of a partial dissociation of light-sensitive substances. C. L.-F.

T

as the Young theory has done. The theory of Young waited fifty years before it received any attention at all. The reply to this is that the fate of a colour theory (as Shakespeare says of the fate of a joke) lies in the ear of him who hears it. There are plenty of things still to be discovered on the subject of colour, and any colour theory may well form the ground-work upon which new problems are considered. Dr. Ladd-Franklin writes : " Not everybody is interested in hypotheses (theories) ; some are content with a plain diet of fact. But it is well known that successful theories of complicated occurrences in nature are not only intellectually satisfying but also most important guides to further investigation." [1]

The Ladd-Franklin theory, based as it is upon the actual facts of the development of the colour sense, has served to bring those facts, hitherto too much neglected in connexion with the scientific treatment of colour, into the foreground. They serve to raise the question whether we may not expect, in some dim future, the occurrence of a further differentiation of the colour sense in the direction of a still greater specificity.

[1] Hartridge, "The Ladd-Franklin Hypothesis," *Br. J. Ophth.*, 1923, vii, 139–42.

APPENDIX D

LIST OF DATES AND ORIGINAL SOURCES

PART I

I. 1902. *Dictionary of Philosophy and Psychology.*
II. 1892. *Proceedings of the International Congress of Experimental Psychology, London.*
III. 1893. *Mind*, N.S., vol. ii, p. 473.
IV. 1895. *Psychological Review*, vol. ii, p. 137.
V. 1900. *Psychological Review*, vol. vii, p. 600.
VI. 1909. *Comptes rendus du VIe Congrès International de Psychologie, Genève*, p. 698.
VII. 1914. *American Encyclopaedia of Ophthalmology.*
VIII. 1916. *Psychological Review*, vol. xxiii, p. 237.
IX. [1924.] *Helmholtz's Treatise on Physiological Optics*, Appended to vol. ii, p. 455.
X. 1922. *Psychological Review*, vol. xxix, p. 180.

PART II

1. 1892. Part of Abstract distributed at the Congress on 2nd August, 1892.
2. 1897. *Science*, N.S., vol. v, p. 310.
3. 1898. *Psychological Review*, vol. v, p. 309.
4. 1899. ,, ,, vol. vi, p. 212.
5. 1903. ,, ,, vol. x, p. 551.
6. 1893. *Nature*, vol. xlviii, p. 517.
7. 1895. *American Journal of Physiological Optics*, vol. vi. p. 70.
8. 1925. Joint Meeting of the Physical and the Optical Society, New York. *Journal of the Optical Society of America*, vol. xi, p. 128.
9. 1926. *Proceedings of the National Academy of Sciences*, vol. xii, p. 413.

APPENDIX A

1892. *Zeitschrift für Psychologie und Physiologie der Sinnesorgane*, vol. iv, pp. 211—21.

APPENDIX B

1. 1925. *American Journal of Physiological Optics*, vol. vi, p. 70.
2. 1924. *Psychological Review*, vol. xxxi, p. 498.
3. 1925. *American Journal of Physiological Optics*, vol. v, p. 242.
4. 1925. *Psychological Review*, vol. xxxii, p. 248.
5. Not before published.

GLOSSARY

ACHROMA.—See chroma.

ACHROMATIC.—The colour system of the totally chroma-blind.

ACHROMATICITY.—See chroma.

BRIGHTNESS.—This word has been hopelessly vitiated by the Hering view that the brightness of a colour-sensation is due to a constituent whiteness (a thing which there is no reason to think is present at all in colours of high chromaticity) ; for it should be substituted the perfectly sufficient *luminosity* or *(subjective) intensity.*

BRILLIANCE.—(Subjective intensity) . . . Luminosity expressed in number of just perceptible steps.

CHROMA.—The sadly ambiguous word *colour* should be used in its inclusive sense, as including the whites, black, and the black-whites (or greys).[1] The colour-sensations should then be divided into the achromatic and the chromatic ones—of the former, white is a *light* sensation, black is a *non-light* sensation. The chromatic sensations are, in the order of their development, the " unitary " yellow and blue, red and green ; the two latter chromata, being the most recent, are also the most fragile—they vanish first in such diseases as progressive atrophy of the optic nerve ; they are undeveloped in the ordinary cases of partial chroma-blindness. In addition to the unitary chromata, we experience four (not six) dual chroma blends—the blue-greens, the green-yellows, the blue-reds (" purples ") and the red-yellows (oranges). The remaining two dyads of chroma, red and green, yellow and blue, are " vanishing " chroma pairs—they unite to form respectively yellow and white. Besides the word chroma (plur. chromata) we shall also need (for white and black) achroma (plur. achromata). It will then be easy to substitute the perfectly good and significant words *achromaticity* and *chromaticity* for the poor " degree of non-saturation ". and "degree of saturation".

CHROMA BLENDS (dual).—The blue-greens, etc., the non-unitary chromatic sensations.

CHROMA-BLIND.—To be substituted now for *colour*-blind. The latter term really means the same thing as *totally blind*, since white is a colour.

CHROMA-TONE.—This should be substituted for " hue " ; the latter term is wholly unnecessary, and besides it has no correlate in either French or German—a distinct defect when we come to introducing an international language.

CHROMATIC.—See Chroma.

CHROMATICITY.—See Chroma.

" MONOCHROMATIC."—The physicist makes a sad mistake when he says that a homogeneous (as regards light-waves) blue-green e.g. is monochromatic—it is di-*chromatic*. He has a perfectly good word for what he means in *homogeneous.*

PSYCHOPHYSICAL PARALLELISM.—For this say *neuropsychic correlation.*

ROD PIGMENT.—The proper name for what is usually called the " visual purple ". This is a substance which exists in three different stages :

[1] The term is now used in this sense by the Illuminating Engineering Society—*Nomenclature*, 1925, p. 9.

283

first " purple ", then yellow, then colourless (or white). But in the first stage it is not purple (in the English sense), but crimson—" purple " was a wrong translation from the German. In the last stage it is known to be still a definite substance, from the fact that it is, with the proper distribution, fluorescent : it is lacking in the central part of the retina and also in the periphery, as can readily be seen entoptically when it is " purple "—it appears as a middle zone. In its yellow stage it is a good absorbent for the blue end of the spectrum, and this fact it is which was originally emphasized as the Purkinje phenomenon ; later, when it is " purple ", its maximum absorption is in the green. Moreover, when first discovered by Boll, it was taken to be the " visual substance " (Sehstoff), and to exist in both the rods and the cones ; as is now known, its most distinctive feature is that it exists in the rods only, and this fact should be properly indicated in its name. It is best called, therefore, rod pigment (crimson, yellow, white).

STABLE COLOURS.—The colours that do not change in tone as they are seen farther out on the retina ; crimson and verdigris (Titchener). Hering, by a not unnatural mistake, took these to be also the Urfarben.

TETRACHROMATIC.—In the extreme periphery of the retina vision is practically achromatic ; in the mid-periphery it is dichromatic (yellow and blue are seen, as in the case of the dichromatic defectives ; in a good middle of the retina red and green are also sensed—vision is tetrachromatic.

TONELESS COLOUR (light sensation).—White.

VISIBILITY CURVE.—This is an unsuitable term for what can perfectly well be called equal energy luminosity curve (Chaffee).

VISUAL PURPLE.—See Rod-pigment.

INDEX

Abelsdorff, 51, 93
Absorption-distribution of the rod-pigments (visual purple and visual yellow) in human retina, first determination of, 94
Accessory phenomena, 152, 262
Achromaticity (for non-saturation, 168
Achromatopia, cerebral, 57, 61
Acuity, foveal, of achromates of cerebral type, 99
After-image, negative (residual image), in retina, 65, 69, 270
All-or-none law, for nerves of sensation, 233, 235 n.
Analogies with the visual system, 237
Analogy, 85

Bayliss, 184
Black, 9 n., 149, 211–12, 241–6 ; cortical, 242 n. ; of one intensity only, 242, 258 ; why we see, 244 ; may not be seen by fishes, 245 n. ; a non-light sensation, 255, 258
Blindness, total foveal, of achromates, 99
Brightness, of a saturated red, Hering, 111
v. Brücke, 121
Burdon Sanderson, 127

Cattell, 50, 148, 152, 179
Chemical evolution, analogy for, Harkins, 184
Chemical reactions assumed, 230 n.
Chroma, 127, 150
Chromaticity (for saturation), 168
Coincidence of (1) achromatic defective, (2) achromatic scotopic, and (3) rod pigment absorption curves for the human eye (König), 94
Colour blend, dual, 120
Colour molecule, hypothetical, 53
Consciousness, " explanation " of, 182
Contrast, 146 n., 152, 270

Defective, the visual mechanism, 144
Dichromatic vision, blue and yellow, 191
Dissociation, partial, of colour molecule, 91
Dissociation products, not preformed, 182
Distinction of colour, not correlated with distinction of cones, 235 n.
Donders, 54, 70–1, 91, 158, 229
Double structure and double function of the retina, 57, 105 ; absolutely established (not a theory only), 113, 228 n.

Ebbinghaus, 63, 209–10
Ellis, 235
Embryonal identity of rods and cones, 199
Engelking and Eckstein, 272
Epicycle theory, 55 n.
Evolution theory, 240
Exner, 50
" Explanation," 82

Ferree and Rand, 271
Fick, E., 97, 227
Fluorescence of rod-pigment, 96
Four colour theory and three colour theory, 229 n.
Foveal blindness of the typical achromates, 127
Fröbes, 160, 241
Fröhlich, 146 n., 152, 167, 270

Greef, 49 n.
Grey, change of intensity gives change of quality, 242

Harkins, 182
Hartridge, 269
Hecht, 162–3, 219
Hegel, 160
Hegg, 271–272
Hellpach, 49
Helmholtz, 148, 157
Helmholtz-König facts, 153–8; curves, 159

Hens, night-blind, 58
Hering, 67, 80
Hess, 137
Howell, 181
Hypotheses, *ad hoc*, 117

Instability of equation between whites of different physical constitution with change of intensity, discovered, 89

Katz, 216
Kirschmann, 97
Klebs, 103
König, 54, 100, 213, 229
König and Köttgen, 94
v. Kries, 56, 63, 108, 116, 123, 152, 228 ; " duplicity " theory, 60–1

Langley, 94
Lasareff, 216
Leber, 81
Light sensation from pressure, 270 ; from electric current, 270
" Local sign," 216 n.
Luminosity spectrum, 55
Luminous-paint spots, for darkness foveal fixation, 98

Minimal requirements, 164, 261, 266
Müller, G. E., axioms, 150, 158, 214, 232

Neifeld, 231, 241
Neuro-psychic correlation, 116
Newton, 151 ; law of colour mixtures, 56 ; law " tested ", 193
Night-blindness of the fovea, normal, 97, 127
Nodon, 217

Parinaud, double structure and double function of the retina, 58, 126, 228, 264 ; Purkinje phenomenon, blue is brighter, but whiter, not bluer, 59
Periphery, 227 ; ultra-extreme, 49 n.
Perrin, 183
Physiological substances, economy in, 184
Piéron, 214
Place-coefficients, 215, 245 n. ; instead of local sign, 251
Pole, William, 191–2

Pre-psychological and pre-evolutionary, 179
Purkinje, 215 ; phenomenon absent in the fovea, Parinaud, 58 ; blue end of spectrum becomes whiter, not bluer, due to rod vision, 101 n., 107, 250 ; extended, 193–7, 250

Radiation theory of chemical activity, 183
Raehlmann, 61
Ramon y Cajal, 103, 126, 171
Red, green, and blue receptor process in one cone, 144
Reddish-blue arcs and reddish-blue glow of the retina, 215
Residual image (after-image), 216
Rod or cone, one to each spatial point, 233
Rod-pigment in the human retina, 93 ; crimson, yellow, white, 281
Rods and cones, 227
Rosanilin carboxylate, 239, 268 269

Schenck, 121
Schultze, Max, 126, 228, 264
Sciences, connected with the colour-sensations, 213
Scotomata, negative and positive, 258
Scotopia, 127
Self-light of the retina, due to pressure on optic nerve fibres, 241–2.
Specific " brightening and darkening " powers of the colours, Hering, 55
Specific features of the visual processes are in the receptors, 181
Spectrum, when fainter, first red and green, then white, 59
Spring, 109

Terminology, 118–21, 136–7, 150, 167–9
Tetrachromatic, 229 n., 235
Theory, Ladd-Franklin, 52, 83–4, 89, 130, 148, 160–3
Transformer mechanism, 186
Triangle, colour, 43
Trilinear co-ordinates, 152, 154
Tri-receptor process, 160 n., 229 n.
Troland, 231, 253

Visible radiation from excited nerve fibre, 215, 217

Visual purple, and the light of dense forests, 103 ; different colour in (1) fishes and (2) other vertebrates, 109 ; a sensitizer, and not the " visual substance ", 109

Visual sensation stimuli, inadequate, no after-image, 242 n.

Visual white, 58

Ward, James, 267

Warren, 166, 241, 257

Whites of different physical constitution, change in relative brightness of in photopic and scotopic vision (extended Purkinje phenomenon, 209

Young-Helmholtz theory, 66, three-fifths of a colour-theory, 149

Printed in Great Britain by Stephen Austin & Sons, Ltd., Hertford.

CLASSICS IN PSYCHOLOGY

AN ARNO PRESS COLLECTION

Angell, James Rowland. **Psychology: On Introductory Study of the Structure and Function of Human Consciousness.** 4th edition. 1908

Bain, Alexander. **Mental Science.** 1868

Baldwin, James Mark. **Social and Ethical Interpretations in Mental Development.** 2nd edition. 1899

Bechterev, Vladimir Michailovitch. **General Principles of Human Reflexology.** [1932]

Binet, Alfred and Th[éodore] Simon. **The Development of Intelligence in Children.** 1916

Bogardus, Emory S. **Fundamentals of Social Psychology.** 1924

Buytendijk, F. J. J. **The Mind of the Dog.** 1936

Ebbinghaus, Hermann. **Psychology: An Elementary Text-Book.** 1908

Goddard, Henry Herbert. **The Kallikak Family.** 1931

Hobhouse, L[eonard] T. **Mind in Evolution.** 1915

Holt, Edwin B. **The Concept of Consciousness.** 1914

Külpe, Oswald. **Outlines of Psychology.** 1895

Ladd-Franklin, Christine. **Colour and Colour Theories.** 1929

Lectures Delivered at the 20th Anniversary Celebration of Clark University. (Reprinted from *The American Journal of Psychology*, Vol. 21, Nos. 2 and 3). 1910

Lipps, Theodor. **Psychological Studies.** 2nd edition. 1926

Loeb, Jacques. **Comparative Physiology of the Brain and Comparative Psychology.** 1900

Lotze, Hermann. **Outlines of Psychology.** [1885]

McDougall, William. **The Group Mind.** 2nd edition. 1920

Meier, Norman C., editor. **Studies in the Psychology of Art: Volume III.** 1939

Morgan, C. Lloyd. **Habit and Instinct.** 1896

Münsterberg, Hugo. **Psychology and Industrial Efficiency.** 1913

Murchison, Carl, editor. **Psychologies of 1930.** 1930

Piéron, Henri. **Thought and the Brain.** 1927

Pillsbury, W[alter] B[owers]. **Attention.** 1908

[Poffenberger, A. T., editor]. **James McKeen Cattell: Man of Science.** 1947

Preyer, W[illiam] **The Mind of the Child: Parts I and II.** 1890/1889

The Psychology of Skill: Three Studies. 1973

Reymert, Martin L., editor. **Feelings and Emotions:** The Wittenberg Symposium. 1928

Ribot, Th[éodule Armand]. **Essay on the Creative Imagination.** 1906

Roback, A[braham] A[aron]. **The Psychology of Character.** 1927

I. M. Sechenov: Biographical Sketch and Essays. (Reprinted from *Selected Works* by I. Sechenov). 1935

Sherrington, Charles. **The Integrative Action of the Nervous System.** 2nd edition. 1947

Spearman, C[harles]. **The Nature of 'Intelligence' and the Principles of Cognition.** 1923

Thorndike, Edward L. **Education: A First Book.** 1912

Thorndike, Edward L., E. O. Bregman, M. V. Cobb, et al. **The Measurement of Intelligence.** [1927]

Titchener, Edward Bradford. **Lectures on the Elementary Psychology of Feeling and Attention.** 1908

Titchener, Edward Bradford. **Lectures on the Experimental Psychology of the Thought-Processes.** 1909

Washburn, Margaret Floy. **Movement and Mental Imagery.** 1916

Whipple, Guy Montrose. **Manual of Mental and Physical Tests:** Parts I and II. 2nd edition. 1914/1915

Woodworth, Robert Sessions. **Dynamic Psychology.** 1918

Wundt, Wilhelm. **An Introduction to Psychology.** 1912

Yerkes, Robert M. **The Dancing Mouse** and **The Mind of a Gorilla.** 1907/1926